UNBRANDED

U N B R

Four Men and Sixteen Mustangs.

ANDED

Three Thousand Miles across the American West.

BEN MASTERS

TEXAS A&M UNIVERSITY PRESS *College Station, Texas*

This paper meets
the requirements of A
NSI/NISO, Z39.48–1992
(Permanence of Paper).
Binding materials have been
chosen for durability.
Manufactured in China
by Everbest Printing Co.
through Four Colour Printing Group

Library of Congress Cataloging-in-Publication Data

Masters, Ben, 1988– author.
 Unbranded: four men and sixteen mustangs: three
thousand miles across the American West /
Ben Masters. — First edition.
 pages cm
 Includes bibliographical references and index.
 ISBN 978-1-62349-280-9 (cloth: alk. paper) —
 ISBN 978-1-62349-281-6 (flexbound: alk. paper) —
 ISBN 978-1-62349-287-8 (ebook)
1. Adventure travel—West (U.S.) 2. Masters, Ben,
1988—Travel—West (U.S.) 3. West (U.S.)—Descrip-
tion and travel. 4. Western riding—West (U.S.)
5. Mustang. 6. Wildlife cinematography. I. Title.
 G516.M38 2015
 917.804'34—dc23
 2014032873

Photographs by Phillip Baribeau, Korey Kaczmarek,
Dan Thorstad, Thomas Glover, Jonny Fitzsimons,
Ben Thamer, Ross Hecox, Cory Richards, Ryan Bell,
Ryan Rickert, Clean Slate Group, Ben Paschal, and
Ben Masters

State maps hand tooled by Ben Masters

Dedicated to conservation, the wise use of our natural resources

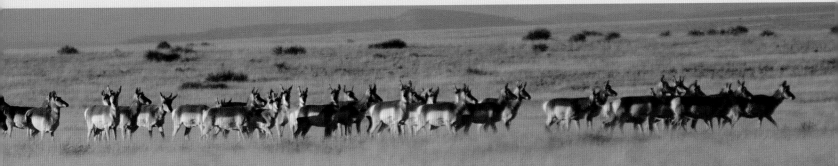

CONTENTS

PREPARATION

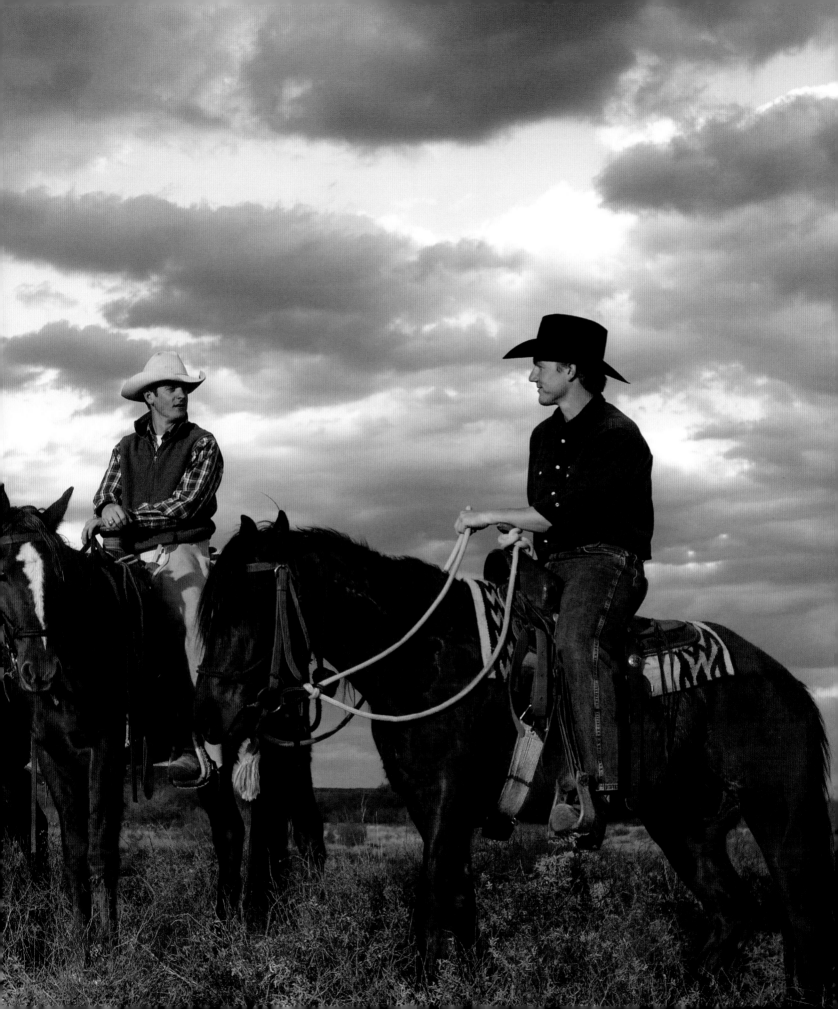

Inspiration

Unbranded started with cheap tequila and greasy enchiladas in one of the few places in the world where you can find people crazy enough to ride a horse for thousands of miles—Texas A&M University. Raising his glass, Parker Flannery, horse trainer, polo player, cowboy, adrenaline junky, and firm nonbeliever in lethargy, toasted to my proposition. Of course we should take a semester off from school, save some money, gather a string of horses, and ride them through the state of Colorado. So we did. I recruited Mike Pinckney, whom I'd packed with in the mountains of Colorado the previous summer, and the three of us rode horses through the entire state. We went ahead and rode through parts of New Mexico, Wyoming, and Montana while we were at it.

That trip was in 2010, and it really changed my life. We traveled more than 2,000 miles in four months through untamed country with few human inhabitants and great fishing. We were really broke and couldn't afford all the good horses we needed, so we adopted some cheap, unwanted mustangs from the Bureau of Land Management (BLM) to supplement our quarter horses. Those unwanted wild horses ended up being the best horses we had. But the lifestyle was tough; it iced on us for the last two weeks, and when I finished that ride on September 22 with an empty belly, cold fingers, soaking wet clothes, and sore legs, I swore to myself that I'd never do a horseback trip again.

A few weeks later, after my fingers thawed out, after I'd gained ten pounds and bought new clothes, I began to plan another one. But this time it would be different; I'd learned from my mistakes. We would need more horses, horses bred for that kind of trip, more time, and a different route that avoided Colorado's 12,000-foot snow-clad passes. I wanted to ride every single inch of the most backcountry route possible from Mexico to Canada, and I wanted to film it. The 2010 ride was so unusual and exciting that I felt confident people would want to watch a film of it. Making a movie couldn't be that hard.

I also wanted to show people that mustangs aren't the worthless beasts that are currently wasting away in holding pens but are excellent, usable stock, especially in the backcountry. Some of them make great mountain horses, they're inexpensive, and they're living symbols of the American West. Mustang management is also in dire need of policy change, and currently the only method of population control is adoption. By using mustangs, I hoped to inspire adoptions and educate viewers on the necessity of population control.

I ruminated over the idea for a couple of years, looked at cameras, crunched numbers, and approached several production companies. The big ones wanted to bring large crews to the project and produce the reality junk typically shown on TV. I wanted the show to be raw and to tell the true story, documentary style, without a script.

Finally, in Bozeman, Montana, I found the right man for the job: Phillip Baribeau, one of the top adventure filmmakers in the industry. We put together a plan. All we needed was a crew of willing guys, a bunch of wild horses, some cameramen fit enough to do the job, and a couple hundred thousand dollars.

Everyone wants to go on a 3,000-mile, five-month-long pack trip until they really look at what it entails: hard work, no pay, dirty, expensive, slow, hot, dusty, sore—it's

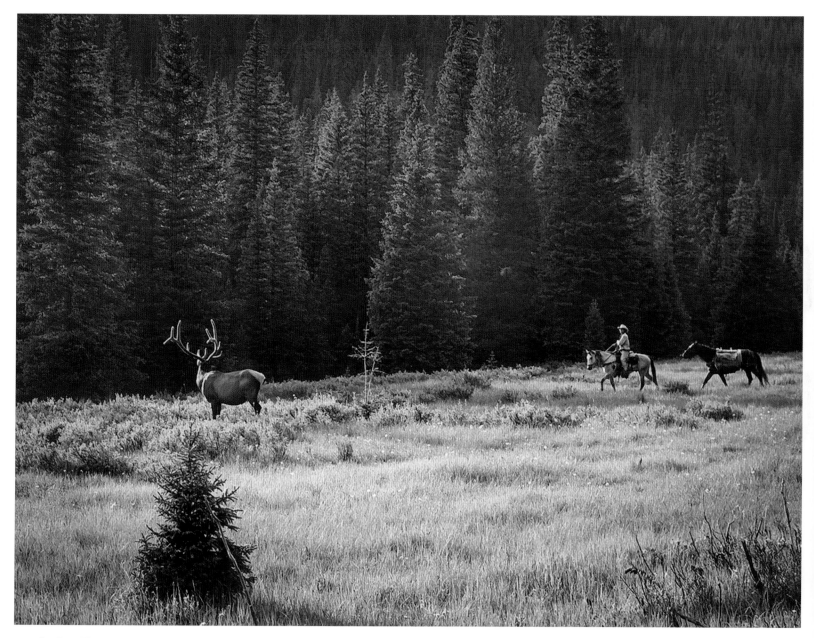

Parker Flannery watches a bull elk in northern Colorado during our 2,000-mile ride along the Continental Divide in 2010. Moments like this inspired the Unbranded *ride three years later.*

not an easy commitment. To find the right crew I had to go to Aggieland.

Jonny Fitzsimons, a new friend I'd met at a party, was the first to commit, and he was the perfect candidate. Jonny grew up on a cattle ranch near the Rio Grande in South Texas. A good horseman, Jonny had worked at a guest ranch one summer in Wyoming and knew a bit about mountain travel. Jonny committed to the trip within a few days of my bringing it up.

Thomas Glover was the next to commit. Tom and I were close friends in college, guided elk hunters in Wyoming one fall, and worked at the same dude ranch in Colorado. Tom grew up in the city of Houston but took to horses and the mountains like an old-school packer. He was exactly the type of guy you want in the backcountry when things go really wrong, really fast. He is also hilarious and pulls more than his weight, both important traits in someone you have to live with for five months.

Ben Thamer was a childhood friend of mine and a close pal of Jonny's at college. After Thamer graduated from Texas A&M, he started working at a feedlot in the Texas Panhandle. Thamer also led horseback trips for an outfit in Colorado during a college summer and spent a lot of time in high school wrangling at a kid's camp. Thamer's quick wit and willingness to be the cook made him ideal candidate number four.

We had a good crew; now we just needed money, horses, and a production team to go out and make a movie. When you need cash in Texas you go to the oil fields. It's a hard, hot, and sweaty lifestyle, but the pay is great and they will work you ninety hours a week. So I went out to West Texas, lived on my brother's couch, and screwed pipes together on a caliche pad in the Texas sun for four months to save up to buy a nice camera and lenses. When I had enough money, I quit and headed north to Montana with the intention of shooting a promotional video to use for fund-raising.

I worked at Mountain Sky Guest Ranch for two weeks, where I shot footage of horses moving through the mountains. Then I spent two months filming pack trip elk hunts in Wyoming, and later two more weeks filming wild mustangs in the Pryor Mountains of Wyoming. I gave the footage to Phill Baribeau in Bozeman, where I learned that there was a lot more to making quality video than just having a nice camera. Although I got some fair shots, it just wasn't enough to make a video of high enough quality to attract production funding. We needed better footage, with the entire crew and more action. We decided to bring a cameraman along to film the adoption and training of 11 wild horses to be used on the trip. That would be the exciting footage we needed to raise production money.

Why Mustangs?

The image of horse and rider is a powerful symbol inextricably tied to the European conquest and settlement of the New World. During the course of 500 years, horses took conquistadors forth, moved settlers west, pulled the plow, carried the soldier, and transformed pedestrian native societies into some of the greatest equine cultures the world has ever seen.

Fossil records show that the ancestors of modern horses originated in North America but by the end of the last Ice Age were extinct on this continent. Fortunately, they had crossed the Bering Strait where the first cowboys, on the Asian steppes, broke them to pull, pack, and eventually ride.

Domesticated horses spread throughout Asia, the Middle East, North Africa, and Europe. Each locale required something different in their animals, thus breeds developed to better suit a horse to the task at hand. For example, in the Middle East smaller, more agile horses were bred to travel great distances bearing lightly armored warriors, while in northern Europe massive, heavy-boned draft horses carried fully armored knights into battle.

In AD 711, Moorish armies crossed the Strait of Gibraltar and entered Spain and Portugal. Although the Moors never had complete control of the people or their land, their presence for eight centuries left an indelible mark on the Iberian Peninsula, one that included horses. The Moors brought the Barb horse from North Africa, which was bred with the local Iberian horse to create the Jennet, a compact, gaited horse known for its courage, stamina, and durability. Thirty-four of these horses accompanied Christopher Columbus on his second voyage and set hoof in the Caribbean islands in November 1493.

During the Age of Exploration, horses were commonly transported on ships suspended in belly slings with their front feet hobbled and barely touching the ground. Mortality was high crossing the Atlantic, estimated at around 30 percent, and the ocean voyages were the first of many selection gauntlets that left only the strongest to survive.

Although intact stallions were the gender of choice for warfare, mares were in demand for breeding purposes once in the New World. In the spring of 1519, Hernán Cortés left Cuba with about 500 men and fifteen or sixteen horses bound for Mexico. When they landed, for the first time in 10,000 years the family Equidae was back on the American continent.

Cortés noted that the horses were "worth their weight in gold," and their presence mystified and terrified the native people. Within two years, Cortés conquered Tenochtitlan, a city rivaling the largest city in Europe, and defeated the Aztec empire. Bernal Díaz del Castillo, a chronicler of the Spanish conquest of Mexico, wrote, "The horsemen were also so dexterous and behaved so valiantly that, next to god, they guarded us most; they were a fortress."

For the next 300 years, Spanish conquistadors and their horses explored the land, searched for gold, and allowed missionaries to establish European roots in North and South America. Their horses strayed, were stolen by natives, and set loose to reproduce. Nearly doubling their populations every four years, horses bred and spread from Mexico to Canada, wherever there was ample grass to graze. In less than three centuries, these horses completely changed the lifestyle of

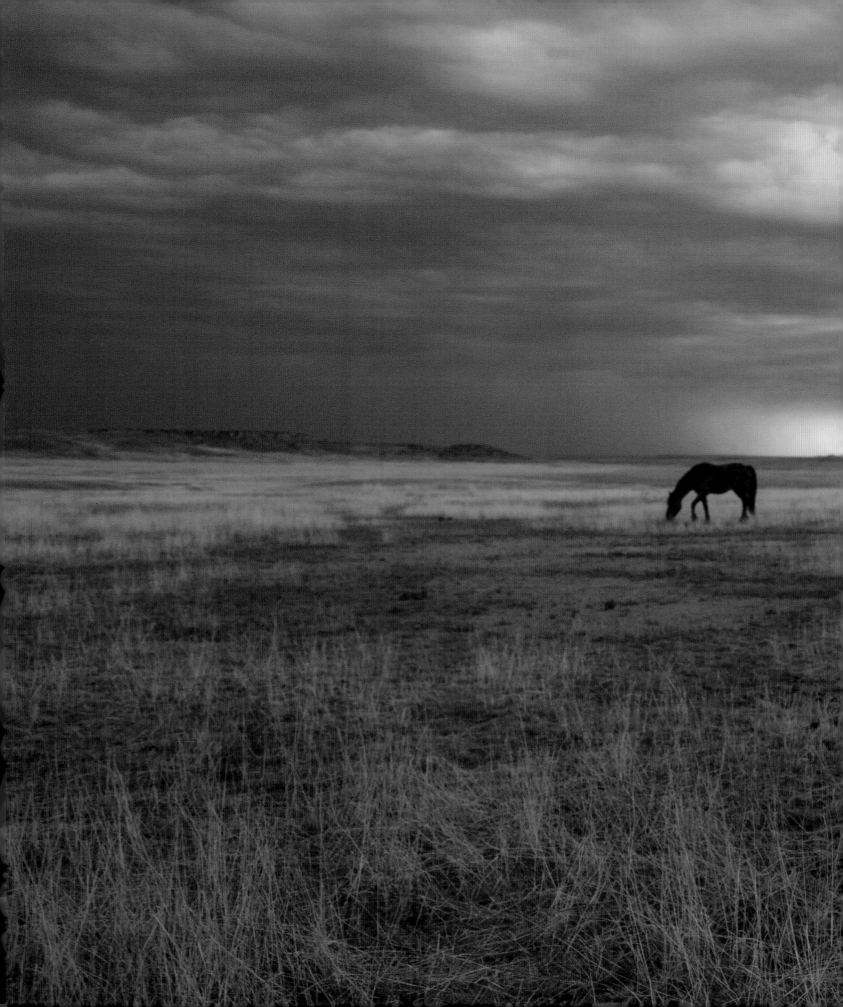

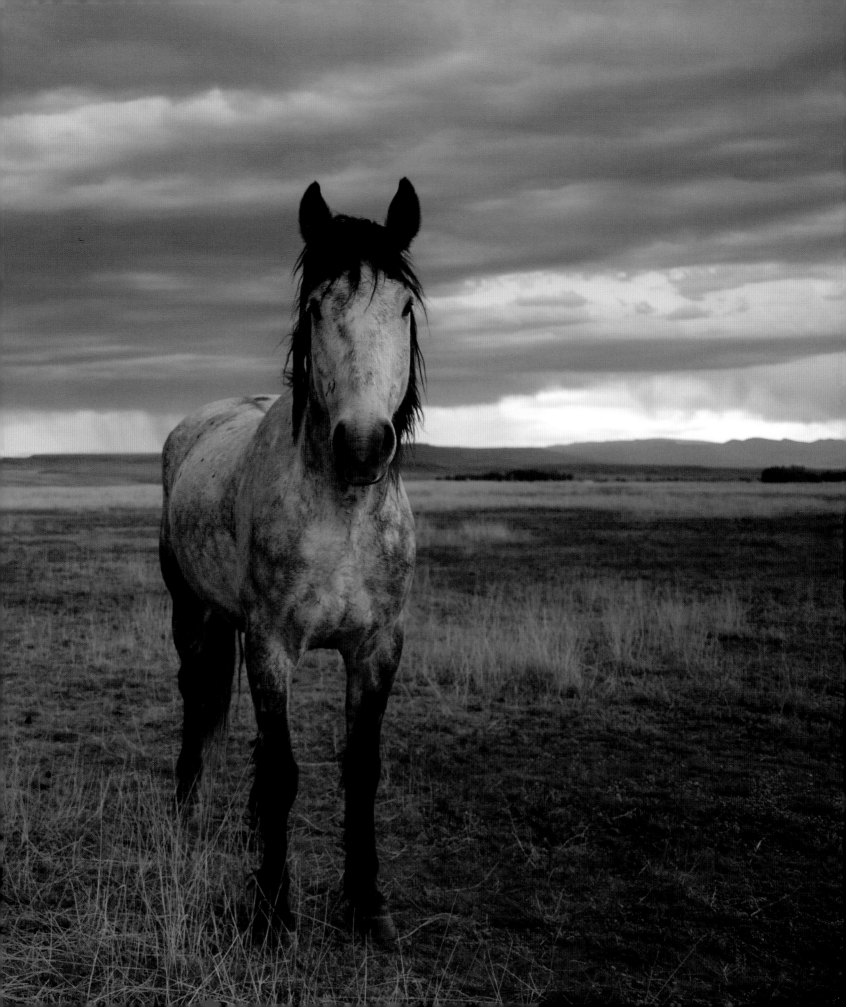

powerful tribes of Native Americans. Indeed, it is hard to imagine the Comanche, Black-foot, and Sioux without their horses carrying them alongside the buffalo migrations.

When Meriwether Lewis and William Clark went west in 1804 to explore the Louisiana Purchase, horses were so plentiful that most of the tribes they encountered—Hidatsa, Otoe, Mandan, Missouri, Sioux, Shoshone, Nez Perce, Osage, Pawnee, Assiniboine, Arikara, Cheyenne, and Gros Ventre—possessed ponies. Supply was ample, and a horse could be obtained for about one dollar's worth of beads and trinkets. Lewis and Clark even relied on traded Indian horses to cross the Rocky Mountains between the Missouri and Columbia River drainages.

The Lewis and Clark expedition opened the way for American settlers to head west, and inevitably horses accompanied them. Draft horses were taken along the Oregon Trail for farming in the Northwest. The US Cavalry relied on larger, thoroughbred-type bays to take them across the plains in pursuit of Native Americans. Texas cowboys brought their horses north during the cattle drives. Horses escaped and were stolen, and stallions with certain traits were let loose among free-ranging horses to improve bloodlines. For example, the US Cavalry released thousands of bay stallions (called "remounts") that stood between 15.1 and 16 hands and weighed between 950 and 1150 pounds, the size the US Cavalry most desired.

As populations of both Native Americans and buffalo dwindled under the European invasion, as railroads eventually stretched from coast to coast, and as barbed wire began to partition Texas and the Great Plains, the free-roaming horse competed for graze with livestock and measures were taken to lower their numbers. Mustangs were shot or rounded up and shipped to meat markets to make way for livestock, domesticated horses, and the farmer. By 1890, Spanish-style wild horses had disappeared from Texas, California, and the Great Plains and existed only in remote, geographically isolated regions in the Mountain West.

Then as now, ranching in the arid west was hard work, and turning a profit was difficult. Wild horses competed with livestock for food, and unlike cattle they couldn't be rotated or taken off the range during drought. Captured mustangs were sold for pet food, human food, and to militaries during times of war. But capturing wild horses was not easy or for the faint of heart. Horses were caught in water traps and bait traps and rounded up by cowboys and later by trucks, helicopters, and airplanes. Massive fences were set up to funnel the gathered horses to pens, where they were shipped or driven to market. Wild animals do not respond well to pursuit or confinement, and the inherent survival instincts of the horse to flee often led to injury during these gathers.

By 1940, wild horses were mostly gone from the West with the exception of the Great Basin, a vast, arid, and sparsely populated 200,000-square-mile region located in Nevada, eastern California, western Utah, and southern Oregon. The remaining wild horses lived there protected by the isolation, lack of development, and inhospitable terrain their surroundings afforded. Little rain, up to 110-degree heat in the summer, and down to minus-30-degree cold in the winter made the Great Basin a challenging place for both horse and human to live. Yet eventually the harsh landscape of the Great Basin

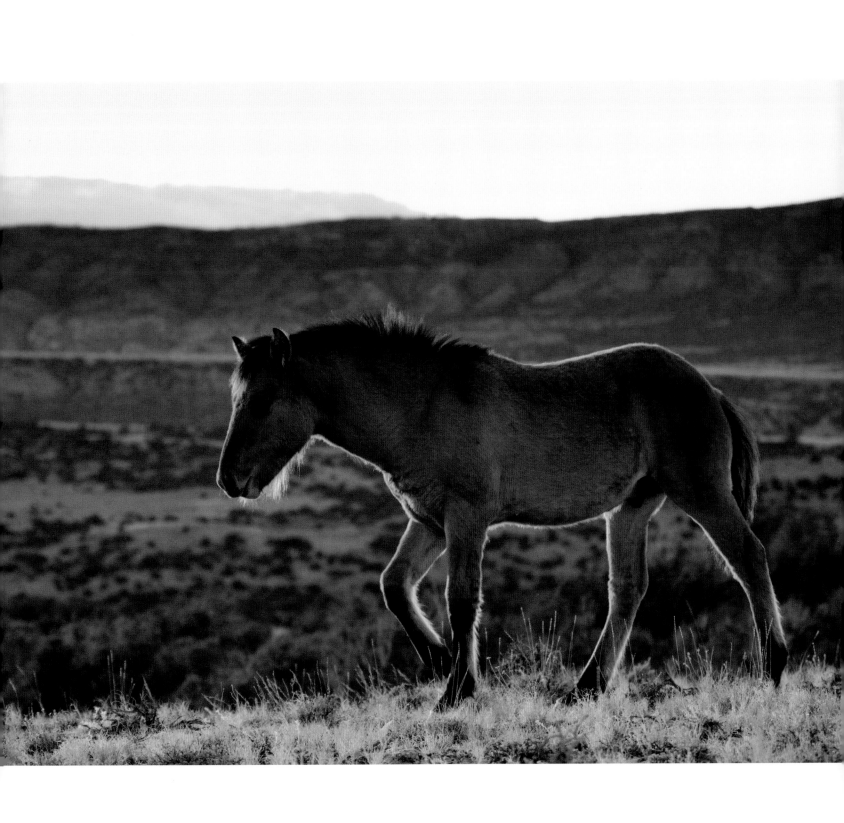

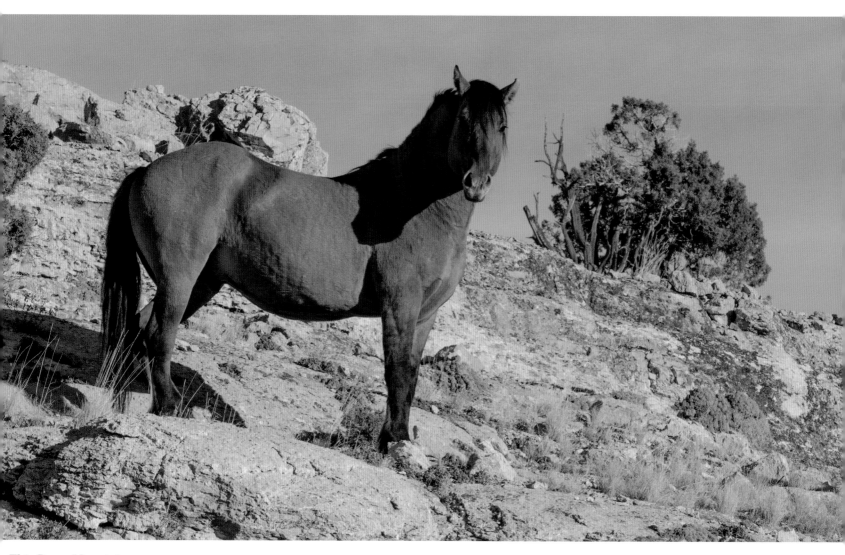

This Pryor Mountain stallion exhibits primitive traits. Note the stripes on his withers and legs.

attracted resilient individuals wanting to make the land their home. Wild horses were inevitably in the way.

In 1950, insurance secretary Velma Johnston was driving to work in Reno, Nevada, when she pulled up to a stock trailer that changed not only her life, but also wild horse management and the future of the mustang forever. Blood dripped from the trailer, and looking through the slats Johnston saw crammed horses with terror in their eyes. She followed the trailer to a meat packing plant and watched as the

horses were unloaded, destined for slaughter. Johnston, later known as "Wild Horse Annie," would dedicate the rest of her life to the welfare of wild horses.

Johnston investigated the conditions of wild horse roundups and found them "barbaric beyond belief." She showed grisly evidence and gave eye-witness accounts to politicians, ranchers, schoolchildren, and anyone who would listen. She began making political ground with her childhood friend and ally Nevada congressman Walter Baring. Their first success was passing a law in 1952

that made mustang roundups by vehicle or aircraft illegal on private land. However, 80 percent of Nevada is public land, so Johnston and Baring went to Washington, DC, where they pushed for legislation prohibiting mechanical roundups in the state's entirety.

Johnston captivated Congress with her gruesome description of the methods mustangers used to capture her "wild ones," and her testimony was crucial to the passing of Public Law 86-234, better known as the Wild Horse Annie Act. The Wild Horse Annie Act prohibited vehicles and aircraft from hunting or capturing wild horses on public land; it also paved the way for more protective legislation to be passed. Twenty-one years after seeing a bloody trailer and devoting her life's work to wild horses, Wild Horse Annie, which she now used to refer to herself, watched the Wild and Free-Roaming Horses and Burros Act of 1971 pass through Congress and be signed into law by President Richard Nixon on December 15, 1971. The act's first sentence declared: "Congress finds and declares that wild free-roaming horses and burros are living symbols of the historic and pioneer spirit of the West; that they contribute to the diversity of life forms within the Nation and enrich the lives of the American people; and that these horses and burros are fast disappearing from the American scene."

When the Wild and Free-Roaming Horses and Burros Act was passed, horses and burros were present on 53.8 million acres. Today, the animals live and are managed on 179 different BLM Herd Management Areas that cover 31.6 million acres in Arizona, California, Colorado, Idaho, Montana, Nevada, New Mexico, Oregon, Utah, and Wyoming. Each Herd Management Area is different in size, geography, and wild horse bloodlines. Some of the herds have very little or no Spanish descent, while others, such as the Pryor Mountain herd, are thought to be very close to the original Spanish horse. Some of the herds are large draft animals, yet others are tiny and known for being difficult to train. Some herds are mainly paints, others bays, and some exhibit the primitive features of a dorsal stripe and stripes on the withers and legs. Each herd is unique, but all herds have survived a spectrum of serious selection criteria: voyaging to the Americas, riding into battle, taking settlers across the plains, and pulling plows across the prairies.

Hundreds of years of natural selection, of braving extreme heat and cold, and of battling for breeding rights have resulted in animals that survive on meager rations and are resilient, tough footed, surefooted, intelligent, and perfectly suited for a 3,000-mile pack trip through the same lands to which they are adapted.

The Kickstarter Campaign

Money is necessary to make a movie, but it's difficult to acquire—almost impossible with no filmmaking experience and only a crazy idea. I pitched *Unbranded* to quite a few production companies, but each of them wanted either total creative control or money up front. We didn't have any money and didn't want *Unbranded* to be junk TV, so we decided to raise funds to produce the film on our own through a fairly new website called kickstarter.com. Kickstarter.com is a crowd-funding website where the user posts a video, describes the project, sets a dollar goal, and establishes a fund-raising time frame. Donors have the satisfaction of bringing a project of their own choosing to

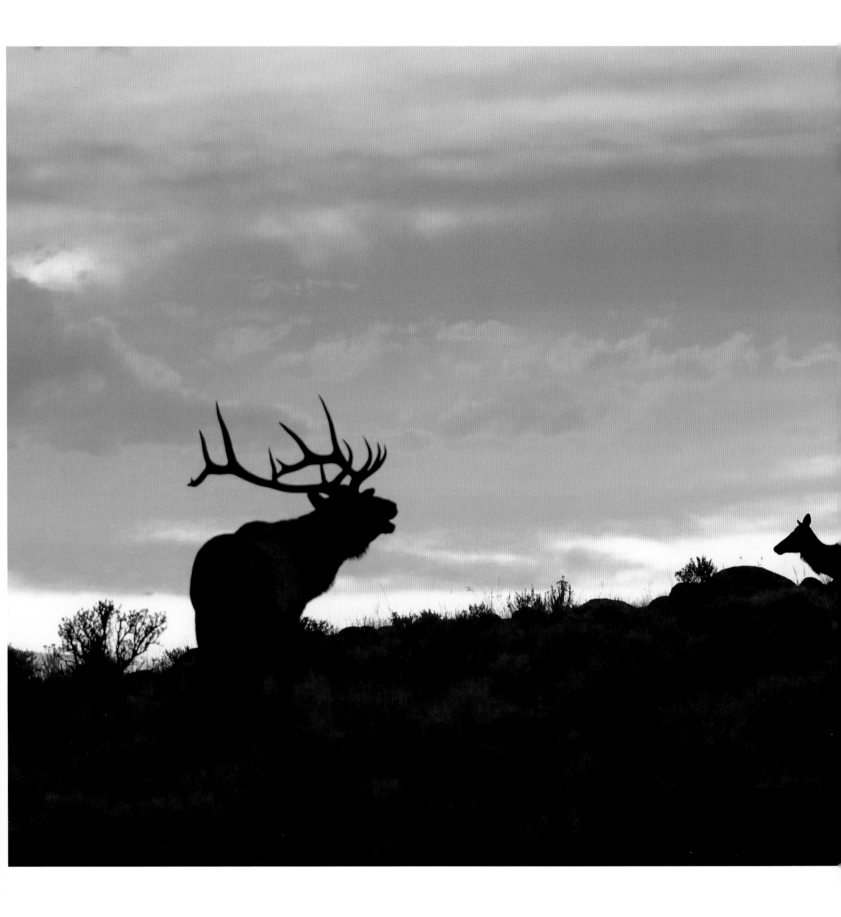

With money I earned in the Texas oil fields, I bought a Canon 5D Mark III with high-end lenses. When I came across this sight in Yellowstone National Park, I tried to capture it on video, but I didn't have a tripod and the footage shook horribly. I switched to taking stills instead but stayed in video mode and later discovered my media card wasn't fast enough to handle it. I ended up with shaky video, missed frames, no audio, and blurry photos. It was a sobering moment when I realized we needed professional camera operators to get professional results. But I did get this shot, a testament to the user friendliness of digital cameras.

life and may receive a premium depending on the size of their contribution (such as a DVD or book). If you don't reach your goal during the time frame, no one's credit card is processed, and you get nothing. We put all of our eggs in one basket, shot for the stars with a $150,000 goal, chose a forty-five-day time frame, and began the process.

The first, and most crucial, component of our Kickstarter campaign was creating a video with high enough quality and appeal to go viral. We accomplished this with a stunning four-minute video shot by Denver Miller, Phill Baribeau, and me and edited by Phill. I still get goose bumps at the memory of seeing the video for the first time; watching it, I felt the enormity of the task we had chosen really sink in.

The video was amazing, but it also needed to reach masses of people who would open their pocketbooks when they saw it. We began to identify large organizations with similar ideals and a like-minded audience that could endorse our trip, provide us with free advertising, and ultimately make the Kickstarter campaign succeed. Fortunately, Kate Bradley of *Western Horseman* magazine had written an article on my 2010 ride, and she agreed to arrange a meeting with publisher Darrel Dodds to discuss our plans. After the meeting, *Western Horseman* magazine, the most popular equine magazine in the world with more than 150,000 monthly subscriptions, endorsed *Unbranded* and offered to place a free, one-page ad in the issue corresponding with our Kickstarter campaign. I was floored by the support *Western Horseman* gave to our project, and to this day we enjoy a great relationship. As it turned out, the one-page magazine ad would be the crucial component that tipped the scales in our favor.

Another key organization that endorsed *Unbranded* in its infancy was the Mustang Heritage Foundation. Through their programs, the Mustang Heritage Foundation helps the Bureau of Land Management adopt out horses. With the foundation's support, we knew news of our project would spread quickly through the small mustang world, an audience likely to financially support *Unbranded*.

On December 17, 2012, we launched our Kickstarter campaign. I'll never forget the trepidation I felt when seeing that $150,000 goal and just 45 days to reach it, then clicking the mouse to begin. Only after it was live did it dawn on me that we needed to raise over $3,000 per day for the next month and a half to reach our goal. I was terrified but way too far in to turn back.

We notified all of our contacts, and within weeks newspaper articles appeared throughout Texas in Amarillo, San Angelo, College Station, Austin, and Lubbock. *Western Horseman* magazine, the Mustang Heritage Foundation, and countless other organizations spread news of our Kickstarter project over the Internet. We began an intense email newsletter promotion, launched a website, and created a Facebook page that grew to more than 7,000 people. We called friends, family, neighbors, acquaintances, friends of friends, anyone we could get hold of telling them to donate what they could and spread the word. Within 24 hours we had raised more than $10,000.

The initial funding was largely from friends and family. After their contributions, the success of our Kickstarter relied solely upon the goodwill of strangers and acquaintances. Ultimately, we were not disappointed, but we did made a horrible mistake in our timing. The Kickstarter campaign

1,062
backers

$171,253
pledged of $150,000 goal

0
seconds to go

Project by
Ben Masters
San Angelo, TX

K First created · **7 backed**

Ben Masters 1409 friends

unbrandedthefilm.com

Share 14 Tweet <> Embed ★

started on December 17, during the holiday season, a time when people's focus was on family, food, and festivities. After an initial spike in funding from close friends and family, we lost momentum, fell way short of our $3,000 per day average for days on end, and I became obsessed. We emailed horse trainers, BLM employees, state representatives, horse rescue centers, and many chapters of backcountry horseman associations.

Then, as the number of strings to pull dwindled and the holidays came to an end, *Unbranded* suddenly took on a life of its own as people all over the world began to discover our project and donate. Complete strangers donated $1, $10, $100, $1,000, even $10,000. It was insane! When the *Western Horseman* February issue hit newsstands and mailboxes around January 10, a massive leap in donations fueled our momentum to the finish line.

On January 27, 2013, we reached our $150,000 goal. Four days later our Kickstarter campaign ended. One thousand sixty-two backers had donated $171,453 in 45 days. In addition, 200 other people outside of Kickstarter donated $60,000. The generosity of family, friends, acquaintances, and total strangers kickstarted *Unbranded* to life. We had the support, we had the money, now all we had to do was finish training a bunch of green mustangs, ride them 3,000 miles across the country, and make a movie.

Choosing a Route

We did not follow in the footsteps of Lewis and Clark, Jim Bridger, or Kit Carson. The early explorers of the American West were sensible people who followed the terrain along river bottoms and other traversable routes. They wanted reliable graze, consistent water, and

the fastest way to their destination. Unfortunately for us, those river bottoms and routes are now almost entirely privately owned, and we mainly rode through what was left that settlers didn't want: high mountains, arid desert, and deep canyons unfit for agriculture.

The Homestead Act of 1862 gave one incentive for Americans to head west: land, the only thing they are not making more of. Settlers by the thousands headed west to establish their futures, each on 160 acres the federal government gave them if they claimed it. Naturally, settlers chose the best land they could find, which was land with a source of water. Large valleys and fertile, well-watered areas filled with people, and soon communities sprang up 15 to 20 miles apart from each other, the distance of one day's horseback travel.

As the West was settled, barbed wire was stretched across the plains, the American buffalo was nearly exterminated, and many Native Americans were forced onto reservations. Government regulations became necessary for the wise use of the increasingly not so vast or wild west. Unregulated timber harvesting, overgrazing, and market hunting, along with a natural resource extraction free-for-all, finally awakened an ideal that has become synonymous with the American identity: Conservation. Efforts began in earnest to protect the incredible resources that made the West so desirable from those seeking only an immediate return on all it had to offer.

National parks were established in geographic wonderlands such as Yellowstone, the Grand Canyon, and Yosemite. National forests were created, mainly to protect watersheds and regulate timber harvesting. Leftover lands, mostly in arid lowlands, fell under the jurisdiction of the Bureau of Land Management to be managed for grazing and resource extraction. Crucial habitat, such as wetlands or old growth forests, for endangered or migrating animals became part of the National Wildlife Refuge system. The foresight of early conservationists such as Theodore Roosevelt, John Muir, and Gifford Pinchot ensured that the West would retain much of its wildness, indigenous wildlife, and scenic majesty while simultaneously allowing for grazing, farming, mining, drilling, recreation, and timber harvesting. Without these visionaries, the West would certainly be more privatized and *Unbranded* would not have been possible.

Federal public lands today contain close to 28 percent of the United States' surface. That is about 640 million acres, more than one million square miles, about two acres per US citizen. Many public lands are available for multiple uses: habitat, recreation, and resource extraction. But some are preserved from the touch of humans. As of 2013, 106 million acres fell under definitions described in the Wilderness Act of 1964: "A wilderness, in contrast with those areas where man and his own works dominate the landscape, is hereby recognized as an area where the earth and its community of life are untrammeled by man, where man himself is a visitor who does not remain." Under the act, no roads, no grazing, and no resource extraction are allowed in designated wilderness, and the land lives by the laws of nature.

Planning as much of a wilderness experience as we could, we chose the most backcountry equine route possible from Mexico to Canada. For hikers, the route would be the Continental Divide Trail, a 3,100-mile trail through New Mexico, Colorado, Wyoming, and Montana. But the trail is not suited for horses, as I had discovered firsthand in 2010.

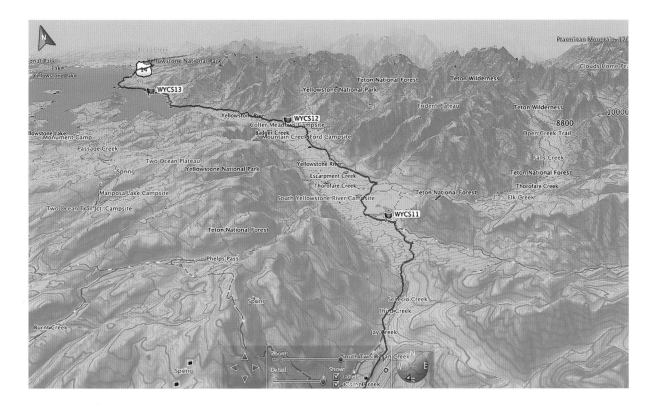

The passes in Colorado are too high and in Glacier National Park and the Bob Marshall Wilderness Complex there is too much snow. To successfully ride through Colorado on the Continental Divide Trail, you have to do it in late July, August, or September. But these are the only dates to go through Glacier and the Bob Marshall Wilderness Complex as well, which makes the trail impossible to complete unless you exhaust your horses, which I was not willing to do. For us, the route lay farther west, forsaking Colorado for Utah, where the elevations are lower and the snowpack melts faster.

I routed our trip south to north through Arizona, Utah, Idaho, Wyoming, and Montana. First, I bought large state maps and pieced together the big public land tracts. Then I bought each individual public land map and marked access and exit points on the north and south sides of the map. Slowly,

I began connecting the maps together trail by trail, which I transferred to my Garmin BaseCamp map with mapping software. I constructed alternate routes and exit routes and created trail networks, from four-wheel-drive roads to dirt roads to gravel roads to pavement to highways. Then I studied other routes and compared elevation changes, mileage, river crossings, water availability, topography, and whether or not the trail was on a north face. Once I had my alternate routes, I overlaid them on Google Earth and picked out topographically flat areas that were next to water and devoid of trees, indicators of locations to graze horses for the night. I identified these campsites every four to five miles so that we would have options once we got on the trail. All of this data was uploaded into Garmin Montana 650t GPS units, which Tom and I used to navigate on the trail in conjunction with paper maps.

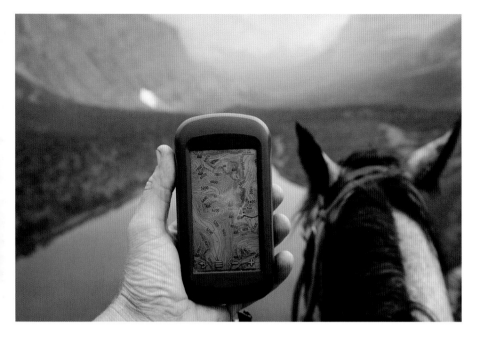

Graze at higher elevations in the summer in the West is typically good. I knew we would encounter consistent graze when we reached the Aquarius Plateau in southern Utah. We just needed to keep our horses fit to that point and then finish the trip with quality graze. Going through Arizona, our horses could not stay in top condition without supplemental feed and water; we would need a support crew.

I met Val Geissler on my 2010 ride at Hawks Rest cabin in the Teton Wilderness of Wyoming, the farthest location from a road in the lower forty-eight. He is one of a dying breed of old school packers and horse traders, a fountain of invaluable knowledge about a disappearing art. Val and I hit it off to the point where he calls me his son and he means it. Val volunteered to drive down to Texas from Wyoming to help us train the horses and be our support crew through Arizona. He also brought us four trail-tested mustangs that he broke in the mountains to use on the trail. Val would be the ideal support crew; he pulls a trailer with ease, shoes horses, plays guitar, sings, and has fifty years of experience packing horses through the mountains.

After I had all my proposed routes, campsites, and exit strategies, I called public land agencies in the areas, as well as outfitters and ranchers, to review the plans and any other considerations. We used considerable portions of the Arizona Trail in Arizona and the Continental Divide Trail once we entered Wyoming and Montana, both of which are congressionally designated National Scenic Trails.

According to extensive testing by the US Cavalry during the settlement of the West, a horse can travel 25 miles a day on flat ground over many days without losing body condition. We were not going to be traveling on flat ground so we cut that distance to 15 to 20 miles, depending on terrain. We also would not be chasing or fleeing from Indians, so we added rest days to give ourselves and our horses a break. Every 100 to 150 miles (or about five to ten days), we arranged to stop at a ranch to give the horses and ourselves one or two days' rest and to resupply our groceries, which our parents shipped to us (thanks, Mom!).

With Val taking care of us and our horses through Arizona, we were confident that we would be able to get into Utah's good graze with fit horses. From there, we would graze nutritious high country meadows all the way to Canada, fueling our horses to maintain a pace of two-thirds of a marathon five days a week through the Rocky Mountains. The route was laid. Now all that could change our plans were Mother Nature, injuries, snowpack, high rivers, lack of graze, government restrictions, and the desire of 16 wild horses to leave us at every chance.

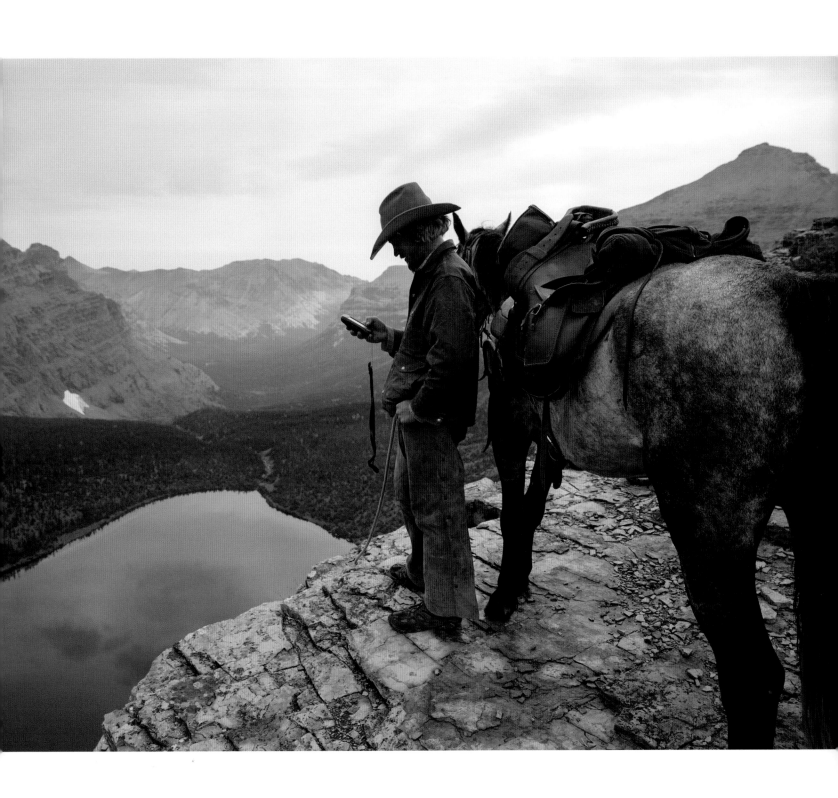

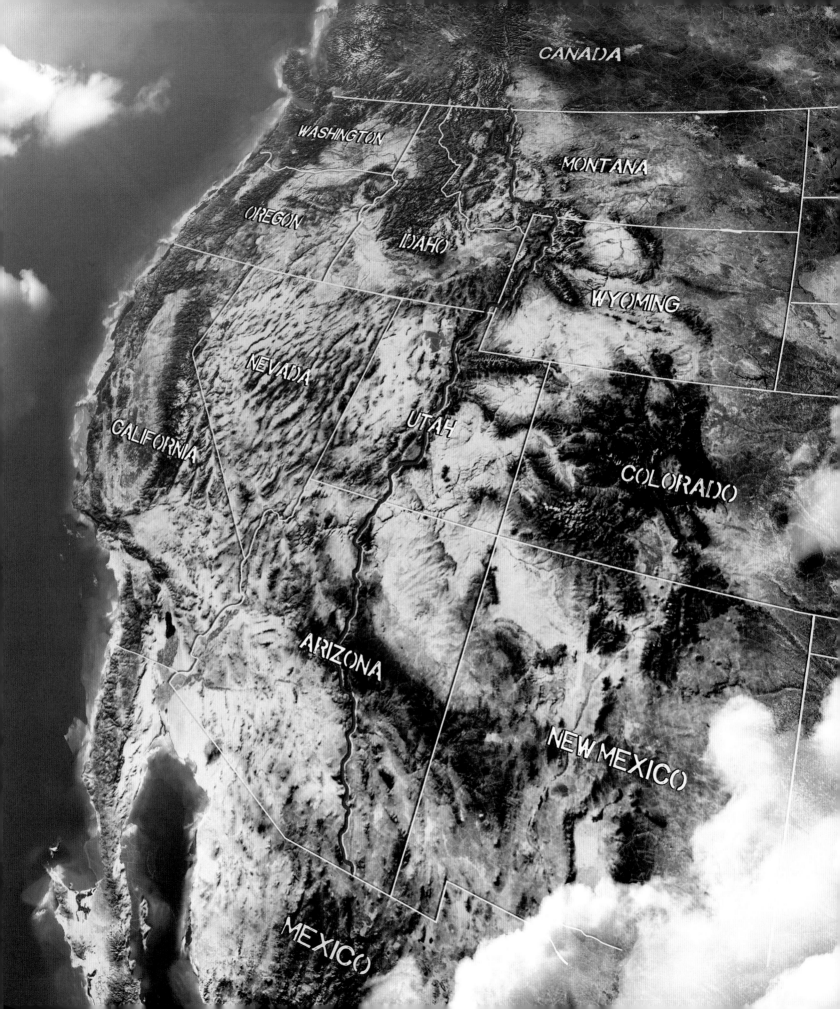

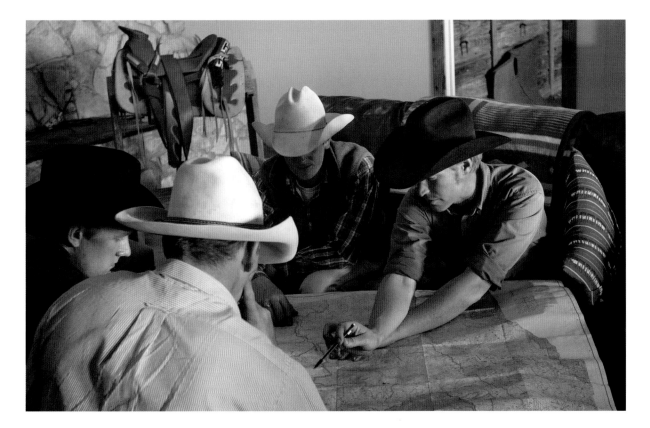

Filming the Ride

by Cindy Meehl

My *Unbranded* journey started in January 2013. I was sent a Kickstarter video for funding a film about four young men planning a 3,000-mile horseback ride through the Wild West. Watching the promotional video, I found myself tearing up over a young man speaking poetically about the ride of a lifetime, which he and three others were planning to take on wild mustangs. When he said they would be taking the mustangs out of captivity, and the horses would be taking the young men out of their captivity, I was hooked. I immediately emailed the contact and said how much I enjoyed the promo and that I would love to talk to them about their film plans.

As a director and executive producer,

I had just finished a two-year promotional campaign for my film, *Buck*. I was busy promoting the newly released *7 Clinics with Buck Brannaman*, which was the educational series we made using footage from the film. I was ready to slow down and quietly work on my next project on animal health.

A day after emailing, a young man called me back; his name was Ben Masters. He was contagiously excited about the epic adventure he had been planning for over a year. He told me about the trip, the guys involved, and that they had all gone to Texas A&M. That fact struck a chord because my father, Dudley Hughes, is a distinguished alumnus of Texas A&M and has always been a devoted supporter of the university.

I asked Ben about his plans for filming the ride and making it into a documentary. I had been surprised that they were only try-

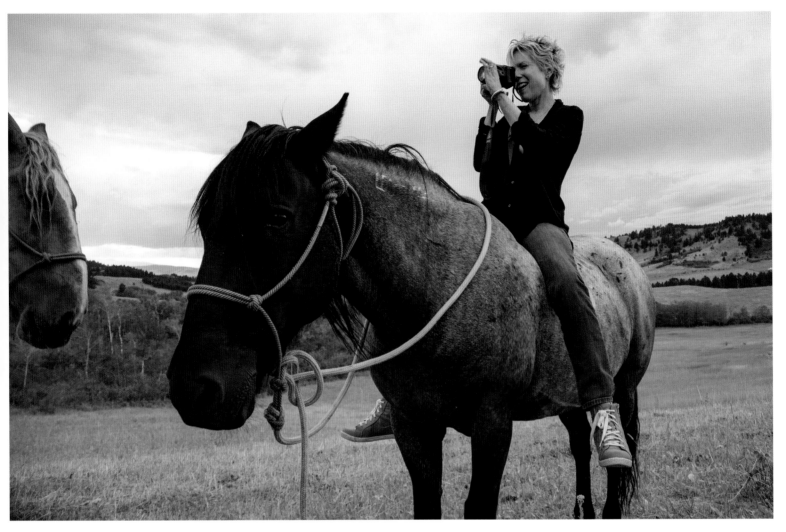

Cindy Meehl on Tuff, with Dinosaur looking on

ing to raise $150,000. The more Ben talked about his film idea, the more I realized he didn't know much about making one. I had been in his shoes myself and felt compelled to share some moviemaking knowledge with him. After spending several years on *Buck*, I knew the audience that would love *Unbranded*. During our call, I was impressed with the determination of this 24-year-old. Ben followed up with a nice email saying, "I really enjoyed talking with you and your knowledge is priceless. I hope we work together in the future."

Over the next two weeks, and after more phone calls, my curiosity and Ben's charm pulled me in. I found myself on a plane to Texas to meet him, Ben Thamer, and the mustangs they planned to ride; the mustangs were in a training program outside of Fort Worth. It gave me a chance to see if Ben's dream was a legitimate project. I was enthralled by an adventure the world would want to see. I asked my daughter, who works in film and is the same age as the guys, what she thought about her mom working on another horse film. She told me it was

something a lot of her friends could relate to because they wished they had taken time off for an adventure when they had finished school. I decided to dive in and join the *Unbranded* team.

A month later, I returned to Texas to do a shoot at the Jacalon Ranch with all four guys and to meet Jonny and Thomas. They were all pumped about their adventure and fearless on what were still wild and dangerous mustangs. I thought their story should be told and prayed they would survive such an arduous journey. Down deep I knew there was another factor urging me to help *Unbranded* come to fruition: to honor my dad, who is so proud to be an Aggie.

THE MUSTANGS

Picking Out the Herd

A mustang's first impression of humans isn't a nice one. Wild horses are tracked down by helicopters, trailed for miles across the desert, corralled into pens, separated from their families, and shipped to holding facilities around the country where they're squeezed into a chute, castrated, branded, and stuck with needles. It takes an experienced horse trainer to gain the respect and trust of these animals.

Tom, Ben Thamer, Jonny, and I had spent a lot of time around horses, but we knew we needed help with untouched mustangs. Fortunately, the nonprofit Mustang Heritage Foundation was there to provide it.

The Bureau of Land Management rounds wild horses off the range to reduce population sizes and puts the horses up for adoption. Fifty thousand of these mustangs are waiting to be adopted, and the Mustang Heritage Foundation created the Trainer Incentive Program (TIP) to help find them homes. Accomplished TIP horse trainers work with the mustangs for 30 days before giving them to others as gentled horses. Not many horsemen or women can train an untouched mustang, but a lot of them can train one after it has had 30 days of professional gentling. The Mustang Heritage Foundation gives the TIP trainer a cash incentive for finding a home for each gentled horse, the BLM gets their mustangs adopted, and the adopter receives 30 days of free training from a qualified trainer. This win-win situation inspired us to use TIP trainers to choose and gentle our mustangs because we are not professional wild horse trainers. (Unfortunately, shortly after we adopted our horses, the Bureau of Land Management stopped supporting the Trainer Incentive Program, and the Mustang Heritage Foundation was forced to eliminate it.)

We chose Jerry Jones and Lanny Leach to be our TIP trainers. Lanny Leach was a seasoned hand with decades of horse training experience throughout the Southwest. He had been on thousands of horses, and his discerning eye was the deciding factor in picking out our horses.

In late November 2012, we drove to the Hutchinson Correctional Facility, a Kansas state prison that holds about 500 wild horses for the BLM. Prisoners give the horses much needed care and training while they in turn receive the proven therapeutic benefits that horses provide. The inmates mainly work with two- and three-year-old colts because they're easier to handle and much more in demand. Horses that are rounded up as adults are more difficult to manage; they've fought for dominance in the herd, chased off predators, and know how to bite and kick. We needed the more mature, fully developed horses to withstand the physical rigors of the trip.

We started with 200 gelding mustangs between the ages of four and ten. We didn't want mares because Lanny said they were meaner than geldings. We started by separating 20 to 40 horses in a large corral and sending them down an alleyway in singles, doubles, and triples. Horses that we obviously didn't want were put back into the original pen, and those that needed closer inspection were pulled out.

Lanny was by far the most experienced horseman, and he made the cuts, using the criteria he describes below.

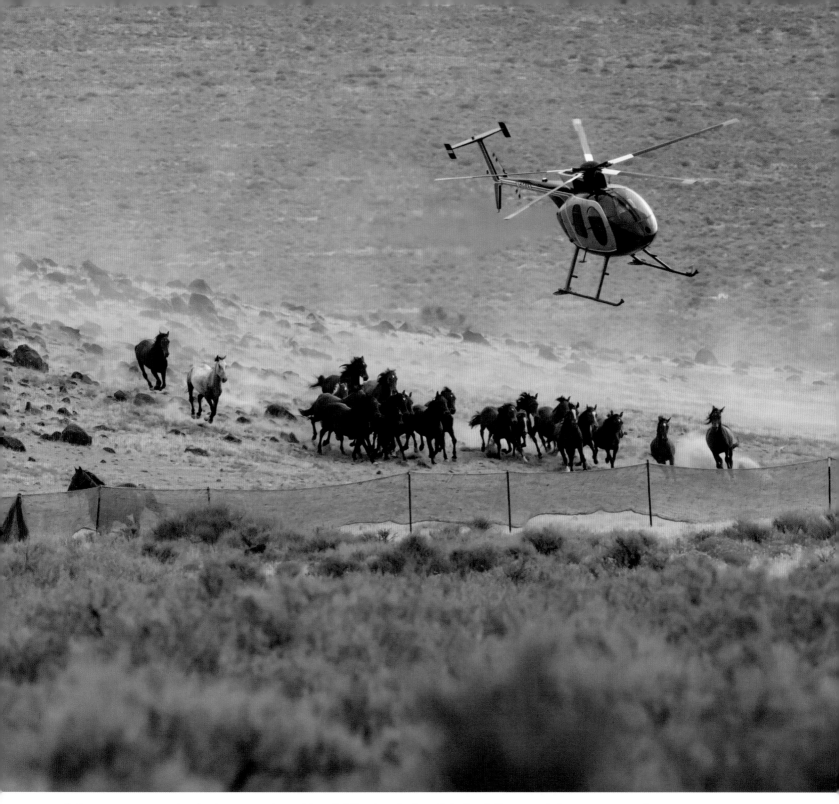

Before a mustang gather begins, a trap is positioned following the lay of the land. Long mesh fences are erected to funnel the horses into the trap. When the helicopter pilot pushes the wild band toward the funnel, the Judas horse (bottom left)—a tamed horse that has been trained to lead wild horses into a pen or corral—is released and runs into the trap. The herd follows the Judas horse as the helicopter applies pressure from behind.

What's neat about horses is that they'll show you on the outside what's in their inside. These boys needed gentle trail horses, so I picked traits for gentleness and good physical conformation. You don't want the biggest, toughest horse that's bossing everyone around, but you don't want the horse that gets picked on either. I look for horses in the middle of the bunch, horses that get respect and give respect.

You can tell a lot about a horse by looking at its head. A nervous, wilder horse will carry his head high to look for an escape. Gentle horses keep their heads lower, level with their withers. Ears that move back and forth while a horse is stationary show that the horse is aware of its surroundings without having to reposition its body; you want that confidence. A lot of white in the eyes means the horse is scared and should be avoided. You want gentle eyes. Hair swirls on the face tell you a lot. The ideal swirl is the size of a quarter between the eyes. Lots of horses have two or more swirls on their heads, which in my experience means they're strong willed and harder to teach. They can still be great horses but might take longer to train.

How a mustang reacts to pressure in the pens is important. You don't want a horse that bunches up in the corner with fear in his eyes when a person walks by. A gentler, more confident horse will watch you and face you. When it does move, you want it to move calmly, without a strong flight instinct.

The physical conformation of the mustangs was the most important factor in choosing the horses for *Unbranded*. An animal that's going to walk 3,000 miles from Mexico to Canada needs to be put together right. For generations, mustangs have been selected for survival, not necessarily traits good for human use. Because the mustang's ancestry is so diverse, they have all sorts of body types. Physically, some of the horses are complete junk; others are great; most fall somewhere in between. Many are too small. We picked big-boned horses 14 hands or higher with stocky builds, short backs, and big black feet. Usually mustangs have pretty good feet because if they don't, they die in the wild.

We sorted out 25 of the best horses from the original 200. Then Lanny's experienced eye searched every inch of horseflesh and noted things that I would have missed. A big bay had a small knot on the inside of his pastern (ankle), and his gait was slightly off—get rid of him. A well-made sorrel had faint scars around his hock—cut him too. Another bay was bossing the other horses around and being overly dominant—he was out. Slowly, we whittled down our herd.

After a full day of sorting, we loaded 11 stout, well-disposed, great-looking mustangs into trailers and headed to Texas to begin training. The guards, staff, and inmates at the Hutchinson Correctional Facility made it possible to begin our journey with the very best mustangs possible, all for an adoption fee of $125 each. And we will forever be indebted to Lanny Leach and his meticulous eye for horseflesh. His judgment was crucial to the success of our trip.

The First 30 Days

by Lanny Leach

In the first few days of training, when 11 wild mustangs were getting to know us and we were getting to know them, we became Lanny Leach's pupils in a master class on horse nature and training. In Lanny's words, this is just a little of what we learned.

The first 30 days of horse training are the most crucial because you're establishing the foundation for the horse's habits. It's either the beginning of the right things or the beginning of the wrong things. I had a big responsibility to ensure that the habits I instilled were the beneficial kind. The boys needed as much help as they could get.

Mustangs come off the trailer with normal, survival-related behavior. My training methods are the same for all horses, but extra caution needs to be taken around mustangs. Most domesticated horses I train have been at least halter broken, and they've been around humans. Mustangs haven't had human contact, and they're scared of things domesticated horses aren't. Slamming a door, dropping a saddle pad, sneezing, or going under a roof are new things that are scary to a horse experiencing them for the first time. The horse is a prey animal, and for all they know, you are a predator. As a defense, they'll kick. With wild horses, you really have to be mentally on top of your game and always in the right spot. If you get sloppy, they'll take the advantage, and you can get hurt, potentially very badly.

I strive hard not to make mistakes that would cause a horse to be even more untrusting of me than it is already. My objective is to gentle a horse and get it to begin to respond in a way that it starts to trust me. Each horse is an individual, and I progress the training methods as they each learn. Some horses learn quickly, others take time. Horses are really good at using body language, and you want to keep them attentive and confident. If they get too scared, they won't be learning.

The first step with these mustangs was teaching them to lead. We let them into the round pen and moved them around. When they calmed down, I roped them off my horse Buckle Bunny. They will usually start running in circles when you rope them, maybe kicking out, and I let them get used to the rope around their neck before applying pressure. If they followed me, the pressure would be released. If they fought me or tried to go the other way, the pressure increased. It was a balance of how much pressure to apply and when to release it. Over time, they found that it was a lot easier to follow than to fight. When they did it right, I released the pressure to reward them.

After a horse was leading with a lasso, I controlled his head with the rope and slipped a halter over his head. Then I took the lasso off the neck and began to lead him around by the halter. Once he figured out how to follow the halter, I dismounted my horse and began working with him while on the ground.

Groundwork can be dangerous with a new mustang, and you need to constantly be aware of your position in relationship

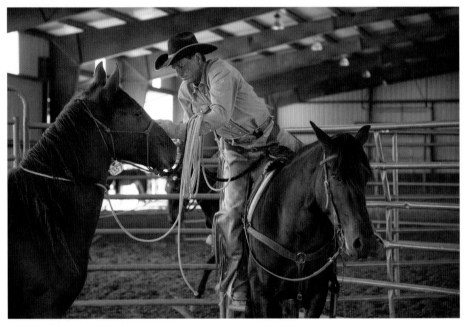

to the horse. Avoid the hind feet. It's good to have the horse tired, sucking wind; they listen better without excess energy. The first step on the ground is to get control of the head. Teach the horse that when you put pressure on the halter, he's to turn toward you. If he fights the halter, pull back, but as soon as he gives to the pressure, release instantly. Pressure and release—timing is everything. Horses begin to realize that when you give a cue, it's easier to follow than to fight. When they start looking for cues to follow, that's when teamwork starts. Unless the horse is moving in a circle at the end of your rope, he needs to be facing you. Don't let him give you his rear end. It's dangerous, and horses don't have eyes on their tails. Make him look to you; that's a good habit.

As the horse becomes comfortable with you on the ground, it's time to teach him that you're not there to hurt him. Start slowly, let him sniff your hand before you touch his face. Make gentle strokes on his head and neck. Watch the body language. If he doesn't like you touching his ears, don't force it. Now isn't the time to pick a fight; now is the time to gain trust. Let a little slack enter the lead rope, but always maintain control of the head because horses can—and will—spin to get into a defensive position. If they turn to flee, be firm with the halter. If they need to get rid of energy, let them run in circles.

Some horses are ready for a saddle on the first day; others need longer. Don't force the saddle onto the horse until he's ready. Start with the saddle pad. Let the horse sniff the pad, then slide it along its back until he accepts it. Take your

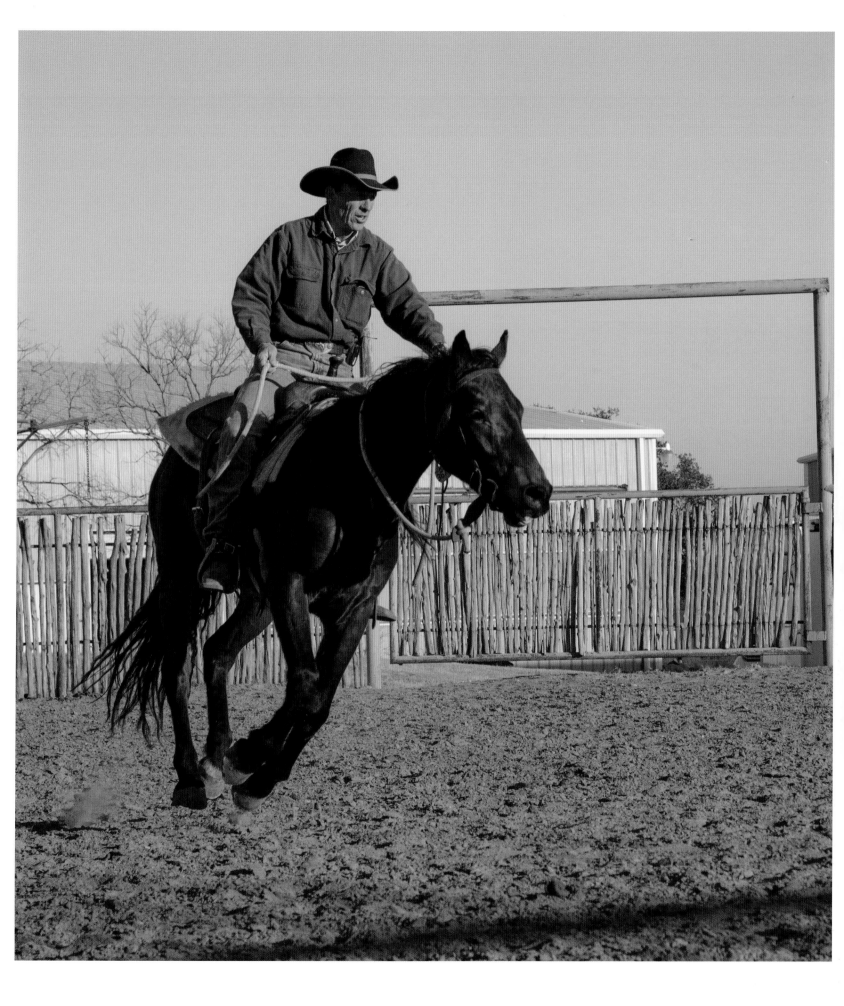

time and let him think about it. Rub on him. Horses read body emotion better than you do. Use a lightweight, beat-up saddle at first. Be soft when putting the saddle on. Always keep control of the horse's head. Hopefully, the horse will accept the saddle, but if he bucks or kicks it off, start over. Move him around until he wants to stand still. Tired horses are better learners.

Anytime horses learn something new, reward them. Give them a few seconds to think about it. Once the saddle is on, let the cinch down. If you trust the horse enough to reach under its belly, grab the cinch from the left side. If you don't trust it enough, use a wire hanger to grab the cinch. Cinching the horse for the first time is a scary experience because the

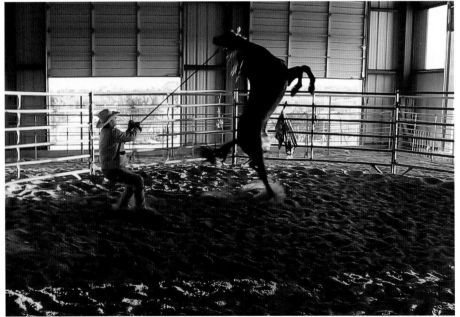

horse is being squeezed around the belly. Be careful, and do it slowly. The horse will have a reaction to the cinch. Some will stand bug-eyed while others will buck. Try to keep them calm, but if they need to get rid of energy, run them in the round pen until they're tired.

Some horses are touchy around the ears, and I try to get the bridle over the ears slowly. Put the bridle on over the halter at first. Always keep a hand on the halter and control of the horse's head. It takes a little time for a horse to become comfortable with a bit in its mouth. Give the horse time to get accustomed to it.

Standing next to the saddle horn, gently pull one rein. As soon as the horse gives you his head release the pressure. That's the reward. Do the same to the other side. Some horses learn quickly, others take time, but you need the horse to give you his head with the rein. Be as soft as you can but as firm as you need to be.

Unless you're looking for a rodeo, it's best to get on a tired horse for the first time. Be in control of the horse's head at all times. Make sure your cinch is snug. Stand on the left side of the horse next to the saddle horn. Apply pressure to the left rein until the horse's head is turned. Hold the left rein to the saddle horn to keep it grounded while you put weight into the stirrup. Take baby steps, add a little weight until he accepts it, then add more weight. If the horse is calm, swing onto its back while keeping his head turned. A horse can't buck as hard with a turned head. Turn in a circle until the horse gets the feel for your body and becomes calm. When the horse figures out that you're on his back and he's not

trying to get you off, release the left rein, give him his head, and turn him the other way. Teach him to turn left, then right. Give him energy to go. Take small steps and reward him when he does things correctly.

After 30 days of training with Lanny and Jerry, 8 of the 11 mustangs were walking, trotting, backing, loping, turning, and stopping. They had been ridden in the round pen, the arena, and outside. We decided that three of the horses hadn't progressed to our satisfaction. One was mean, another bucked, and the third had an uncontrollable fear of us. Robin Suggs in San Angelo, Texas, took the three horses that we cut. They will spend the rest of their lives on her beautiful ranch in the rolling hills of West Texas.

Training the Horses
by Jonny Fitzsimons

When I first met trainer Lanny Leach, I instantly knew he was a horseman. His quiet demeanor conveyed little, other than that he had spent the majority of his life communicating with horses. In conversation, one could easily mistake him for being disinterested or shy. Lanny didn't brag about the broncs he had ridden or the ranches he had worked on. He just communicated what needed to be conveyed in the simplest way possible. His intent was not in his words but in his tone and body language.

After adopting our horses from the BLM holding facility in Hutchinson, Kansas, we went with Lanny and Jerry Jones to their training facility in Cresson, Texas. There, under Lanny's tutelage, Masters, Tom,

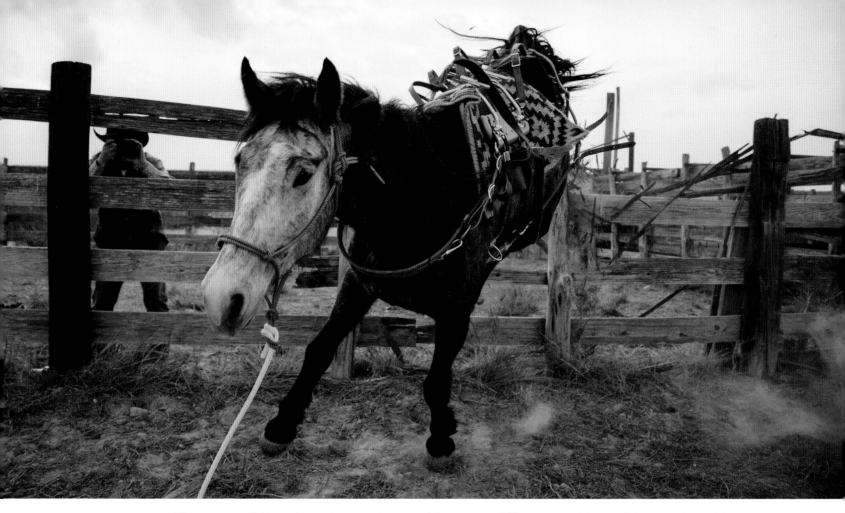

Thamer, and I got into the round pen with wild mustangs for the first time.

As we were running the horses into the chute leading to the pen, Jerry turned to me and said, "I know you have spent a fair amount of time around horses and ridden a ranch bronc or two . . . Before you get in that round corral just remember that everything up to now was teaching a house cat to shit in a litter box and now you're training a full grown African lion not to tear your head off."

I laughed and continued sorting the horses. I didn't fully grasp the disparity between my past and future equine experiences. Then Masters got kicked in the chest.

After a few hard lessons, the weekend of training both the horses and the *Unbranded* crew progressed without serious injury. Hour after hour, Lanny expanded our equine body-language vocabulary from that of scared

toddlers to confident pick-up artists. Like any guy who leaves a bar with dashed hopes, we learned: be timid and they won't respect you; be too aggressive and they will never trust you.

The horses stayed with Jerry and Lanny for a little over a month. In mid-January, we hauled them down to the San Pedro and Jacalon Ranches in South Texas. At that point, we had eight mustangs that had been semi-halter-broken and ridden two or three times apiece. We had 60 days to turn a pen of teenage juvenile delinquents into a group that could at least get their GED.

Our first order of business was separating the herd, putting the horses in individual stalls and working with them one by one. For a fortnight, we spent hour after hour in the round pen, reemphasizing everything Lanny had taught the horses and us. With practice comes perfection, but with familiarity

comes complacency and often, in the case of horses, contempt. We ran the horses around and around wanting perfection but were met with frustration. What we soon realized was the value of learning momentum. We came to understand that once a horse does something correctly, don't immediately ask him to do it again, move on to something else. Keep the horse thinking.

After spending many hours in the round pen, we were finally ready to move to the pasture. With only 45 days until hitting the trail, we began naming the horses. My favorite was a dark bay I named Django. The others would become Chief, Simmie, Gill, Stumbles, C-Star, Violet, and Tamale. How they got their names is a story of its own.

Once we took the horses out of the round pen, they progressed in leaps and bounds. Unfortunately, Django's first leap landed the two of us in a tree. The first mustang I rode out in the pasture, Django had a gentle disposition yet was herd bound. As we walked down the road away from the headquarters, he stepped out beautifully with a curious and watchful eye. What I mistook for eagerness was actually uneasiness at having left his friends. I nudged him into a canter and he readily agreed, staying true to his course down the sandy road. Getting to open country I eased him off the road. Django took this slight gesture as a cue to go home. He veered hard to the right as I reached low on my left rein to pull his head around. His head came around, but we continued traveling straight into a big bull mesquite tree.

The mesquite he picked had very large drooping branches, which we broke with our bodies and faces. Having reached the center of the tree, Django tried to barrel through in true mustang fashion but high centered himself in the fork. Scratched and bloodied yet still aboard, I rocked myself forward and got him off the tree and to the other side.

Day by day, we began exposing the horses to the wilds of the South Texas brush country. Each horse's inaugural trip into the brush was met with a flushing covey of quail or the scent of javelinas, which spurred either a buck or a mad bolt for home. But over time they became more and more comfortable with our long rides.

In March, conditioning and teaching the horses to pack became our primary focus. Once the trip began, the horses would be required to travel 20 or more miles every day without losing weight. We increased hay and grain rations weekly and took the horses for long gallops through the South Texas sand. Having spent the majority of our time training the horses to ride, we were nervous about having so little time left to teach them to pack. Although there was a buck here and there, we were surprised by how easily they took to it. The techniques Lanny had taught us for taming the horses and gaining their trust had paid off.

As April approached we felt ready.

Val's Lessons

Jonny and Thamer worked with the horses for two weeks before Tom and I joined them. The horses were riding, but they still snorted and shied away whenever we approached. They just weren't comfortable with us. We could make them stop, turn, trot, lope, back up, and run, but we couldn't make them calm. When something spooked them, like a shovel falling off a fence, they would run as fast as they could and then stand quivering. They were scared. If they got loose on the trip in this mindset, we would never see them again. Then Val came down from Wyoming.

Val Geissler, who spends four months a year living in a tiny cabin deep in the Wyoming wilderness, responded to my call for help and made his way to Texas with four trained rescue mustangs he had picked for us to take on the trip—Luke, Ford, Tuff, and JR. Val has a skillset in backcountry horsemanship that very few people alive today possess. He says that good judgment comes from experience and experience comes from bad judgment. We were hoping to learn from his experience.

Val got stuck within 500 yards of arriving at the Jacalon Ranch. The truck and trailer he drove were massive, and the weight of the four horses in the trailer made it high center on a bump in the road. We unloaded the horses and tied them up until we got him unstuck. Thamer tied Luke to a deer corn feeder, a contraption that propels corn at different times of the day for animals to eat. Luke was roped to the feeder when it went off, propelling high-speed corn pellets right into his face—for six seconds. He just stood there. Any other horse would have freaked out, but Luke wasn't bothered a bit. Val seemed surprised at the corn feeder but not at Luke's reaction to it. All Val's horses stayed calm.

Under Val's guidance, we began to calm down our horses and make friends with them. His trick? Time. We ate lunch with the horses, took naps with the horses, cleaned tack with the horses, and hung out with the horses. We rubbed their necks until they stopped being nervous and realized how good it felt. Val always had a pocketful of treats, and soon we did, too. After a couple of bites, the horses started following us around. Within a few days all of them would walk up to us, get haltered, and tag along like puppy dogs looking for treats. I felt a little bad about buying their friendship with horse treats, but undeniably it worked. Their new, relaxed nature made them better riders too. Over time they stopped spooking at the slightest sound, slowed their pace, and started listening to us more and more.

We desensitized our horses daily, teaching them that foreign objects weren't dangerous or scary. We rubbed them with plastic bags, threw tarps on them, patted them all over, and spent hours introducing them to new things. They stopped treating us like we were mountain lions and became more easygoing. Finally, we began to handle and work with their front and hind feet every day. They needed to be shod, and the poor farrier had his work cut out for him.

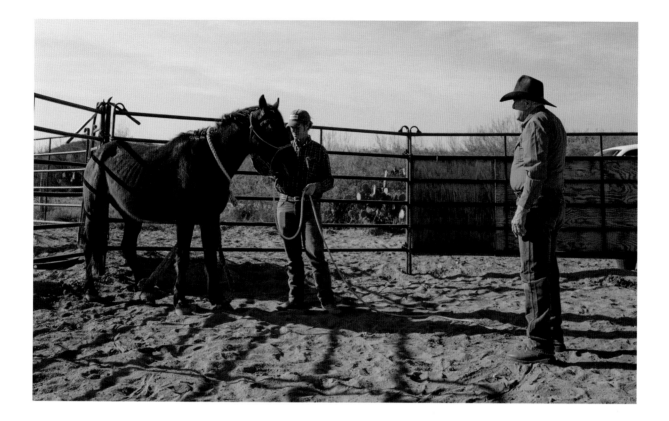

Shoeing the Horses and a Resurrection

by Thomas Glover

March 2013, San Pedro Ranch, South Texas

Getting our mustangs shod was an essential element in preparing them for the rugged mountain trails they were soon to travel. Mustangs naturally have rock solid feet due to natural selection and life in the wild, but we still wanted to do everything we could to give them an advantage on the trail. The last thing we needed was to lose a horse due to foot injury or slip-related falls. We chose to equip our mustangs with plate shoes reinforced with tungsten carbide welded onto the toe and heel. This reinforcement would provide extra grip in rocks and prolong the

life of the shoes. However, getting our green, just-broken mustangs comfortable with having steel hammered into their hooves would prove to be a great challenge.

A tremendous amount of work went into breaking and training our newly adopted mustangs. Although they were still pretty green, we were making good progress with catching, saddling, and riding them. At this point in their training, we were putting as many miles on them as we could to get them in the best shape possible so that they would transition smoothly to the 15- to 20-mile days ahead. The endless sandy roads at the San Pedro and Jacalon Ranches were perfect for doing just that.

As much as we focused on conditioning our mustangs, we also focused on preparing them for the farrier. Luckily, we had the guidance and insight of the legendary Val

Geissler, who among many other things was a seasoned and skilled farrier. He made sure we did everything we could to prepare the mustangs for getting shoes. His knowledge and his commitment to the trip ahead proved to be priceless.

We took the time each day to lift the horses' feet off the ground and get them accustomed to standing on three legs, which took a lot of time and patience. Once we were able to hold each of their feet up for an extended period of time, we introduced various shoeing stands and began tapping on their feet with a stick or rock to mimic hammering. Naturally, they did not like this at all and would pull away. Just like everything else involved with their training, patience was key in this process. As much as we worked on lifting and tapping on their feet, though, nothing is like the real thing. There is a big difference between tapping

a hoof with a stick and driving in nails with a hammer. We were not sure how they would behave with a farrier under them.

The day we had long been anticipating finally came, and it was time to see if our horses would be shod or not. Carly Wells and his son, James, were the men for the job. Carly, who had been shoeing the San Pedro horses for many years, had shod more than 60,000 head and also held a record for the most horses shod in one day. If anyone could shoe these mustangs, it was him. Although getting up there in years, Carly was a grizzled, seasoned, tough man. When questioned about the task at hand, he assured us that "there has never been a horse I couldn't shoe." These words stuck in all our heads as he began the daunting task. However, before the day was done, these words would no longer be true.

As the sun rose and the cool morning quickly became day, the heat began to take its toll. Anyone who has been to South Texas knows that this heat does not mess around. Although still "springtime," the temperatures quickly rose into the high nineties. Carly and his son were impressing us all with their skill and determination as they moved from mustang to mustang, bending shoes and driving nails. We were doing our best to keep up with them, bringing in the next horse as they finished each one. Most of the mustangs were surprisingly cooperative. But a few put up a fight, and it was all Carly and his son could do to wrestle shoes on them.

As we got to the last few horses, it was very apparent that on top of the physically demanding task he was performing the heat was affecting Carly. Several times he would stop and lean against the pole of the barn to catch his breath and wipe the sweat from his brow. He would then drink some coffee and resume work. When it was suggested that we all take a break for lunch to rest a minute, Carly simply shook his head and replied, "I got my coffee here in the truck, that's all I need. Besides, there's never been a horse I've started that I didn't finish." It just so happened, at the time, he was halfway done with Thamer's mustang Ford who was not being cooperative to say the least.

Ford was putting up a hell of a fight. Carly struggled each time to get his foot up, and each time Ford would pull and back away. Thamer was holding the lead rope and doing all he could to control his horse. When Carly grabbed the lead from him, things took a horrible turn for the worse. I was holding another horse that Carly's son was working on when I looked over and saw Carly clutching his chest and falling to the ground. Thamer was right next to him and

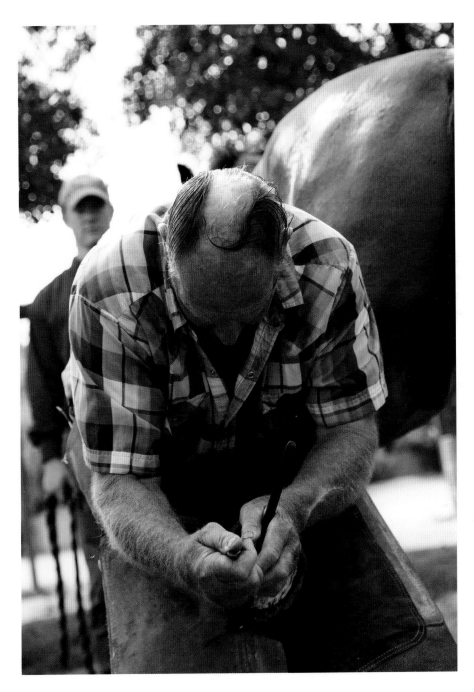

yelled for help. Carly's son jumped up and ran over to his dad screaming "Oh, no, Dad! Dad! Dad!" He then laid him on his back and began chest compressions to try to revive him. Instantaneously, the situation went downhill as Carly's face turned blue and he quit breathing. I remember seeing Thamer on his knees with Carly's head in his lap and Carly's son yelling for his dad to wake up while violently pounding on his chest. Panic soon took over, and everyone was running around not sure what to do or how to help. Someone yelled, "Grab the first aid kit in the office!" so I sprinted to the ranch office, about 50 yards away, and frantically searched for the first aid box. In the meantime, the ranch manager, Daniel, was on the phone with 911 giving the coordinates for the helicopter.

As I searched for the first aid kit, I found an AED (automated external defibrillator) instead and thought, "maybe this will help." I ran back outside to find Carly's situation rapidly deteriorating. Someone had found the first aid kit and the nitro, and Thamer was spraying the nitro into Carly's mouth. I went to my knees beside Carly and opened up the AED. Inside it said: "Signs of cardiac arrest: 1. Unresponsive, 2. Not breathing, 3. No pulse." Check. Check. Check. I then pulled opened his shirt and followed the instructions now playing from the AED, "Remove shirt and place pads as shown." There was a diagram showing where to place each pad: one on the side of the chest and the other on the opposite breast. Once the pads were in place, the machine then said, "Checking heart rhythm. Heart rhythm abnormal. Shock advised, shock advised, push flashing shock button."

At this moment, I stared at the flashing shock button and hesitated while Carly's son screamed "that thing's gonna kill him!"

Thamer then grabbed Carly's son's arms and moved them off his chest and said "do it!" I pressed the shock button, and just like in the movies Carly's body straightened out and I swear was lifted off the ground as the electric shock pulsed through him. The machine then said, "Stand by, checking heart rhythm . . . Heart rhythm normal, no shock advised." At that moment Carly's chest began moving up and down, and he began to breathe normally. The color soon returned to his face. I couldn't believe it.

It's hard to describe how I felt at that moment, but I knew Carly would be all right. Seeing a dead man start breathing again is really a powerful experience. It took about twenty or so minutes for the helicopter to land and the paramedics to arrive at the scene. An ambulance actually arrived at the same time. The feeling of relief at that moment was immense. While Carly was loaded onto the stretcher and then into the ambulance, he was still unresponsive, but he was breathing. When he was all situated in the ambulance, he began vomiting and asking what happened. He wasn't out of the woods yet, but it looked very hopeful.

The head paramedic was a very loud and commanding individual. She had the situation under control. As they were about to close the door and drive him over to the helicopter, stationed nearby on the ranch landing strip, she asked, "Who gave him the nitro?" Everyone looked around, and Thamer said that he had. She then asked, "How many sprays?" And he responded, "Four or five." She then asked, "Who applied the AED and how many times was he shocked?" I nervously raised my hand and said, "I did," still not certain if I had done the right thing. But she then looked at me and said, "That saved his life."

The next day, someone at the ranch

called the hospital to check on Carly and he was doing just fine. They said a 90 percent blockage of a main artery in his neck had caused his heart to stop. They said he was dead at the scene and the AED shocked him back into life.

Looking back, I attribute my use and knowledge of the AED to the CPR training I had in a class I took in college, taught by Anne McGowan. Taking an OSHA safety training class was required for my construction science degree. As in most of my classes, I would memorize everything for the test and then quickly forget much of the information afterward. I guess somewhere in the back of my head was the CPR training where I was introduced to the AED.

AEDs are becoming extremely popular to have around and have proven to be very effective at saving lives if used quickly. The voice prompts and instructions make it almost foolproof to use. The AED was purchased for the San Pedro Ranch after the ranch manager, Daniel, suffered a minor heart attack. Luckily, he survived and did not need an AED at the time. However, he made a point to purchase one for the office because the nearest hospital is more than 100 miles away. It was a damn good thing he did.

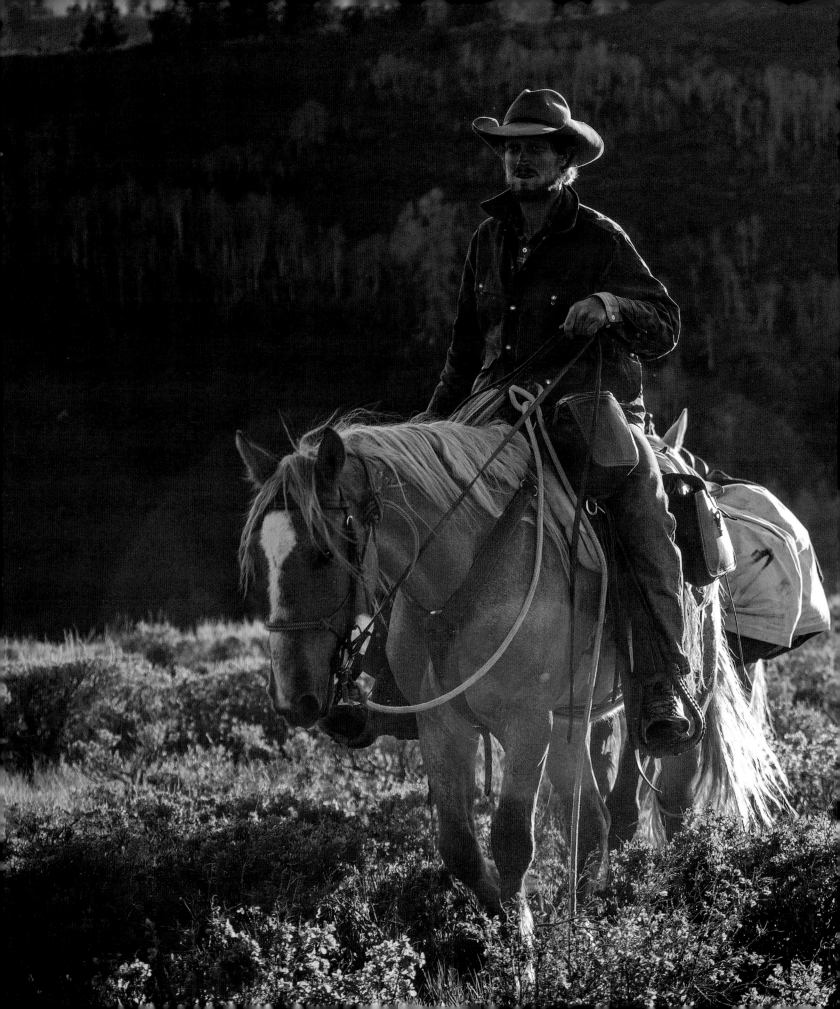

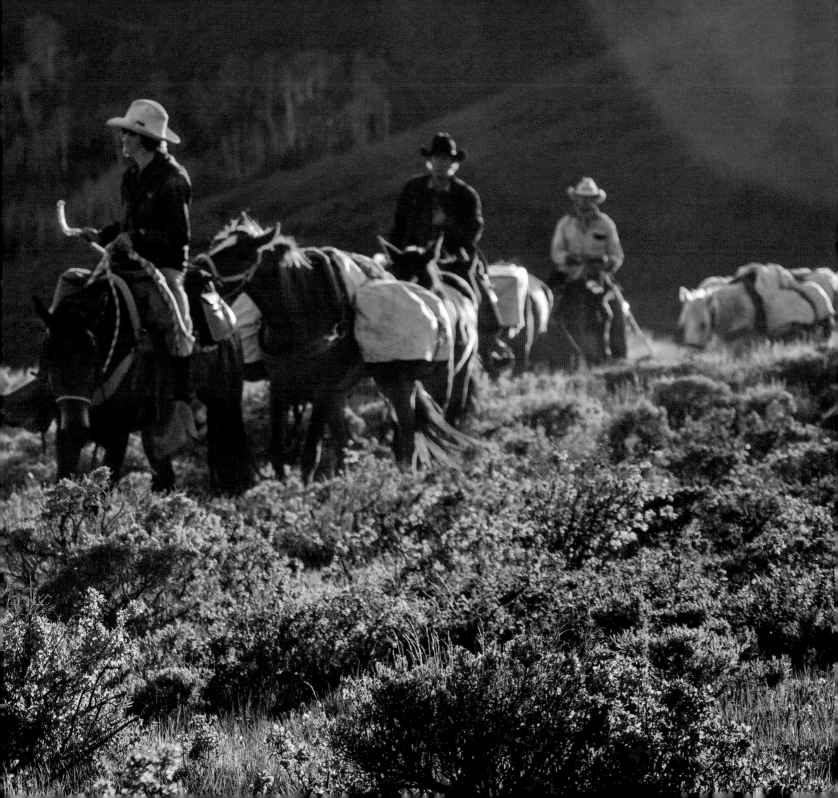

SIMMIE

Simmie was a great worker but wasn't afraid to complain. He'd moan and groan in the morning when it came time to tack up, but he was one of the steadiest horses in the string.

GILL

Gill's personality was that of a dog. He was mischievous in a usually innocent manner but occasionally used his status as herd leader to take the horses far from camp.

FORD

Val brought Ford down from Wyoming. He was the most herd-bound horse of the bunch, which made him a perfect packhorse.

TAMALE
Tamale was a sensible, well-made mustang. He suffered a bowed tendon in Arizona that took him out of the trip, except for a few days in Montana's Bob Marshall Wilderness Complex. His injury flared in the Bob, and he was retired before reaching the Canadian line.

CRICKET
Heath Weber brought us Cricket in southern Utah. He passed away from natural causes near Jackson Hole, Wyoming. It was very sad to lose a member of the team but satisfying to know that he died in the wild, not in a holding pen.

DJANGO
Django had a quick step to cover miles fast and a light mouth to get you there in style. He was the kind of horse you could rely on in any situation.

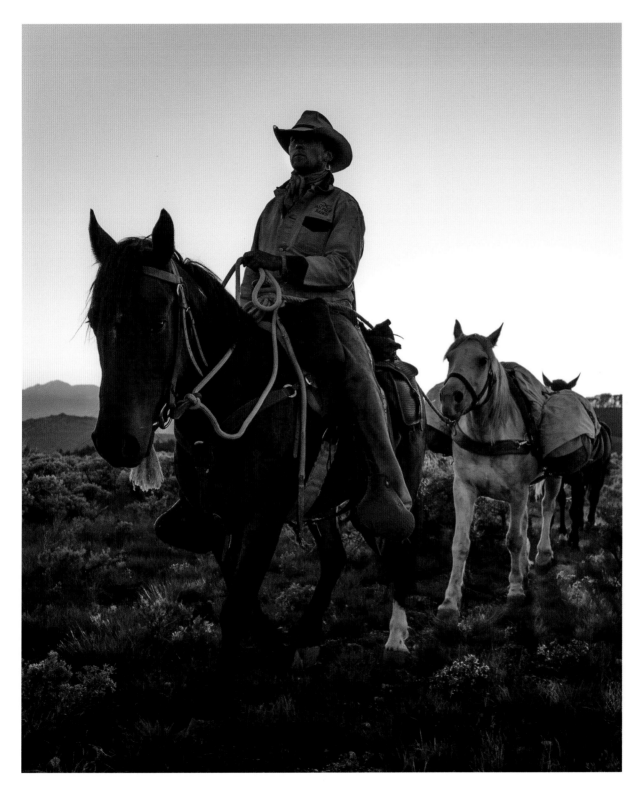

BAM-BAM (at left)
Bam-Bam was a linebacker power-house of a mustang. He jumped logs like a mule deer and attacked the trail with furiously quick hoofbeats.

JR (at right)
Just relaxing. Caution was a higher priority than getting down the trail quickly. We often found JR rolling in fields of flowers.

C-STAR

What C-Star lacked in height, he made up for in bulk and muscle. Sturdy and surefooted, he could be trusted to conquer the most treacherous terrain America had to offer. From day one, C-Star was affectionate toward humans and a quick learner.

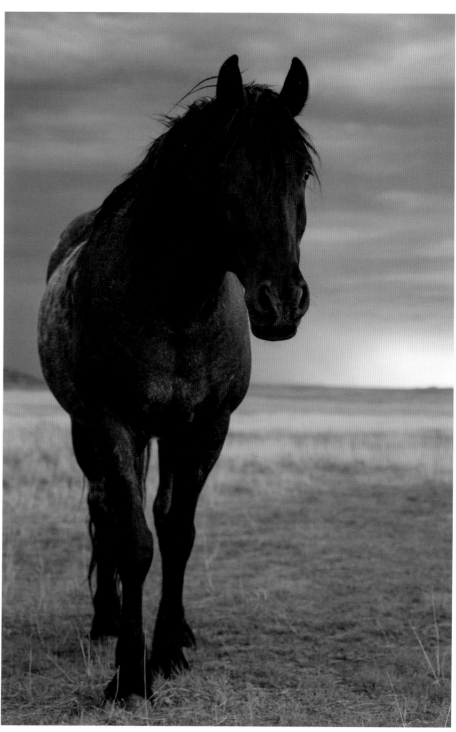

STUMBLES

Yes, I rode a horse named Stumbles across America. Contrary to his name, Stumbles proved to be a great saddle horse on the trail. With a no-nonsense attitude, he could be relied on to get from point A to point B, but not for a happy greeting in the morning. He approached each challenge very cautiously and methodically, always thinking things through.

TUFF

More tank than horse: there was no obstacle that Tuff couldn't handle. Even fully loaded with 200 or more pounds of gear, Tuff had no problem busting through thick brush, toppling over trees, and hopping over large rocks.

Ben Masters & His Horses

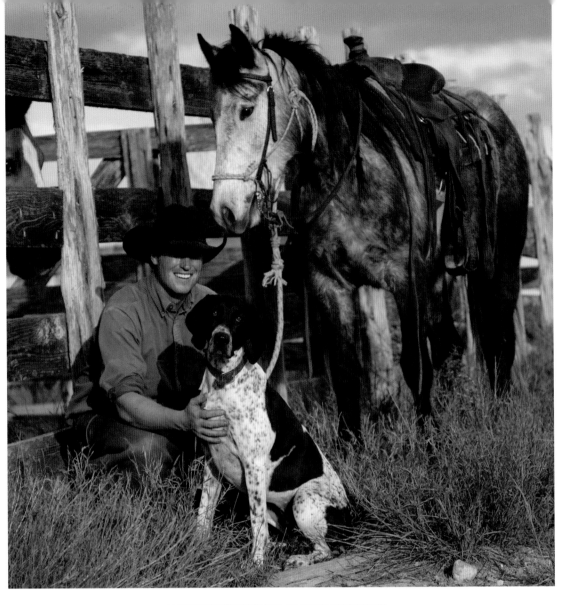

CHIEF (a.k.a. GRAY HORSE)

When we were picking out the mustangs, I was attracted to one horse in particular, a beautiful dapple gray that looked similar to my dog, Ruby, who couldn't go on the trip. The prison guard at the Kansas correctional facility told me he had been adopted but was brought back—a red flag for poor disposition. I adopted him anyway. I named him Chief after my grandfather, Wesley Masters. He can be a little ornery sometimes, but you can't help but love him.

VIOLET

Spooky's name was changed to Violet at the request of Kickstarter donors Lesley and Sherry Al Sharif from Bahrain. Spooky and Violet weren't good names for a fast-pacing bulldozer of a gelding, so most of the time I call him Violent for the way he attacked the directions he received. He was my best horse and could've easily died in a preventable halter-related injury that took him out of the trip.

DINOSAUR

Heath Weber brought us Dinosaur, originally named Littlefoot, in southern Utah. On his first day with us, he singed off all his whiskers sniffing a roaring fire. He was hilarious, harmless, and had a personality that was even bigger than his extra-large head.

LUKE

You could put anyone on Luke, strap thousands of dollars of camera equipment to his side, and even fly-fish off his back without a worry. After the ride, Luke was donated to the Mustang Heritage Foundation and auctioned for $25,000 to support mustang adoptions.

FRISKY

Frisky was a great horse trained by legendary mustang trainer Wylene Wilson. After the ride, he was given to Jerry and Margaret Hodge in appreciation for all their support for Unbranded.

Donquita (a.k.a. Donkey)

Thamer always said that Donquita was the third most famous donkey in the history of the world, behind the donkey that carried Jesus Christ and Eeyore. She was the only lady on the trip and shared mother status with executive producer Cindy Meehl. When horses strayed from the herd, Donquita would bray continuously until we were reunited. She was our guardian and would attack any unwelcome dogs, sheep, or intruders. She never let a bear into camp, and she stood diligently over the gear and food at night. Although Donquita was definitely a princess, her wild upbringing didn't involve civilized table manners. She would eat anything—cornbread, trail mix, cardboard, plastic spoons—but understandably drew the line at our socks.

Donquita's ancestors were likely used as beasts of burdens during mining operations in the West. Like horses, donkeys escaped or were let loose and became feral, establishing breeding herds across the arid western states. Donquita roamed free on the BLM's 635,685-acre Cibola-Trigo Herd Management Area in Arizona until she was gathered by helicopter in September 2010. Wild burros were preventing the recovery of vegetation in crucial but overgrazed riverside habitat.

She was trucked to the Delta, Utah, holding facility and adopted in 2012 by a Utah resident who wanted a brood mare. But Donquita didn't get pregnant, and she was brought back to the holding pens. A few months later, Heath Weber of the BLM brought her to us on the trail at the request of Ben Thamer. She then spent the next three months keeping all of us boys in line. At the time of this writing, Donquita is living

the good life at Thomas Glover's farm in Central Texas. I don't know if all wild burros are as sweet and affectionate as Donquita, but I bet a good portion of the 1,000 burros currently living in pens waiting for an adopter would make wonderful pets for people across the country.

The Hired Guns

Cameramen Phill Baribeau, Korey Kaczmarek, and Dan Thorstad had the difficult task of capturing a meaningful story in harsh elements while riding 20 miles a day on green mustangs. In addition to handling the cameras, they became soundmen, field producers, storywriters, and good hands on the trail. They were the first up to catch the morning sunrise and the last to bed to get a time lapse of the stars. Their duties were divided into 10- to 14-day rotations, and over the course of the summer they all became our close and trusted friends.

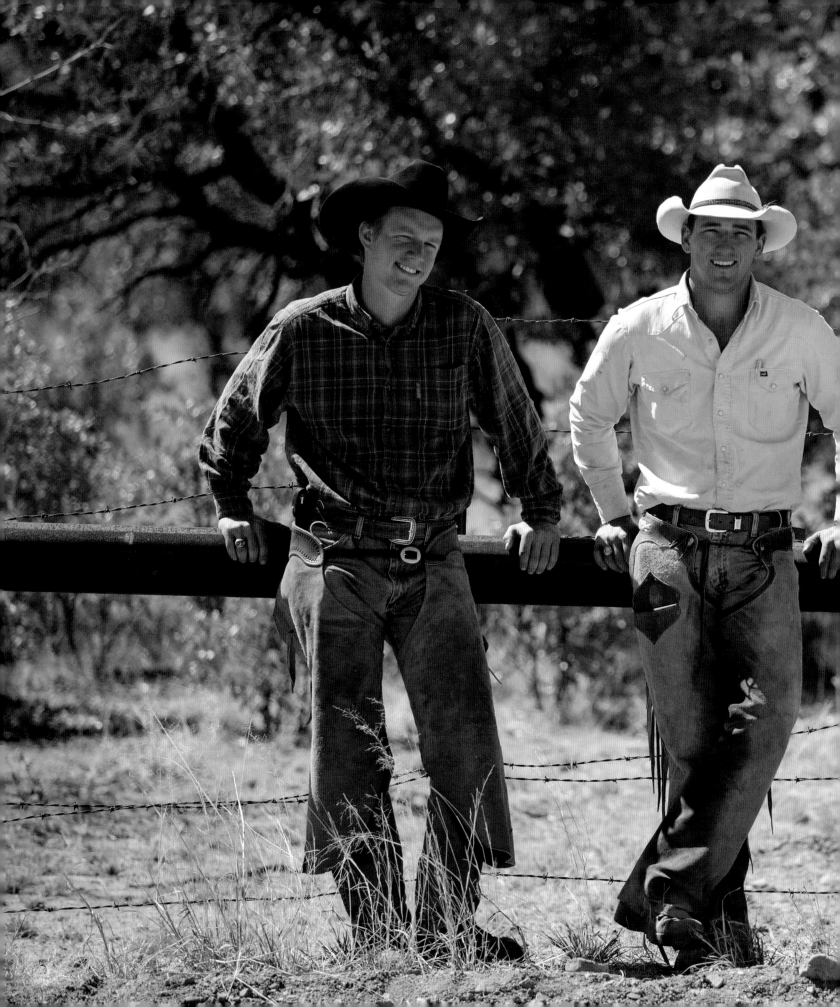

ARIZONA

April 1–May 17, 2013

ARIZONA

Kaibab Plateau

Grand Canyon

Coconino Plateau

San Francisco Mountains

Mogollon Rim

Mazatzal Mountains

Superstition Mountains

Gila River

Tortilla Mountains

Santa Catalina
Mountains

Rincon Mountains

Sonoran Desert

Santa Rita
Mountains

Huachuca
Mountains

The Trail: 850 Miles

The logistics of Arizona were more complex than all the other states combined. Graze and water were scarce, and having outside support to supply feed and reliable water was mandatory. Our route through Arizona was about 850 miles long, mainly along the Arizona National Scenic Trail. The Arizona Trail Association has done a tremendous amount of work compiling maps, locations of water sources, and other trail data. We used this information to find suitable locations every 15 to 25 miles, where Val could meet us with his horse trailer, hay, and water. This allowed us to rotate through our horses to keep them fresh, grain them twice a day, and ensure they made it to Utah in great physical shape. We relied heavily on Val to make the arrangements at the predetermined locations. He never let us down.

April 1, 2013: The starting point of the trip was on the Mexican border at the end of a seldom-traveled dirt road. Small American flags hung from the fence along the border, and green-and-white border patrol vehicles drove past, with the patrol officers scratching their heads when they stopped and heard our plan. The weather was perfect, and the Huachuca Mountains to the north beckoned us.

The first 100 miles greeted us with oak mottes interspersed in vast grasslands through the Canelo Hills and Santa Rita Mountains. Sky islands rose thousands of feet from the desert floor, and the vegetation changed from lowland cactus to towering pines.

The Santa Rita Mountains spat us out onto the dry, rattlesnake-infested Sonoran Desert for the next 50 miles. Unworldly saguaro cactuses materialized out of 100-degree mirages. We watched them fade into the distance as we climbed the Rincon Mountains and found a snowstorm awaiting us. We dropped out of the snow as we left the Rincons into a moonlike, boulder-strewn valley, giving us a view of the Santa Catalinas above. The Santa Catalinas were the most difficult stretch of the trip, and large, dishonest rocks held in place by sliding shale caused our horses to slip and fall as we climbed 4,000 feet of unmaintained switchbacks to the top.

The Oracle Ridge gave us smooth passageway to the north and the desert lowlands below. Rolling hills filled with saguaro and cholla forests were our trail companions for the next 100 miles until we crossed the Gila River and entered the Superstition Mountains. The brush-choked hillsides, massive pines, and old orchards of the Superstitions led us north 40 miles to massive Theodore Roosevelt Lake. We traveled through rolling hills to the west of the lake toward the prominent landmark of the Four Peaks Wilderness Area ahead of us. Coues white-tailed deer bounded through the chaparral and recently burned pine forests of the Four Peaks as we rode north along the sky island Mazatzal Mountains.

A lack of graze, little water, and the sight of the Mogollon Rim, our destination, to the north inspired us to leave the Arizona Trail and shortcut through the Payson Valley. Funneled roads, private property, and No Trespassing signs forced us to ride Interstate 87 in major traffic through the winding hills to Payson. Leaving Payson, we climbed the Mogollon Rim and entered a vast pine plateau stretching hundreds of miles to the north. We enjoyed the easy travel and bountiful graze as we rode north through herds of elk, past Mormon Lake and Lake Mary toward the San Francisco Mountains. Old growth pine forests, lush aspen groves, mountain meadows, and snow-fed streams greeted us as we worked our way through the San Francisco Mountains foothills.

The elevation of the San Francisco Mountains gave us a view of the Coconino Plateau to the north, a 100-mile grassland with pockets of cedar, pines, and lonely hills. We quickly covered the plateau, and on the north side it dropped 5,000 feet to the Colorado River below. The Grand Canyon, possibly the most stunning vista on the planet, left us speechless. We dropped down the South Rim, crossed the Colorado River on a suspension bridge, and climbed to the recently snow-melted Kaibab Plateau. Cold nights, muddy ground, and the first stages of spring accompanied us to Jacob Lake, where we rested our horses for three days and bade farewell to Val.

From that point, we were on our own. Spring grasses were poking up in the high country, and we no longer needed supplemental feed. We continued north along the pine-clad Kaibab Plateau, and as our elevation dropped into the cedars below us we entered Utah, May 22, 2013.

One state down, four to go.

Day 1 and Day 2

Our first day was a piece of cake. We trailered our horses to the starting line on the Mexican border, unloaded them, and with high spirits took off on day one of our journey. We started at a walk, trotted a little here, trotted a little there, and let the hecticness of all the preparation that led to this point fall behind us as we slipped into a steady three miles per hour. Fourteen miles later, mainly along dirt roads, we rode into camp at Parker Canyon Lake, an easy first day.

That evening I spent some time at the maps pouring over the two options we had for the next day. Option 1: Travel 14.5 miles to meet Val and the horse trailer at the next available road and camp there. Pros: Easy travel day, plenty of daylight, safe. Cons: No water at campsite (we would have to find a solution), possible poor road conditions, short distance day. Option 2: Travel 31.1 miles to the second nearest camping place in the town of Patagonia, Arizona. Pros: Lots of distance covered, water tanks on the way (according to the map). Cons: More distance than we had ever covered, unknown trail conditions, no room for error, new to the country, limited daylight. Day one was easy, confidence was high, and after a group discussion we decided to commit to option 2 and travel 31.1 miles on the second day.

The next morning we were up well before sunrise, but being only day two, it took us a while to get everything situated. We had to water the horses, build loads, eat breakfast, pack camp, and before long the sun was well up and half the morning was gone before we started out. The Canelo Hills stretched northwest ahead of us with the Santa Rita Mountains beyond; the town of Patagonia lay between. We knew that the Arizona

Trail would take us to Patagonia but did not know how many winds and wiggles we would encounter as the trail switchbacked up and down the many scrub- and oak-filled hills. Early on, travel was easy and the only hiccup occurred when Violet, my powerful bay, "blew up" and flew straight through the pack string when I dropped a granola bar. We eventually made our halfway point as the shadows started to stretch through the hills; we were in for a long night.

The sun set in our faces and lit the Canelo Hills, now behind us, into a golden glow as thigh-high grass danced in the last light. Stars began to appear, and it got dark fast. Navigation became more and more difficult as the trail became swallowed in the sea of grass. Landmarks faded and then disappeared altogether. The temperature went from a balmy 60 degrees to freezing, and the coyotes sang as the last slivers of pink on the western clouds turned black. We still had 12 miles to travel, through country that none of us had ever been in, on green mustangs, and according to the topo map, it was going to be steep. I cursed myself for leaving my jacket in Val's truck.

Wielding Garmin GPSs, we located our position and stuck closely to the Arizona Trail, which we routed onto the unit. The problem with GPSs and maps is that things don't always exist in real life like they should according to a screen or paper. Sometimes trails are 100 yards away from where they tell you they are, sometimes they don't exist at all, and sometimes you just don't get the satellite signal you need to use a GPS. This isn't a problem in the daytime because you can see drop-offs, cliffs, and other hazards before you get to them, but at night you can't pick out landmarks easily or adjust to the lay of the land. For the first time, but certainly

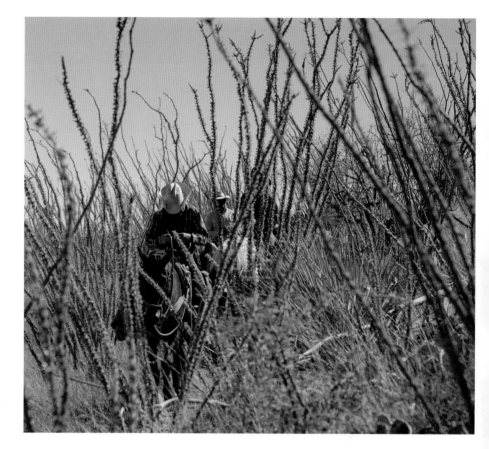

not the last, we put trust in our horses to get us out of the mess we'd gotten them into. They picked out cow trails, stuck to the Arizona Trail, and negotiated streambeds and drop-offs like they were born and raised for that type of country (they were). Travel was slow, but we managed to go up one drainage, down another, onto a ridge, traversing the darkness with relative ease.

The creak of leather and the sound of hoofbeats was only interrupted by the occasional groan of discomfort by cameramen Korey Kaczmarek and Phill Baribeau. Korey and Phill are two of the world's top adventure cinematographers, but they were finding out real fast that riding for 30-plus miles uses muscles that don't get used very often.

At midnight we came to an intersection of the Arizona Trail and a seldom-used two-

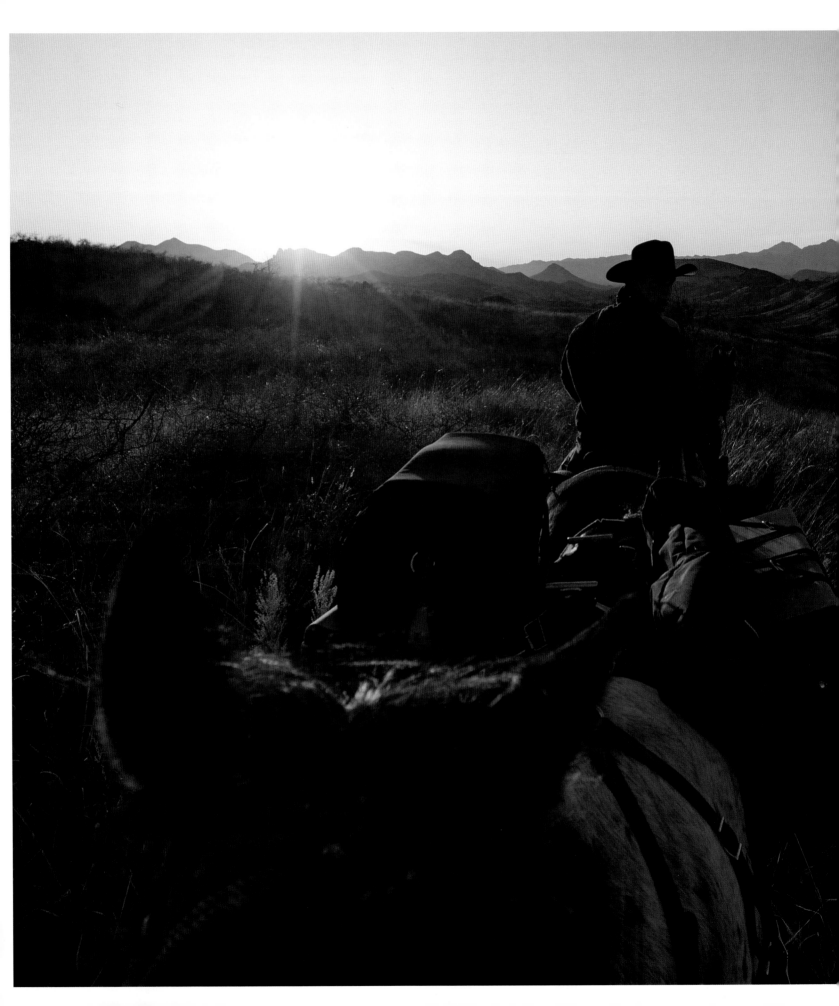

The sunset on day two was beautiful but came hours too early; we still had 12 miles of rugged terrain to go. Blundering in the dark on green mustangs through a foreign landscape on a trail that kept disappearing wasn't fun. But the stars sure were pretty.

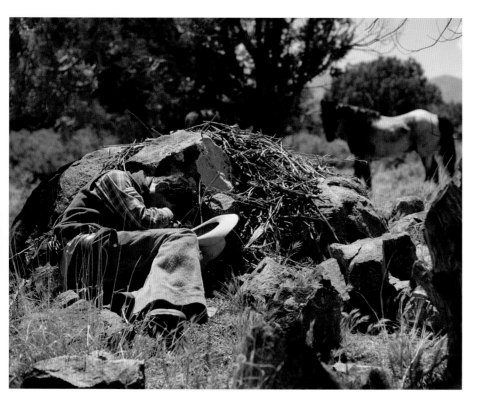

it was another two miles past Patagonia. Too cold to ride, I walked the rest of the way, too exhausted to care. Horses don't smile, but if they could they would have had a big grin when we unsaddled them that night.

Cameraman Down
by Phillip Baribeau

When Ben Masters called me in the fall of 2012 and explained the project—adopting wild mustangs, breaking them, and then riding them from Mexico to Canada—my first thought was that it sounds like an amazing trip. But there was one small problem—I didn't know how to ride a horse. Like the optimistic guy Ben is, he said, "Oh, don't worry about that. I'll show you how to ride. All that matters is that you can handle being in the backcountry for six months." Living in Montana, I wasn't worried about that part of it, but trying to ride a mustang while shooting a film sounded a little crazy.

As a filmmaker, almost all of my work is done outdoors, but adding the horses brought a whole new dimension. Could I film from a horse? How do we pack cameras and gear on them? What cameras are best to pack? Do we need solar chargers? How big of a team do we need? These were just some of the questions I asked myself. With Montana producer Dennis Aig now on board, we only had a couple of weeks to figure these things out. On top of everything, I was trying to learn how to ride.

We figured out how to rig up the horse I was riding, Luke, with all the audio and camera gear. We set up a Canon MK III in a smaller pack off the saddle horn as an accessible DSLR camera for quick shoot-

track road. We were tired of the winding Arizona Trail, and after looking at the map we decided to take the longer way around by getting off the trail and going on the road. The road might be longer, but we would be able to cover ground more quickly, or so we thought. Three miles later we came across a cattle guard, a No Trespassing sign, and a locked fence. We were 30 miles into the second day, tired, and not in the mood to retrace our steps. We unwired the fence, passed the horses through, and wired it back up. Five hundred yards later we repeated the process. For the next six miles we cut and fixed fence all the way to the town of Patagonia. The temperature was in the teens, we had been moving all day, and we were worn out.

We finally got enough cell service to contact Val and figure out where we were supposed to spend the night. As always, Val had gotten us a spot, but the downside was

ing from horseback. We strapped down the tripod behind the saddle and put the audio recorder, which is a device that wirelessly records the four riders, in the saddlebag. We chose the Canon C500 for our main camera. We wanted to make this look like a western film, and this camera produced a cinematic look that was different from the look of most documentaries. Ben thought we needed to name the camera, so we came up with "Princess," which stuck for the entire ride. Because of its size, we tied the camera bag for Princess onto the hard panniers that were accessible on foot. In addition to these cameras, we packed GoPros, a slider, all the audio gear, batteries, and cards.

Cameraman Korey Kaczmarek and I decided to shoot the initial part of the trip, from the Mexican border, together. The first days were brutal. Going from a few short practice rides to more than ten hours a day in the saddle was painful to say the least. On top of that, we were running around on foot trying to shoot the guys as they were riding. Every day's travel time was long, which didn't give us much chance to set up shots. We had to get creative about shooting while not holding up the ride. Our first idea was to ride ahead to get set up, but we quickly learned that the horses were extremely herd-bound and didn't like leaving their buddies. The next option was leaving Luke, with the camera and audio equipment, at the back of the pack to record the guys, grabbing Princess, and running ahead of the pack. Once I got the shot, I would run farther ahead and do it all over again. This process seemed to work, but Korey and I slowly became better riders and got so we were able to ride ahead to shoot once in a while.

It was the fourth day of the trip, and I started to get some false confidence. At the top of a pretty steep climb, we all decided to walk down the other side of the pass and give our horses a break. As we were walking down, Jonny's horse, Tamale, was ahead of me. He was not tied off to his pack string. Like a rookie, I was talking to Korey behind me, not paying attention to the trail ahead. In mid-conversation, I felt a blow to my thigh and instantly dropped in pain. I didn't see what happened, but knew I just took a full-on haymaker from Tamale. We figured he must have been eating, and I walked right into his safety zone. It felt like I took a blow from a sledgehammer, and my first thought was a broken femur. After lying there for a while I was able to get up. I could feel my leg wasn't broken, but I knew it was bad and the trip might be over for me. All that preparation and hard work, and I only made it four days? After six painful miles back to camp, we met up with Val, who pulled me off my horse and sat me down with a cold beer. The next day, he took me to the nearest hospital to get checked out, and luckily it was just a bad hematoma. Two weeks off and a little R&R, and I would be back on the trail.

Phill and Tamale make peace after a vicious kick sent Phill home for two weeks.

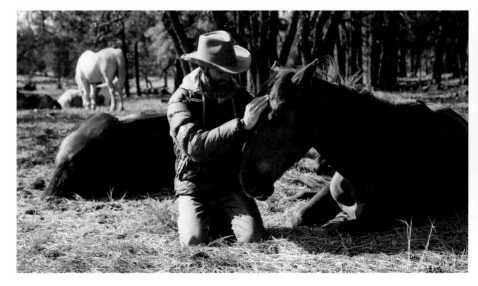

Violet's Injury

When we sorted the horses my last choice was a bigger, dark bay gelding we dubbed "Spooky." Spooky isn't a good name for a horse, and a Kickstarter donor bought an incentive to name one of the horses "Violet," so Spooky became Violet. Violet was powerful, fast, and responsive, and he quickly became my best horse. I almost killed him.

In the Superstition Mountains, logistics demanded that we spend two nights in the wilderness before we rendezvoused with Val and the support trailer on the other side. On the first night we camped at a beautiful clearing with a bubbling spring and fairly decent grass to graze. Because of the importance of keeping weight on the horses, I picketed Violet by the front ankle in the meadow so he could graze through the night. Out of laziness, I left his halter on him so that I wouldn't have to put it on in the morning.

I woke up at first light and went to check my picket horse. I immediately knew something was wrong because the halter was dangling from his face. Closer inspection showed that Violet had caught his hind foot in the halter when the heel of the horseshoe snagged the thin rope halter. His struggle to free his foot broke the halter and scratched his face. I fixed the halter, put it over his head, walked him around, and considered myself fortunate to learn a lesson that could easily have killed my horse.

That day we rode 18 miles through the steep, rocky Superstitions. The next day we rode 20 more difficult miles. Violet didn't show any symptoms of lameness, and he continued to lead the way with his quick speed. When we reached Val at Theodore Roosevelt Lake, we were utterly exhausted and happy to have some corrals for our horses. We fed and watered them, looked at the maps, and turned in.

The next morning, Violet was favoring the leg that had been caught in the rope. It was really painful to watch him hobble to and from the water trough. Val had seen this happen in the past and told me that a muscle in the hind quarter had torn when Violet struggled to free his leg from the halter. He was done for the trip, a hard lesson for me to learn. I loved that horse, and I was sick that laziness and negligence almost killed him. Violet rode in the trailer for the rest of Arizona, and Val took him with him to his home in Cody while we rode through Utah, Idaho, Wyoming, and Montana.

After the trip, I slowly began to ride Violet again. He made a full recovery, and before packing season was over for the year Violet and I had traveled a couple hundred miles through Wyoming in search of elk. He's still my favorite horse, and every time I see him it's a reminder to be vigilant about the safety of your stock. They can get hurt in countless ways, and many of them are preventable.

Val at the Vineyard

by Val Geissler

I've got a saying, "There ain't nothing I can't do and darn little I won't try," and after traveling with me for a couple of days, film man Korey added, "and nothing we won't ask for."

Arizona was a logistical challenge from the standpoint of feed and water for the horses. The desert country was short on grass, and water could be a fair distance between. Could the horses go a couple of days without water? Sure, but this wasn't a survival exercise, and we worked hard to get hay and water to the camp locations. Armed with my folder full of maps, articles about the trip, and papers that clearly showed the legitimacy of what the boys were doing, I was ready to knock on doors, walk through gates, hike across fields, and flag down any passing car or truck to accomplish my mission. My truck and trailer, loaded with stuff and maybe a horse or two, also raised attention and probably a suspicion or two at first. But when I pulled out *Western Horse-*

man magazine, with full-page pictures of the boys along with a several-page article, why it was "Oh my!" "Really?" "I'll be darned!" "Now what's this again?" "All right! Yea! What can we do to help?" If a cameraman was with me, I usually got an even better reaction.

Just outside of Patagonia, we'd laid over for two days with Ronnie and Barb, as wonderful a retired couple as you'll ever meet anywhere. The plan was for the boys and horses to rest and then start north again through the mountains west of Patagonia, heading toward Vail, Arizona. I was to hook up with them a couple of nights on at a place called Double Tanks, and I was supposed to be able to drive in there.

The boys rode out, and I drove north to Sonoita, Arizona, and the only feed store between us and Vail. I found the store and walked in ready with my folder and my pitch, and as usual I got lots of help, advice, and feed. I left Sonoita headed up the road with Korey and his camera equipment riding shotgun. Masters's directions were always excellent, so no trouble finding the place, but

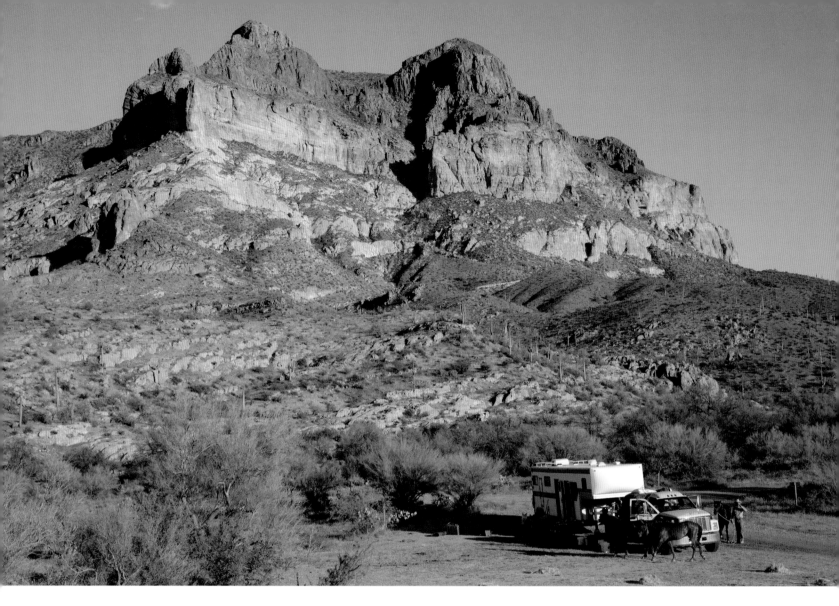

the road and terrain disruptions were a little iffy at times. We located the turnoff to get to Double Tanks, and it didn't look so good for my non-four-wheel-drive, 60-foot-plus truck and trailer. I had a feeling that if the two horses in back could have seen it, they might have said, "Hey, Dad, let us out first."

We pulled off the road at a good, wide spot and spied some homes and buildings off in the distance with a sign saying "Welcome to Such-and-Such Winery." We started walking down the road and hadn't gone very far when we saw a pickup and a few motorcycles off to the side. When we got there, we found this old desert rat working on a cycle, sure 'nuff a nice

feller, except he had fewer teeth than I do, but I have store-bought ones to put in.

We explained the situation about not knowing whether we could get into Double Tanks or not, and he said "get in the truck and we'll go check her out." We dropped Korey off at our rig and went to see if there was any way into Double Tanks. No way! It was rough enough in his four-wheel-drive truck. We made a loop back to the highway, but just before getting there we passed a good set of corrals, and I thought, by golly I can get my rig in there. Might take a bit of maneuvering, but I was willing to try.

I checked out the corrals and really liked

them—a good place to gather cattle, load them, and haul them from—but they were chained and locked and there was no water. I thought this shouldn't be a big problem, just cut the lock and find water and a way to haul it to the corrals. So me and my best new friend got Korey and his camera stuff and went off to the winery, thinking they would have everything we needed for sure.

We found several cars parked at the winery and a sign pointing to the Tasting Room. With my teeth in and my folder under my arm, and Korey with his camera on his shoulder, we walked into a wine tasting party. Some folks smiled, some looked blank, and some turned away. A distinguished gentleman in a sport coat and tie said, "May I help you, please?" I start my pitch, and he said, "We are having a wine tasting party here." I'd gotten enough of my pitch out, along with the magazines, that a few of the wine tasters got interested before the sport-coat guy could shut me down. Somehow, we got a glass of wine apiece and an apology from the gentleman, who turned out to be the owner and wound up saying that he was not able to help us right then, but his neighbors up the road were horse people and they might. With a lot of "good lucks" and "safe travels" from the wine tasters, we were off up the road. We drove into the place and out comes this lady to three grubby guys, one with a camera on his shoulder.

I went into my pitch again, and she just started offering all the help we needed. Her name was Korgal, pronounced *cordial*, and boy was she. She knew the people who owned the corrals and tried to reach them but couldn't, so the next best thing was that she had bolt cutters.

When we got back to the corrals, I cut the link next to the lock and we were in. Korgal went to hauling water from the house, which was about three miles away one direction. We were going to need a lot because it was a long day's ride and there wasn't a drop to be had until horses and riders reached the corrals. It took her three or so trips, but we had hay and water for the boys when they rode in. Then Korgal went 15 or so miles to a pizza place, came back with food and beer, and wouldn't let us pay for it. After we ate, she pulled out a bottle of tequila and shot glasses for a toast to the trip, and then a toast to something else, and soon the bottle was empty, goodnights were said, and Korgal and her husband, Dave, headed home for the night. But they were back in the morning with breakfast and a final farewell as the boys rode off again.

When Korey and I pulled out later, Korgal insisted I keep the four 25-gallon water containers because she said I might need them, and they did certainly come in handy at times. I called her later to thank her again, and she said that the cowman wasn't too happy about the corral situation, but he'd get over it.

Arizona thermometers have a tough life: 100 degrees to 20 degrees within 24 hours. We danced in the mirages of the blazing Sonoran desert in the morning and slept in the snow that night.

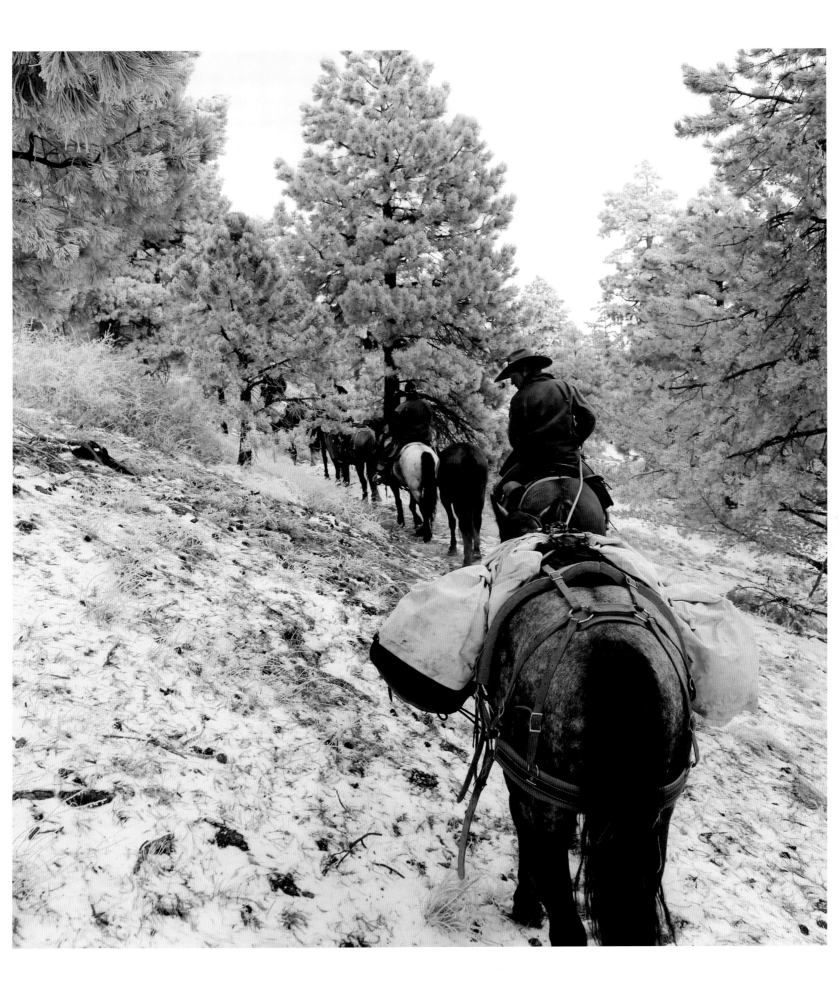

The Cholla Incident

Growing up in Texas, I thought the South Texas brushland was prickly, nasty country, but after we encountered southern Arizona's jumping cholla cactus, the mesquite and pear flats back home seem as tame as a manicured lawn. Scattered in lower elevations throughout southern Arizona, jumping cholla cactus, also very inappropriately called the teddy bear cholla, gets to about ten feet high and seems to grow in clumps of a couple acres where the hills flatten into small plateaus or tabletops. The cactus has a trunk of sorts that grows up and then branches into two- to four-inch segments that are easily broken off from the rest of the plant. These segments are completely covered by spines about three-quarters of an inch long. When an animal or other object passes by, the air disturbance moves the cholla segments back and forth, sometimes enough to break them off the cactus and propel them to whatever caused the air disturbance, thus the name jumping cholla. The plants seem to be about one horse width apart, wide enough to be tempting to go through but close enough to cause a big wreck if something goes wrong. Something went wrong.

We were traveling through the Tortilla Mountains in the Sonoran Desert about 50 miles southeast of Phoenix. It gets hot there in April, real hot. It's rocky, and the water situation consists of muddy pools every 20 miles or so. Beautiful country but tough on horses and horsemen. Late one afternoon, we were dragging through the last five miles or so to our camp. One of our horses, Gill, was walking along and decided he wanted a trail snack. I've seen horses eat some funny stuff on the trail—tree bark, pine needles, lead ropes, branches—but this horse reached over and took a bite of a cholla cactus.

Gill reared back and crossed his eyes to see what he bit into, and a big chunk of thorn-covered cholla cactus was stuck to his bottom lip. He started quivering his lip and shaking his head back and forth and up and down trying to get it off. But that cholla was stuck solid, and the harder he tried to get it off the more spines he managed to get into his lip.

Gill is a good-natured mustang who likes hanging out with humans; he doesn't have a mean bone in him, or at least until he gets cholla spines in his mouth. Thamer hopped off Simmie, the horse he was riding that day, and pulled out his cell phone to whack the cactus out of Gill's mouth. Cholla is hard to dislodge, and it hurts horribly when you try to yank it out of your skin; I don't even want to imagine it in my lip. Gill shied away from Thamer, but Thamer stayed with him and landed a solid swat on the cactus piece in Gill's lip.

Thamer saw it coming, but it was too late. With one quick movement, Gill reached up and punched Thamer right in the face. I was standing next to Thamer and heard his glasses break and thought it was his head. He hit the ground, rolled up, and stared past me and Gill to a commotion behind us. I spun around to see Tamale blow up with Jonny on his back and cholla cactus flying in every direction. Jonny tried to ride the buck out of Tamale for seven or eight hops before realizing that the horse wasn't about to stop bucking, and he bailed off in a flat spot. Tamale ran for about a half mile before stopping and looking back. It turned out that Gill's reaction spooked Tamale into a cholla, which stuck him right in the rear, including a piece right below the tail.

It took us another ten minutes and some mean looks from the horses before we realized that there was no getting the cholla out from sensitive areas on a riled-up, green horse. And all the people who've told me that BLM mustangs can't buck hard would have changed their minds really fast if they had been there that day.

Over the next couple of days, all of the cholla fell out of the horses, and we later learned that that is the way the cactus spreads, by attaching to an animal and detaching after a couple miles or so. But don't get your horses in cholla cactus; it's not a plant worth spreading.

Dysentery
by Ben Thamer

I remember as a kid playing a fantastically simple game called Oregon Trail. It was a 2D computer game we played during computer class, in which you were a wagon boss tasked with getting your crew from St. Louis, Missouri, to XYZ, Oregon (I have no idea where because you could never make it there in a 30-minute class period). I really only recall three distinct events from Oregon Trail: shooting buffalo at a prodigious rate, swamping my wagon because I was too cheap to take the ferry, and having most of my crew perish from dysentery.

Until April 2013, I held dysentery in the same category I do the biblical plagues, smallpox, and polio—terrible maladies of a

bygone era. Unfortunately, I was horribly mistaken. Dysentery is still a very real affliction and an incredibly miserable experience. Only those of us unfortunate few who have been clutched in the grasp of the Dirty D can truly empathize with our fictitious trail mates from the game, and what follows is a snapshot of what those poor computerized souls endured.

The day my dysentery manifested itself was like any other day on the Arizona Trail. I woke up, had my coffee and hot Tang with Uncle Val, and proceeded to the facilities available for my morning constitution, which, based on my 90 percent Velveeta and Wolf Brand Chili diet, was normal. However, when I had to return to the government-issue outhouse four times between rolling up my bedroll and saddling my horse, with a few poorly concealed vomit sessions in between (during which I returned my coffee and hot Tang ration to the earth from which

they came), I knew something might not be right. However, we were playing cowboy, and as John Wayne once said, "Courage is being scared to death but saddling up anyway." So that's what I did, albeit with a legitimate fear that I would ruin a perfectly good pair of Wranglers and my self-esteem for life.

We got our usual pep talk from Uncle Val and headed off. The first 500 yards were fine, but at 501 my stomach decided it couldn't handle the sip of water I drank to get the bad taste out of my mouth, and I again began to hurl. That was okay, though. I had, unfortunately, tossed my cookies horseback several times before, and though not pleasant it's not the end of the world; you just try to keep it off your legs and ride on. Unfortunately, my bowels began to talk to me yet again, and that's a call you can't ignore, so after 45 minutes or so of intermittent vomiting and emergency "pit stops," as my dad would say, my compadres graciously

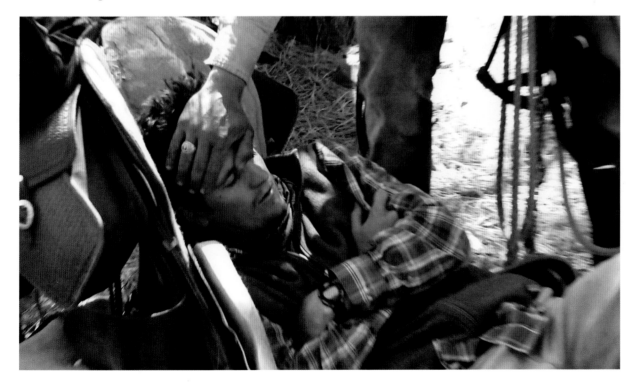

suggested we take our one and only break-fast stop of the 3,000-mile journey so I could rest and be sick all in one place.

After making me some pancakes, which after eating I promptly recycled, the guys let me crawl up in the fetal position and rest between "episodes" while they attempted to construct and implement a travois. Once they had it constructed, I was treated to a truly once-in-a-lifetime experience of puking my guts out, crapping my brains out, and laughing my head off all at the same time as I watched these guys try to get the horse, JR, to accept the crude device. Eventually the plan was abandoned, and it was decided that I was in no condition to travel.

We were fortunately able to make arrangements with a gentlemen who, for the price of three cold Budweisers, would take me to the hospital in Winslow, Arizona (yes, *that* Winslow) so I could receive proper med-ical treatment. From that point on, it was fairly uneventful. I was poked, prodded, and filled with a truckload of saline solution, and within a few days I was on horseback again. There has never been a conclusive explana-tion for how I contracted the bacteria, but I can promise that even though I was able to sleep in a bed for three jigs and shower frequently, it wasn't worth it. When in the backcountry, always pay attention to your water source and be alert to the bacteria, parasites, and viruses you may be inadver-tently exposing yourself to.

The Grand Heatstroke

The park ranger told me over the phone that they had heard of someone taking their own horses from the South to the North Rim of the

Grand Canyon, once. It was a couple of years ago. No, they never heard how it turned out. Mules went to the bottom of the canyon and back to the rim on a regular basis, but they had their own set schedules and routine. You didn't want to meet a mule train on its way up when you're headed down. There's almost no place to turn around, and the trails are much too narrow to pass by. Yes, once you begin to fall, you won't stop for a long way. Recreational users just don't take their horses through the Grand Canyon.

Well, we had no choice. We could either cross the Colorado River on the suspension bridge at the bottom of Grand Canyon or travel 100 miles out of our way to cross at the nearest dam. Besides, I wanted to go through the Grand Canyon because it was the Grand Canyon. Riding through the Big Ditch, as it's locally called, was something we had looked forward to since day one.

We arrived at the South Rim of the Grand Canyon in miserable, drizzling, cloudy weather. The first view over the edge was of a misty void that left its depth to the imagination. The weather was awful, and we were tired of being wet and uncomfortable. So we put our horses into some pens and went inside the hotel. The clerk looked at us like we were a bunch of crazy guys living in the woods. I told him that we hadn't had a bed or a shower in well over a month; he believed us.

It took two long showers and four shampoos before I felt clean. I didn't realize how disgusting I was until I stepped my clean body back into my dirty clothes. They reeked of sweat, horse poop, and canned chili and were coated with a thin, slimy layer of an unknown dark substance that smelled almost as bad as my boots, which I left in the hall. After cleaning up, which took a long

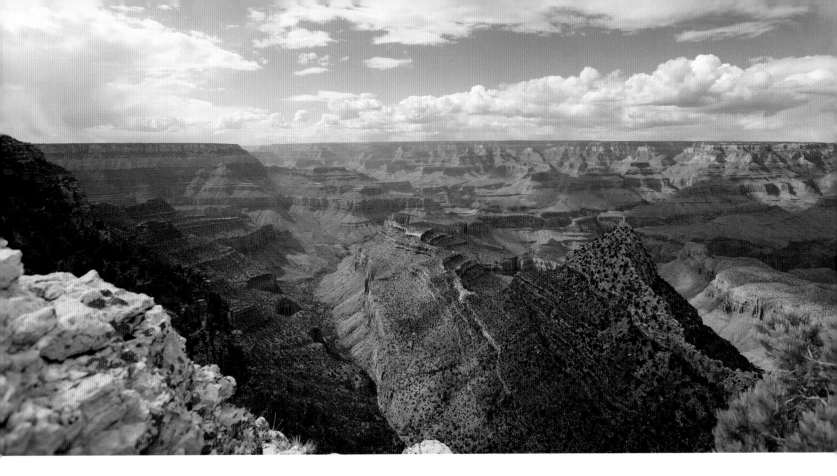

time, we grabbed our boots out of the then stinking hallway and went to dinner. We felt great watching the rain through a window while someone else brought us steaming dishes of delicious fresh meat and veggies that didn't come from a can.

I didn't want to get out of bed the next morning until Tom rolled over and I got a whiff of his armpits. Whew, he may have tried to clean up, but it didn't work. Reluctantly, we left the hotel and had our horses saddled about the time the sun came up.

I'll never forget walking to the rim of the canyon and seeing the golden morning light fill up a landscape that I couldn't comprehend. It was impossible to take it all in. The view stretched for 10, 20, 30, maybe 100 miles? The air was clean from the night rain, and the opposite side of the canyon seemed deceptively closer than the ten miles the map showed it to be. There wasn't a breath of wind, and I was dumbstruck as I watched

the sun's rays pierce through the long shadows to dissipate the mist rising from the depths of the canyon. My gaze continued down to the Colorado River, just barely visible from the canyon rim.

The canyon seemed to swallow us as we descended down the South Kaibab Trail toward the river. The drop-offs were fatal, but the trails were wide, smooth, and switch-backed methodically down the steep cliffs toward the river far below. Miners first cut the trails through the Grand Canyon, and

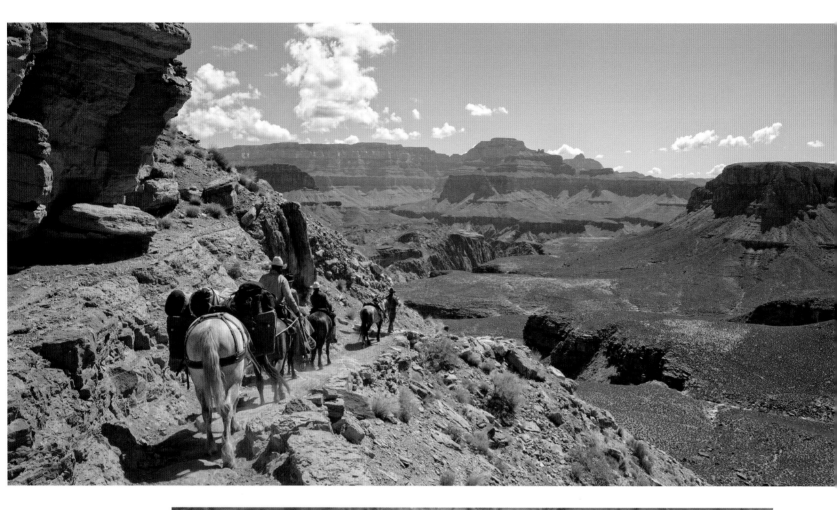

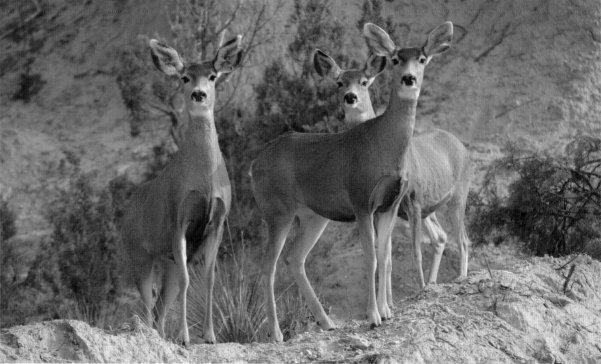

the National Park Service now maintains them in excellent shape. The fear of poor trails and drop-offs was soon lost to the grandeur of the landscape.

Director and cameraman Phill Baribeau was experiencing a severe case of Dog-Beach. DogBeach is a photographer's term for when the light is perfect and there are so many epic things to shoot that you don't know what to do. Like a dog on the beach surrounded by frisbees, yelling children, crashing waves, birds, and footballs. Where to begin? He had only one chance to shoot the Grand Canyon, and he wasn't going to miss a shot. Phill ran up the trail, down the trail, climbed up and down rocks, and toted around a 20-pound camera and tripod. Two

hours later, he still hadn't slowed down, and I started to worry about him, though he seemed fine, even running half a mile to catch up after getting a silhouette shot from an opposing ridge.

The shimmering Colorado River slowly got closer as we dropped down into the canyon. The suspension bridge came into sight far below us. It looked pretty dicey from a distance. There was a tunnel to go through before we reached the suspension bridge, and Phill ran ahead (again) to get on the other side. Patting my gray horse, Chief, and praying that we wouldn't have a horse wreck, I entered the black tunnel, took a turn, and led us toward the light and the bridge. The water was turquoise green about

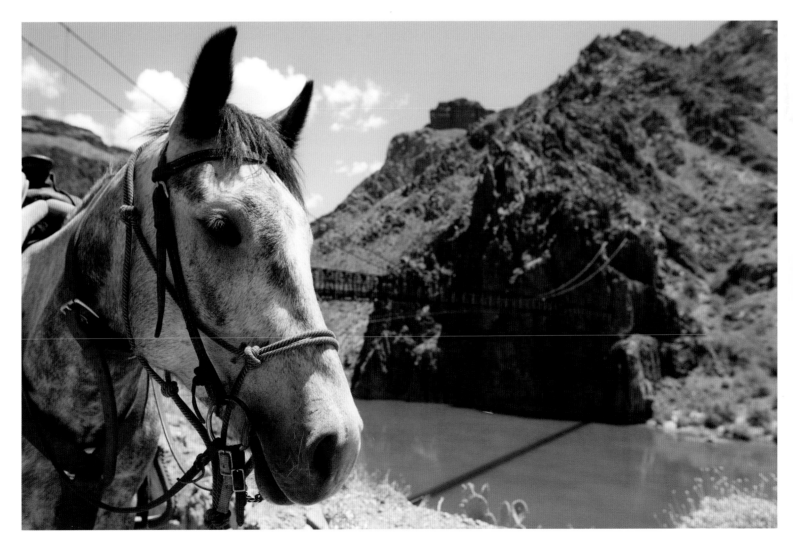

a hundred feet below us, and the bridge was much sturdier than it appeared. Our mustangs didn't have a hiccup. They passed through the tunnel and over the bridge like old pack mules had done a thousand times. I was pretty proud of my ponies.

After crossing the bridge, we stopped at Phantom Ranch, an oasis at the bottom of the canyon on the hot desert floor. We stuffed ourselves with sandwiches and guzzled cold drinks while cooling our feet in the horse trough. Life was good, except for Phill.

His efforts in trying to capture every angle on the way down had left him with a full memory card of great footage but a bad case of heatstroke. He sat in the shade, ghost pale and dehydrated, sipping from a water bottle with a dazed look in his eyes. Hours later he had recovered enough for us to continue up Cottonwood Creek toward the North Rim.

Night had fallen before we set up camp. The stars shone brilliantly above the canyon walls, with not a light in sight or even the dimmest glow of a light. Before closing my eyes, the moon came out and cast a white glow on the canyon walls. It was too beautiful not to get a time-lapse photo, so I crawled out of my sleeping bag, climbed a cliff, and set up a camera to capture the stars streaking across the sky above the moonlit canyonlands.

Back at camp, before the weight of my eyelids became too much to handle, I thought about how lucky we were to live in a place with more wild lands in it than a person could ever possibly explore in a lifetime. Two hours later, when it started to rain and I had to climb a wet cliff in the dark to save my camera, I thought of the shower and bed of the night before.

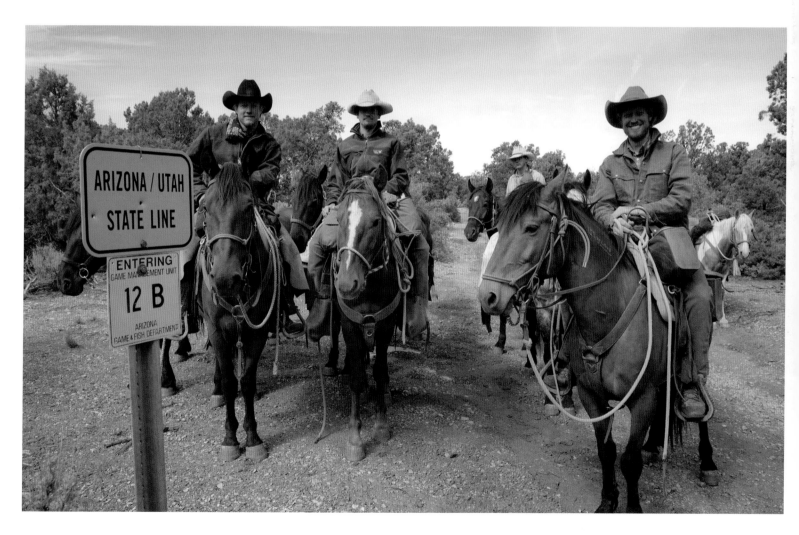

UTAH

May 17–June 27, 2013

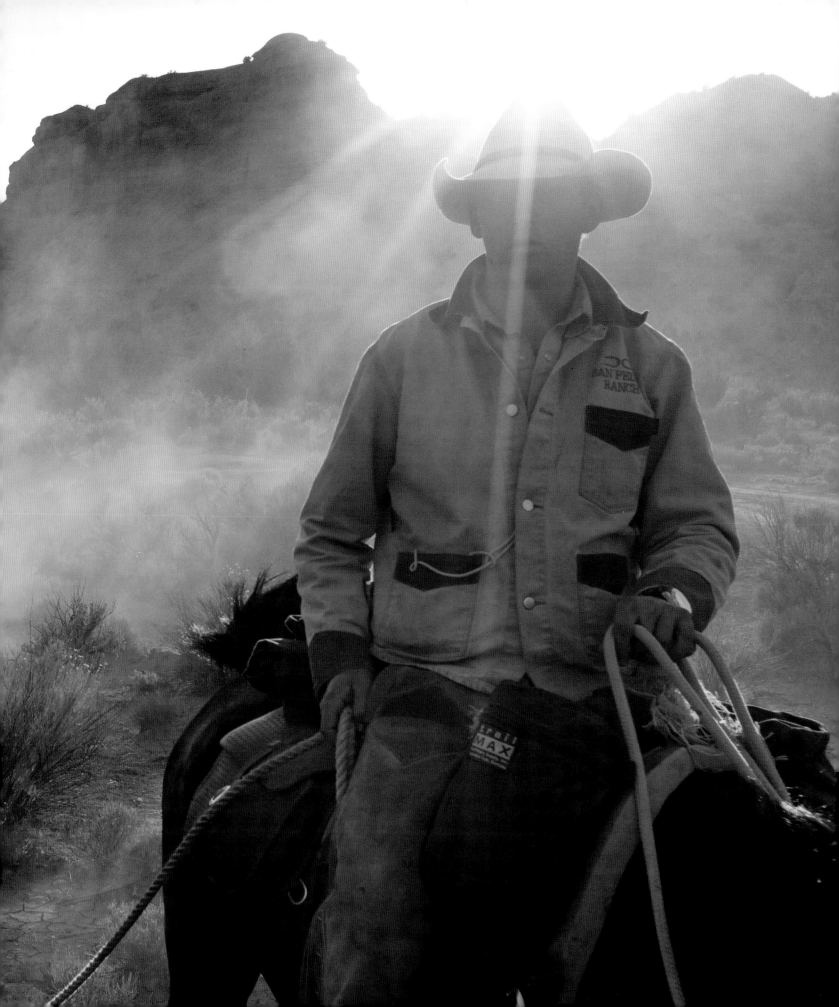

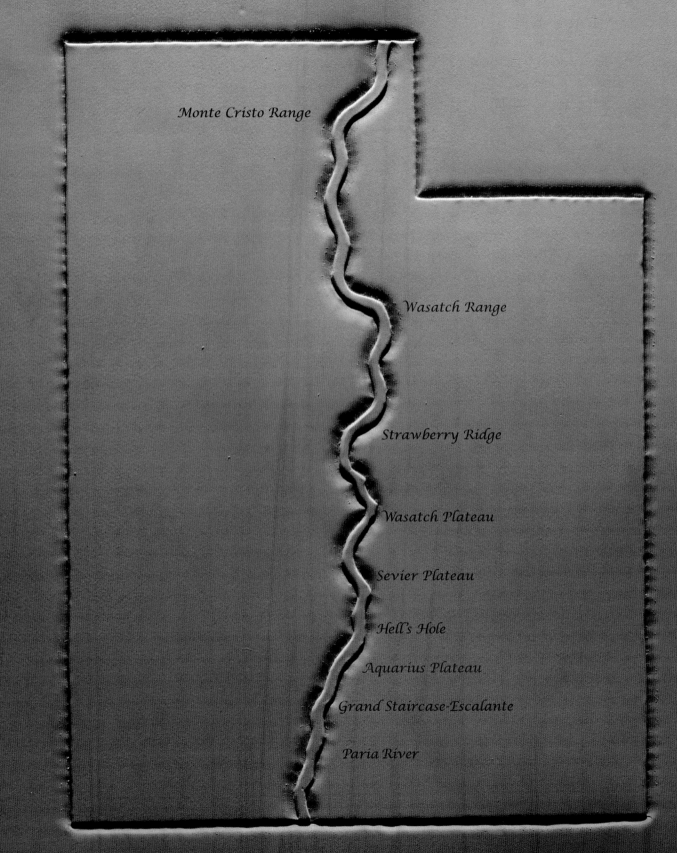

UTAH

Monte Cristo Range

Wasatch Range

Strawberry Ridge

Wasatch Plateau

Sevier Plateau

Hell's Hole

Aquarius Plateau

Grand Staircase-Escalante

Paria River

The Trail: 830 Miles

Utah is a beautiful state filled with diverse terrain—we rode through desert bottoms, alpine meadows, irrigated croplands, snowfields, and everything in between. But none of us had ever spent time in Utah, and it was a difficult state logistically.

Val left us before we reached the Utah border, and we were now alone with no support crew, no guaranteed water, and the unpredictable graze that nature provides. Deep snows plagued our route, and our horses went through a month-long ordeal that made them bolt at the slightest inclination and run for miles. Public land was noncontiguous and horses were prohibited from some of it, which placed massive obstacles in our path. If it weren't for the helpful people we met along the way the hardship we endured would have been much worse.

We crossed into Utah on the northern edge of the Kaibab Plateau and dropped into the Paria River drainage to head north through the colorful Grand Staircase–Escalante National Monument. We lost all of our horses for a full day, but Jonny tracked them on foot for 12 miles and brought them back. Irrigated, luxuriously green fields below dusty, sage-filled hills took us north to the Aquarius Plateau.

Expansive snowfields, tiny rivulets of melted snow, and frozen mud greeted us atop the plateau. Sun-filled south faces and meadows showed the first signs of spring, and our horses enjoyed the inch-long green shoots, as did the elk herds that had recently migrated back to summer pastures. For a hundred miles we stayed at timberline between 9,000 and 10,000 feet along the Aquarius Plateau before moving down into the Fremont drainage. We rested in Teasdale, bought three fresh BLM horses, and scrambled our way north through the steep shale of Hell's Hole onto the Sevier Plateau. Budding aspen and flowers of all colors filled the hillsides, cold streams were full, and fresh green grass took us northward to the looming snow-clad Wasatch Plateau.

We climbed up the muddy south face of the Wasatch Plateau to find a snowy wonderland stretching ahead for the next 75 miles. Every step was a battle as our horses post-holed through an icy crust to find two to three feet of snow before reaching muddy ground below. Where the snow became too deep our horses floundered, exhausting themselves belly deep in snow with no traction. With no relief for miles, we had to turn back.

The struggle through the snow and the windy conditions had our horses on edge. As we lowered in elevation out of the snowfields, four-wheelers blew past us and stampeded our horses.

For the next three days they ran, hid, and scattered, leaving our team strewn across unknown country with no communication between ourselves. With the help of locals we eventually found all the horses uninjured. We regrouped and proceeded north through the lower elevations of the Sanpete Valley. Then we climbed Strawberry Ridge and followed it northwest into the snow-clad, pirouetting peaks of the Wasatch Range.

The Wasatch Range runs south to north and gets huge snowfall from the lake effect of the Great Salt Lake. The western slopes are off limits to horses due to a ridiculous ban on recreational horse riding in Salt Lake City's watershed. The eastern slopes are steep enough and get enough snow for the Winter Olympics, held here in 2002. We were forced

to ride close to the crest of the Wasatch Range for nearly a week, trying to stay out of the prohibited watershed and on dry ground. Eventually we got out of the Wasatch, away from the booming Salt Lake City area, and rested for two days at the Browning Firearms Facility in the Morgan Valley. We had reached the halfway mark.

After shooting guns nonstop, swimming in the Browning pool, eating as much Browning food as possible, and mowing their lawn with our horses, we left the facility (our favorite stop) and headed northeast through patchwork public lands into the Monte Cristo Range. Flowers were at their peak, grass was at its finest, water was plentiful, our horses were behaving, and life was great as we lowered in elevation to Bear Lake. We rode along the east side of the 25-mile-long lake, swam where we wanted to, and galloped along the beach into Idaho. Although difficult at times, Utah was good to us. We entered Idaho well ahead of schedule with no injuries and healthy horses.

Losing the Horses: Round One

Day three in Utah, and Jonny and I were up at daybreak following the tracks of our horses, who had strayed away from camp during the night. They were hobbled so they wouldn't go too far. My biggest concern was that our horses would meet up with a band of wild mustangs and try to join them. It wouldn't take much to return them to their wild state.

We crested a ridge and saw all the horses lazily grazing in the sage below. I shook a feedbag and they came running. We unhobbled them then hopped on JR and Tuff bareback and led them all back into camp. I only fell off once.

We had camped by a water well, and cattle from all around were coming to it like the oasis that it was. Because the lowlands of southern Utah were dry and grass was sparse, we carried pelleted alfalfa cubes to supplement whatever our horses could scrounge out of the desert. We poured the pellets into an old feed trough and started to pack up camp while they had breakfast.

As we packed up, Jonny walked out a couple hundred yards and fired his pistol at a cow patty. The horses' heads shot up at the report of the gun, and Thamer hurriedly haltered his horse, Ford, and tied him to a rail. The horses were a little nervous but went back to their feed. The next shot triggered a stampede. None of the horses were hobbled, and they just took off, galloping over the horizon. We stood there, dumbfounded at our idiocy, and thanked Thamer for having the sense to halter Ford. Then Ford pulled back, broke his halter, and ran off after the herd.

When Jonny realized what had hap-pened, he took off, running after the horses. A random car passed by, and he waved it down. He hopped in. Thamer and Tom were together on foot, headed in the direction of the horses. I freaked out for a moment before packing a bag full of food, water, flashlights, radios, and batteries. I went after them, fol-lowing their tracks.

A mile later, I met Thamer and Tom on top of a ridge with a good viewpoint. We scanned the vast sagebrush below us, and they pointed to a large band of cliffs on the horizon where they last saw the horses headed. Good, I thought, we have a natural barrier to help us contain them. The cliffs were miles away but looked too steep for horses to climb. In order to cover the land in front of us, we needed to split up. Thamer and Tom would follow a big ridgeline to the east while cameraman Phill Baribeau and I would follow a ridgeline to the west. Both ridgelines worked their way to the cliffs in the distance, and there was nowhere the horses could hide. By circling back when we reached the cliffs, we would certainly cut across their tracks.

Then it began to rain. It figures; the only time it rains in the desert is when you're tracking lost horses. I gave Ben and Tom a radio, and we split up. Phill and I walked along our ridgeline for two hours to the base of the big cliff. I thought I saw tracks once, but they were mixed with cattle prints and the rain had made it difficult to decipher them. We paralleled the cliff to the next big rise. The view that met us had no horses. I radioed Ben and Tom. No tracks. No horses.

Storm clouds were building, and we had lost the trail. But horses have a tendency to go back to a water source they know. We decided to meet back at camp to make a game plan. I wasn't too worried about our

horses; they would come back. The pasture we were in may have been big, but fences did exist and the map didn't show any other water tanks. It was just a matter of time before they got thirsty and came back.

I began to walk back to camp when I found horse tracks. Old horse tracks, without horseshoes. Wild horses were here, too. If our horses joined a band of wild horses and reverted to their wild lives, we would never catch them.

When we rendezvoused back at camp, Jonny still hadn't shown up. I was worried about him. He had taken off running by himself without a map, water, cell phone, or radio. The last we saw of him, he had hopped into a strange vehicle and disappeared over the horizon.

We didn't know what to do or where to go, and it began to rain again. We started to put our tent up when the wind whipped into a rage. SNAP. The main pole broke, making our tent worthless. We stuffed the worthless tent and broken poles back into the bag and climbed into the tiny personal cameraman's tent. It was pretty uncomfortable. The tent was miniscule, and when Tom took his boots off the tent filled with a despicable foot odor. We sat crammed in that stinky tent, horseless, not knowing what to do, while the wind whipped around us and the rain covered all the tracks of our horses. Jonny was gone without any communication, and it was Sunday—no agencies were open, and we couldn't call anyone to get help.

Hours wore on as we made a game plan. We looked at every inch of that map. There was no other water source except for the water well where we were camped. The horses had to come back. The next day was a weekday, and we would be able to contact the BLM and the cattle rancher who leased the

grazing land; they'd be able to help us out.

Waiting for the next day, we were depressed, but our mood changed quickly when Jonny showed up riding JR bareback with three horses in tow. He told us he had found the horses and corralled them in makeshift pens TWELVE miles away, and then he asked for water.

Leave Your Guns at Home, Jonny

by Jonny Fitzsimons

I am an idiot. Fix this now. Those were the only things going through my mind as I watched the horses trot away with heads held high.

Earlier that morning, after Masters and I had found the herd nestled on the leeward side of the hill where they had been obscured from view, we had unhobbled each horse and they readily followed us back to camp for their breakfast of alfalfa cubes. While the horses happily ate their morning ration, we lounged around camp. We only had 15 miles of easy travel that day so we took our time. Phill cleaned his camera equipment while Tom and Masters had the same conversation they had had thousands of times before about prime elk hunting areas. Thamer was engrossed in *Fifty Shades of Grey*. Wanting something to do other than inventing a better way to stuff all my gear into a 40-liter dry bag, I decided to shoot my pistol.

Although the horses were unhobbled and free, I wasn't very worried about them taking fright at the report. In Arizona, we shot our pistols during the three days Thamer

was nursed back to health after a bout with dysentery, and the horses became accustomed to the crack of our guns.

A hundred yards from camp, I took aim at a cow pie and fired. A few of the horses picked up their heads and looked around, but they seemed content with their meal. Taking this as validation enough, I fired the rest of my cylinder.

Gill picked up his head from the trough and walked a few steps away. Several others did the same. Seeing this, I stopped and turned back toward the corral. The remaining horses at the trough picked up their heads. Ford, the one horse tethered to a post, watched the others intently. Then Gill threw his tail in the air, gave a playful kick, and took off north in a long trot. In a split second the herd fell in single file behind him. Ford set back on his tether, and the dust went flying as the lead rope snapped and he ran after the herd.

Sprinting through camp, I grabbed a hackamore and a halter off my saddle as the others jumped from their seats in the dirt. I shouted "Sorry!" as I ran.

The horses had hit the dirt road several hundred yards ahead of me and were gaining ground fast. I reached the road and settled into a jog, hoping they would slacken their pace. Past the horses, half a mile up the road, a speck was leading a cloud of dust. *A car, what luck!* We hadn't seen but one or two cars the previous day. The herd and the car quickly closed the gap between them, the herd splitting in two around the car then resuming their path north. Frantically waving my arms, I ran down the middle of the road. The Subaru squeaked to a halt in front of me. It had Utah plates and two bewildered looking men in the front seat. Thinking my situation self-explanatory, I ran around to

the back door and hopped in. Clearing the dust from my mouth and out of breath, I found it hard to say anything for a moment. They were silent and the car didn't move. Finally my words spilled out.

"Hey, guys, thanks so much, those are my horses you passed. Y'all mind driving me up the road so I can try to catch them?"

Nothing. They traded scared but excited glances.

"I would really appreciate it. We are out here all alone and you could save me a lot of time."

Again, nothing. *What the hell?*

Finally the driver laughed nervously and said something to the passenger . . . in German. *Oh, shit, I still have my pistol on. They think I am some American bandito trying to rob them.* I grabbed the driver by the arm, his face going from white to green. *Awesome, now I am going to have a tourist throw up on me.* Letting go, I pointed up the road then back at myself repeatedly. The driver finally nodded and turned the car around. He got the car headed back north just in time for me to see the herd head off the road to the east. We quickly closed the distance to where the horses turned and I jumped out. Not knowing how to thank them, I handed the two Germans a handful of .45 casings as I went. I'll never know what they said or what they were thinking, but I am sure whatever it was has been repeated many times to all their friends.

The horses had secured a significant lead on me. The ground they were crossing had a thin clay crust with loose sand underneath. I could no longer see the herd, but their track was like a fingerprint in icing. Having determined their direction, I looked around and formulated a plan. Headed northeast for the ridge at the edge of the plain, the horses

We thought this ridge was a natural barrier that would stop our runaway horses. We were wrong.

would eventually have to deviate from their course. Millennia of unrelenting winds had left the ridge buttressed by sheer sandstone cliffs and towering parapets. Upon hitting these cliffs, the horses would be forced to turn south back toward camp, or northwest back toward the road. If they headed south, the others were sure to see them. So I decided to intercept should they choose the other option. I walked along keeping a close eye on the foot of the ridge, hoping to catch a glimpse of them. After some time, I looked up to see 11 specks bound over the top of the ridge at a trot. *This might take a while. Time to run.*

An hour later I reached the top of the ridge, having crawled on my hands and knees over what the herd had climbed at a trot. Stopping to get my bearings, I studied the tracks and my options. From my vantage point, I could see for miles to the south and west, and there was no sign of Tom, Thamer, and Masters. I knew they were somewhere below, tracking me and the herd. To the north, dark cumulus clouds were forming,

and I could hear the distant roll of thunder. *Rain. That is a game changer.*

Rain meant that the horses would not be forced to return to camp for water. In addition, their tracks could be washed away and eliminate our one chance of finding them. At this point, I realized my biggest mistake. I had left camp without water.

I had two options. Go back to get the others and some provisions, or continue on the trail and hope to catch the herd before their tracks were washed out. Choosing the latter, I checked my watch. It was 11:30 a.m. Two hours had elapsed since the horses ran off. Alone without water, I had to choose a time to turn around should I not find the herd. Three o'clock would be my turnaround time. Before heading out, I drew my pistol and fired off three shots in quick succession, hoping to alert the others to my position.

The east side of the ridge was gradually sloped, and I followed the tracks down through scattered cedar trees. Although the herd had dispersed to pick its way through the trees, the tracks were still relatively easy

to follow. Halfway down, the cedar gave way and the ridge rolled down to the plain below. Here I began to see running cow tracks and depressions under the trees where a herd of cattle had been bedded down. The cow tracks merged with the horse tracks, and it was impossible to distinguish one from the other. I made a wide circle, hoping to pick up where the horses had gone, nothing. Again and again I made wider circles looking for fresh horse sign. A cold drop hit the back of my neck, and the heavens opened up. Panicked thoughts raced through my brain. *What if the rain washes out their tracks before I can find them again? What if they run into a herd of wild mustangs that are in the area? This could be the end; we may never find them. It is all my fault.*

After 30 minutes of searching, I found a single track headed north. I followed it. After a few hundred yards, another joined it, then another. The rain stopped as I stepped out atop a low rise that had been obscuring my view to the north. There, several miles away, I could make out a tiny string of objects moving across the plain. I ran.

The herd was moving directly away from me but had slowed to a walk. I kept my pace at a slow jog and caught up in a little over an hour. The herd had wandered not a quarter mile from an old abandoned shack surrounded by a dilapidated fence. I approached them cautiously. Taking my hat off, I filled it with several rocks and shook it to simulate the sound of a feed bag. They ignored me and continued walking away. I followed, shaking my hat in desperation. Finally, C-Star stopped and looked at me. I stopped. He took a step toward me. I took a step toward him. Cautiously, we closed the gap between us and I slid the hackamore around his head. With C-Star caught I hoped the rest would

follow us over to the shack, but they didn't. *Hold what ya got. Take them one at a time.*

Leading C-Star, I headed for the shack. The fence around it was good enough to hold horses, but there wasn't any water. I turned C-Star loose in the pen and inspected the premises. There was the shack, a dilapidated livestock shed, and an old school bus. The shack and shed yielded nothing. Inside the bus I found an ancient bail of alfalfa hay. Taking a flake of the musty old hay, I headed out to coax the other horses in. After what seemed an eternity, I managed to guide them in one by one.

With the horses secured but lacking water, it was time to make a new plan. I noted the time, 2:00 p.m., and took an inventory of my resources. I had my pistol, belt, chaps, phone-with-no-service, a lighter, Leatherman, one hackamore, one halter, Ford's broken halter, and two pairs of hobbles, which had been wrapped around one of the horse's necks. As I studied my materials my head began to throb and my vision blurred. Dehydration was beginning to set in. I needed water. From my seat in the hull of the rusty old bus, I noticed that its roof was sagging. Climbing on top, a small pool of water greeted me. The pool was tinted red from rust and it left a dull metallic taste in my mouth as I slurped it dry.

With all the time it took to catch the horses the others would have caught up by now had they found my trail. I was definitely on my own. It was time to move. Knowing it would be impossible to herd them all back to camp on my own, I decided to take four horses. I singled out JR, Ford, Tuff, and Luke. They were buddies, and I knew it would be easy to keep them together. Selecting JR to ride, I put my hackamore on him. This left three horses and one and

a half halters. To remedy the broken halter on Ford, I buckled my belt and two pairs of hobbles together for a makeshift lead. An old piece of bailing twine allowed me to secure Tuff's lead rope to Ford's tail, and we were off. Riding one and leading two, I let Luke go free, confident he would follow his buddies. As we rode out of the corral, the wind picked up and it started to rain sideways.

From my position at the old shack, I was only four or five miles north of camp. However, traveling directly south was impossible due to the ridge between us. My only choice was to ride west to the road and follow it back to camp. Traveling was slow. Every couple hundred yards, we were forced to cross deep washes cut through the plain. Finally, against my better judgment, I decided to travel down the deep gullies to save time. The rain had stopped, and my eyes nervously scanned the skies, wary of being caught in a deep wash with no way out.

Several miles after leaving the shack, I came to a broken-down old fence crossing the wash. The banks were sheer and more than

20 feet high at this point, making it impossible to search for a gate. I was going to have to dismount and cut the fence. As I clipped the last wire, a mule deer launched off the bank directly above me. Ford reared back and pulled the lead from my hands. In a split second, I was left with only JR as the other three ran full speed back to the herd.

Back I went to the shack. Leaving for the second time, I retraced our path and hit the wash at a run with the horses in tow. It was getting late and there was no time to spare. An hour later, we finally hit the road.

At 6:30 p.m. I rode into camp. Nine hours had elapsed since the horses ran off. I was tired, chafed from riding bareback for ten miles, and on the verge of collapse from dehydration. I quickly briefed the others, and then we tacked up and rode out to get the rest of the herd. Hours later, we arrived back in camp and Masters made a massive meal. We stuffed ourselves, tied our horses up for the night, and crawled into our sleeping bags. Never again did we leave horses unhaltered and unhobbled.

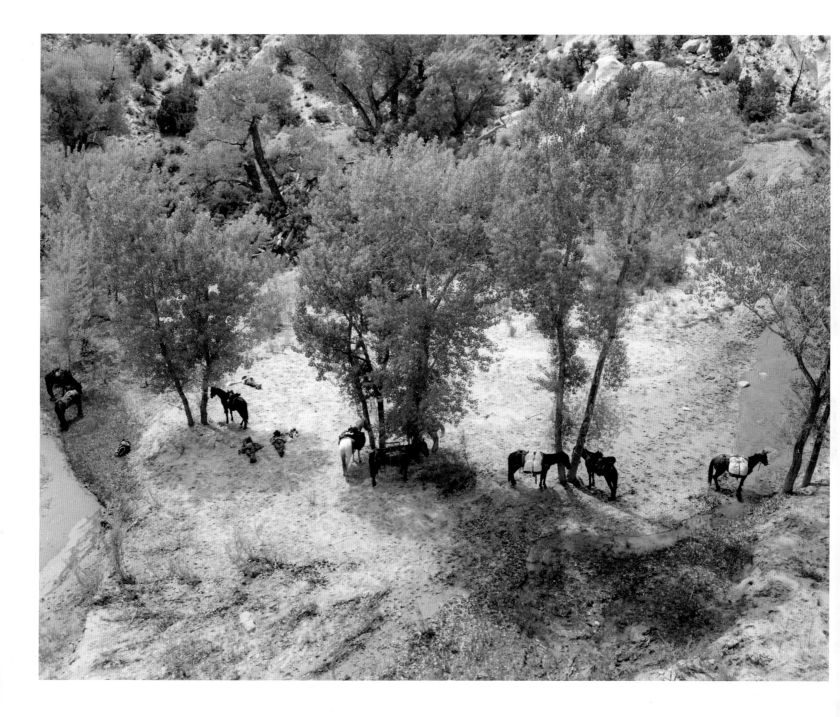

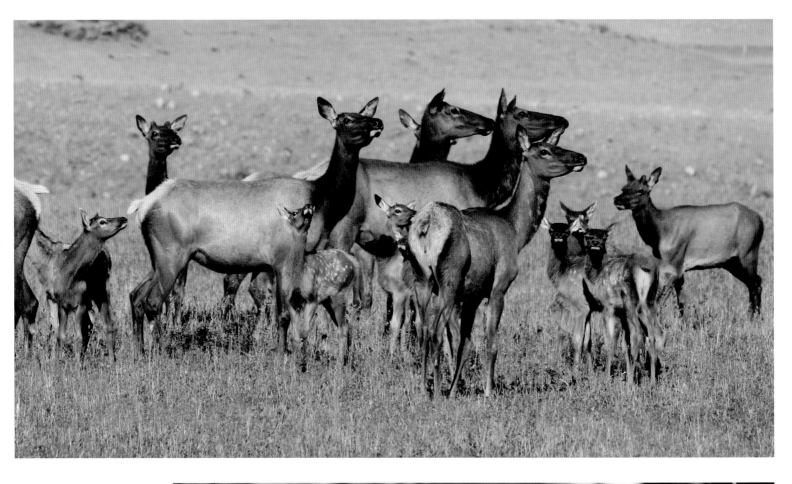

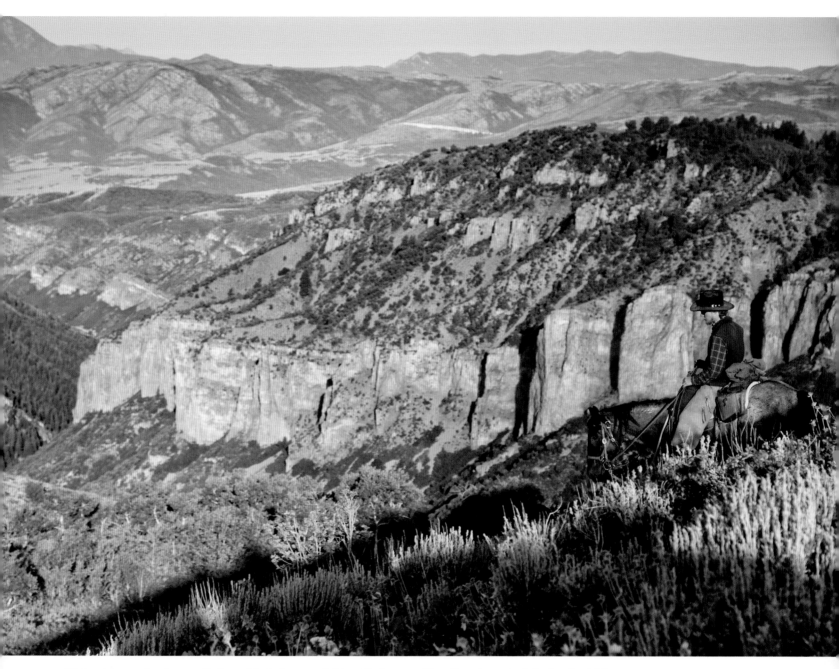

We kept one or two horses tied or picketed every night so that we could gather the rest of the herd, which may have wandered off, in the morning. Here, Tom and Tuff ride along an exposed ridgeline in search of the other horses. After finding the herd, we corralled them back to camp to tack up and begin the day.

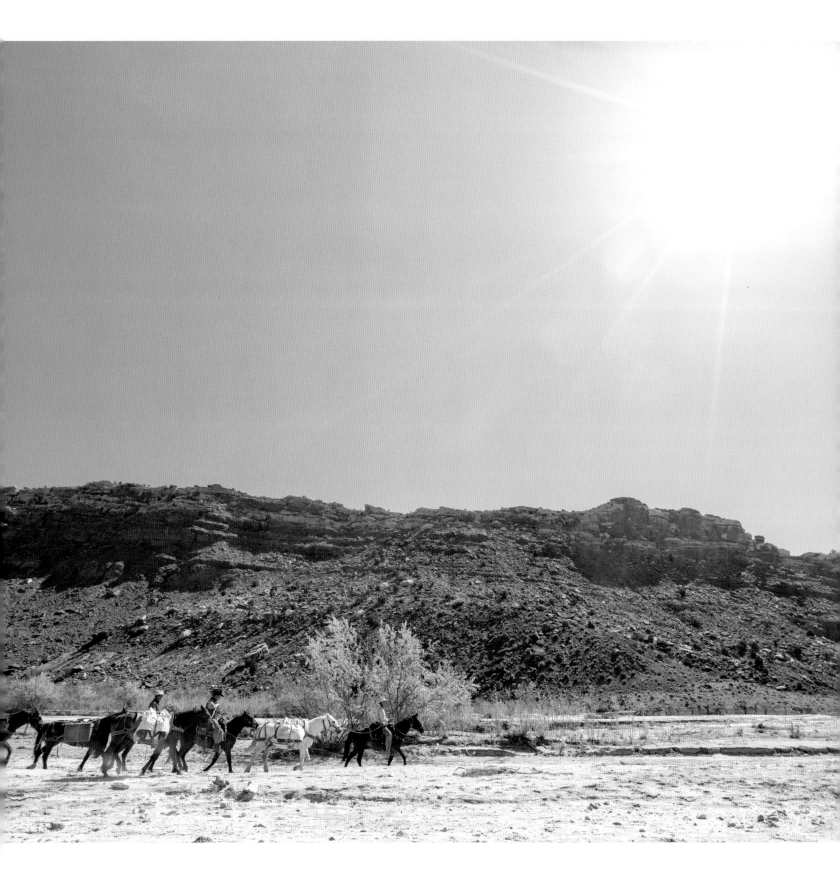

Hell's Hole

Halfway through Arizona we had decided to get some fresh horses to supplement our remuda, so Joseph Fitzsimons, Jonny's father, arranged for BLM employee Heath Weber to bring us some recruits. We met Heath at the LaForborn Ranch near Teasdale, Utah, on a rest day. He brought three broke BLM mustangs: a stocky linebacker bay dubbed Bam-Bam, a well-made black named Cricket, and a hairy, jug-headed palomino roan named Littlefoot. Jonny bought Bam-Bam and Cricket from Heath, and I got Littlefoot. Jonny and I took the recruits because we both had horses injured in Arizona, Tamale and Violet, and needed replacements.

Heath decided to ride with us the next day to see some new country and make sure his horses behaved. The logistics leaving Teasdale were unpredictable. Trails that existed on one map didn't exist on the next map (or in reality), and there was no straight shot. I spent hours studying the maps and decided to take the safest route, a four-wheel-drive road marked on the forest service map that was topographically very steep. The map hadn't been updated in 30 years, but if a vehicle could get through it 30 years ago then our horses could get through no problem, or so I thought.

Leaving Teasdale, I stared at my GPS and maps trying to figure out why the drainage we were going up had a headwater basin called "Hell's Hole." We found out a couple hours later when we took a bend in the drainage and were confronted by towering red and yellow ramparts hundreds of feet high on all of the horizons. We were in a box canyon, and there was no way out except to follow a small strip of vegetation that made

it to the top. That ribbon of vegetation was our road out, and it was steep, so steep that I had to zoom in very close to the GPS to see that the topo lines weren't actually on top of each other.

If we turned around, we wouldn't have water for the next ten miles and the day would have been a total waste, given the distance of the backtrack. Besides, the next nearest route over the Hell's Hole basin also looked incredibly steep and may have been just as bad or worse.

As we started up the strip of vegetation, we found out it was never a road at all but an old water line that was marked as a road on the map. As always, mountainsides are a lot bigger and steeper when you climb them than when you look at them. Hell's Hole was no exception, almost 2,000 feet straight up through tangled underbrush, boulders, and sliding shale.

We began the ascent trying to switchback as much as possible. It was hot, the horses hadn't watered in hours, and the new horses weren't in shape for the gruesome climb. Lathered, salty, sweat dripped off their bodies as we made it up the hill. The mountain got steeper the farther we went and not just in our heads. Switchbacks became more and more difficult as we couldn't find places to safely turn our horses. Quivering horses and humans scrambled twenty yards before stopping and repeating again, and again, and again.

Three-quarters up the mountain, it became increasingly steep and above us rose a near vertical cliff. The crux of the climb. Beyond the cliff, Hell's Hole leveled off onto a large plateau and safety. Jonny went ahead of us and scouted for the safest route. Thirty minutes later he returned with news that it was bad but makeable. We led our horses up

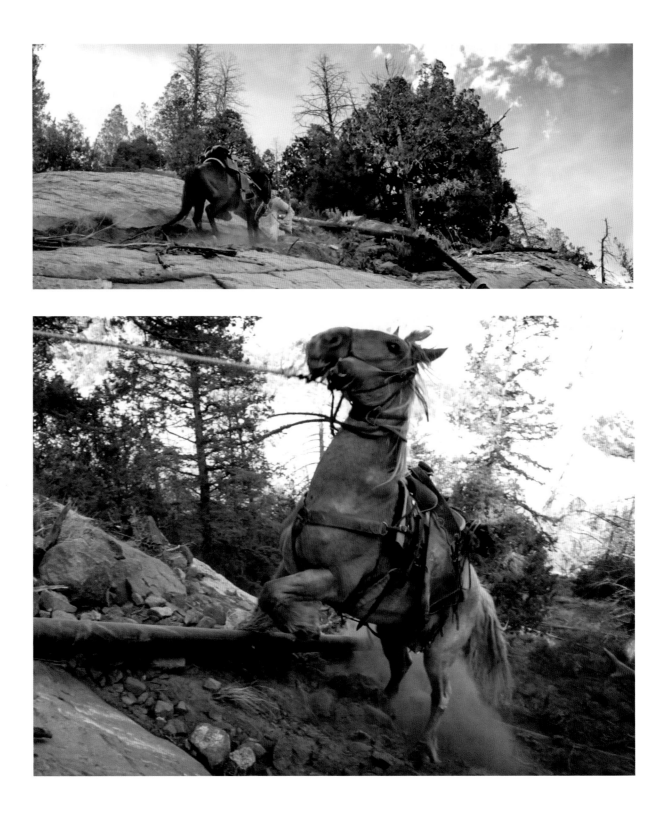

another 150 yards to the base of the cliff, tied them to trees, and made a game plan.

The horses would initially have to run straight up a steep grade through pine trees for thirty yards. Next was a steep, angled, rocky ledge merely inches wide that cut through the nearly vertical cliff wall. The ledge was 40 yards long and very makeable except for the very last stretch where a water pipe lay two feet above the surface and the horses would have to jump over it with the tiny ledge as takeoff and landing. It was bad but we had to do it. We had come too far, and going down the horrific steep grade we came up wasn't safe.

Jonny went first, leading his horses through the crux. They had no problem jumping the pipe, and beyond lay safety. His new horses, Bam-Bam and Cricket, were tired but holding up well, and they followed him through the difficult footing to the top. Next went Ben Thamer, then Tom, then myself. The pucker factor was intense watching our horses walk, putting one foot in front of the other along the slick ledge, but they all made it. The only remaining horse and rider was Heath Weber and the new horse, Littlefoot.

Heath made it past the scramble to the crux. Littlefoot looked at him crazily when Heath started across the ledge, but with a pull on the lead rope he began to follow. Heath and Littlefoot clambered across the slippery ledge and stopped to look at the water pipe and freedom on the other side. Heath stepped over the water pipe, gave Littlefoot plenty of time to look at the obstacle, and gently pulled on the lead rope encouraging him to jump the pipe. Littlefoot balked, rose up on his hind legs, but didn't commit to the jump. He landed awkwardly, almost caught a leg under the pipe, and struggled to regain his balance on the slick ledge. With encouragement he tried again. This time he committed to the jump with his back legs but didn't clear the pipe. High centered, Littlefoot reared up and reversed to get his front feet over the pipe. He got his front feet over when he lost traction with his hinds. He struggled, slipped one hoof, slipped another hoof, and fell from the ledge rolling down the near vertical cliff to the bottom.

Dumbstruck we watched the scene unfold. I felt powerless. There was nothing I could do to help Littlefoot so I stared in awe at the growing dust cloud created by sliding horse and rocks. Long seconds later, 70 feet below me, Littlefoot appeared. He took a step forward . . . and began eating grass. Relief flooded over us when we saw that he was alive, but we were shocked when Heath made his way down, gave him a full body inspection, and did not find one injury. That is a tough horse!

Heath brought him back up the trail, and when Littlefoot came to the water pipe he leaped over it to the safe side out of Hell's Hole. Later that evening Heath made a comment about not wanting to give us a horse that falls off cliffs. I replied that if he gets up every time unscathed and continues down the trail then he has a place in my string. However, to celebrate the survival of Littlefoot and his arrival into the *Unbranded* crew we renamed him Dinosaur. Because he should be extinct.

Trail Food

by Ben Masters and Korey Kaczmarek

As we prepared for the trip, Ben Thamer offered to be the camp chef. Thamer was the skinniest guy among us, which should have been a red flag, but I was grateful that the job didn't fall into my hands. Thamer coordinated with our parents, who shipped food to our resupply points about every seven to ten days. I don't recall ever not enjoying a meal, although rice with jerky, Rotel, and wasabi peas in a tortilla were pretty bad. Rotel and wasabi are not to be mixed: creativity gone wrong.

For breakfast we ate granola bars except for special days when we had oatmeal. And coffee, we drank lots of coffee. We made coffee by boiling water in the percolator over a fire or using the Jetboil. We dumped coffee grounds into the boiling water, let it sit, then sank the grounds to the bottom by adding cold water. The hot water rose to the top and the cold water went to the bottom taking the coffee with it. The consistency was like mud, but it was good mud. Beware the last cup, though, which was mainly coffee grounds.

We had one pannier designated as the snack pantry, which we raided every morning for the day's snack ration, typically three granola bars, one candy bar, a couple of pieces of gum, lemonade powder for water, jerky, trail mix, and Copenhagen. For lunch some days, we had cold soup, but that was a rarity.

Dinner provided our main caloric intake. Thamer would begin cooking as soon as we arrived at camp. We almost always built a fire, and most nights we made biscuits. The rest of dinner was out of a can or freeze dried, with hot sauce and tortillas. At first,

the biscuits were usually burned, but over time chef Thamer and Jonny perfected their backcountry biscuit and cornbread techniques. By the end of the trip and after months of experimentation, we were eating golden-crusted, moist cornbread topped with mashed potatoes along with a layer of pan-seared corn beef hash smothered with gravy. I thought the food was pretty decent, but the feeling wasn't universal.

Cameraman Korey Kaczmarek, who rode with us for about a fourth of the trip, was a snowboarder extraordinaire, a health freak who ate organic:

> When I first heard that horses were carrying all of the provisions for our trip, I painted a picture in my mind of a western buffet of sizzling steaks, buttered biscuits, and fresh vegetables. Boy, was I wrong.
>
> I learned quickly that Thamer had a different idea of trail food. It was like we were in the military and the only things left to eat were provisions from a bomb

shelter. Come dinnertime, we never really knew what Thamer was going to come up with. A typical meal might consist of a few cans of either beans or some sort of Mexican pork and a block of Velveeta. Fittingly, the Texans wrapped everything in a tortilla and drowned it in Mexican hot sauce.

When supplies dwindled, we dug deep into the panniers and pulled out bagged, horse-salve-covered camping meals. Mixed with some questionable creek water, you got a sodium gut bomb that kept you up all night.

I will say that with a few months' practice chef Thamer made great corn-bread. I think it tasted so good because he mixed the dough with hands that were barely washed during the entire ride. That and the fact that on the trail hunger was the best seasoning. The funny thing was no one got sick, except Thamer.

After Korey's first ride with us, he packed his own food.

Impassable

The Wasatch Plateau rises 8,500 to 10,500 feet above sea level and stretches 70 miles north to south through central Utah. A beautiful, straight-running four-wheel-drive road on the crest, if passable, would give us days of fast travel without the normal winding and switchbacks of a side trail. Only long-distance hikers and riders can really understand how wonderful straight paths are; they are cherished miles.

Forest service employees and local outfitters warned me of the snowpack on the Wasatch Plateau during the planning stage of the trip. As we approached, I noticed snow on the south faces of the mountains, a red flag because if there's snow where the sun can reach, there's a lot more on the north faces where the sun can't. However, we recently went over the snow-clad Aquarius Plateau, which reaches 10,600 feet, and our horses plowed through the big drifts and snowfields with ease.

As we gained in elevation, the soil became muddier, the grass shorter, and tiny white flowers covered the ground. Small rivulets of snow runoff made their way to off-color streams nearing their high-water marks. We began to hit snow at 10,000 feet on the south face, but it was soft in the mid-day sun and easy to travel through Scraggly

pines shorter than a horse grew in bunches, and as the snow got steadily deeper our horses struggled more and more.

A bend in our snow-covered road gave us a view of a turquoise blue lake hundreds of feet below us. Ice chunks the size of pickups floated around the lake, and it looked like a good home for a polar bear, not horses. We had to get to the top of the plateau to see what lay ahead of us for the next 30 miles, the distance needed to get below 10,000 feet again.

We continued up, and our horses began to post-hole through an icy crust lying over two to three feet of sloshy snow. A big drift, 20 yards wide, lay in front of us, and I dismounted to tie my packhorse, Chief, to Ben Thamer's pack string while I led my lead horse, Dinosaur, through the shallowest portion of the snowdrift. The line I took was bad, and Dinosaur got high centered on his belly, his legs going through the snow crust but not deep enough to get traction on the ground underneath. He floundered, gained a few feet, and stopped, exhausted.

Thamer tried a different route close to me and made it through on his saddle horse, Simmie, but his packhorses, which were tied together, got bogged down in the snow. As they struggled to get up, Chief tried to come toward Dinosaur and me while searching for solid footing and safety. Because Dinosaur was high centered in the snow up to his belly, the stirrup on my saddle sat on top of the snow, and Chief's front foot went through the stirrup, attaching him to Dinosaur. Chief's halter rope was tied to Gill's pack saddle in front of him, and Gill was trying to lunge himself free from the snowbank, pulling Chief forward and stretching his attached leg.

Horses don't understand ropes and stirrups and being attached to each other very well. When they get into a bad situation their primal instinct is to run to freedom. Horses tied up to each other in a snowbank with their feet caught is a recipe for broken legs, and I had to act quickly. I jumped into the middle of the horse wreck and cut through my saddle, like a razor slicing a stretched rubber band, except there was a 1,000-pound struggling horse putting frantic energy and tension into my saddle fender.

Seconds after I cut through my saddle, Ben Thamer cut through the breakaway connecting Chief to Gill and freed all the horses. With a little coaxing, we got them out of the snowbank and plowed a path, making it easy for the horses behind us to follow. We continued up the snow-clad mountain with growing uncertainty about what awaited us on top.

One-half mile later, we reached the top of the Wasatch Plateau to find a winter wonderland interspersed with small muddy patches and not a blade of grass or a dry spot within viewing distance. We attempted to travel along the top of the plateau for a quarter mile, but it was a futile effort. There was no way to know how deep the snow was, and our horses kept sinking to their bellies after cracking through the icy surface. According to the map, in a few spots we would be on a northern face free from all sunlight. Snowdrifts could still be 10, 20, 30, or 100 feet deep, and no way of knowing. We turned back.

We made our way off the plateau, below the snow line, and back into the muddy quagmire. After tying our horses to gnarly short pines, we got out the maps to decide on an alternate route that would bypass the plateau. We would have to go west, drop down in elevation, and travel through the Sanpete Valley on the only public access,

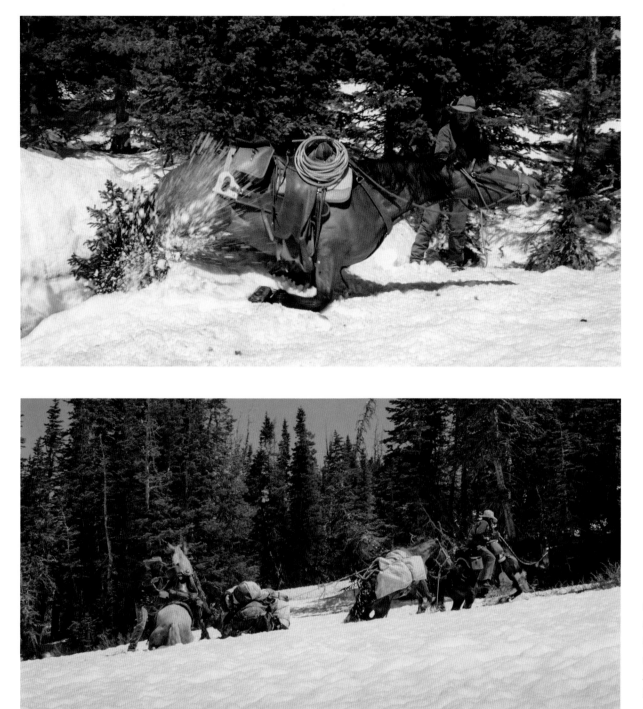

Gill was struggling to exit the snow, pulling on Chief. Chief's leg was caught in the stirrup of Dinosaur's saddle, and he couldn't move. I had to cut through the saddle to free Chief from a potentially disastrous wreck.

Highway 89. Feeling dejected, we looked at the map with sadness as the realization that the reroute would add days of wasted miles onto an already long trip.

Graze was sparse, it was already mid-afternoon, and we had to cover ground in order to get lower and hopefully find grass for the night on our new route. We decided to turn loose all the horses that weren't carrying a load so they could graze alongside our pack string on our way to camp. That way they would be able to browse what they could in case we didn't find a good campsite and had to tie them up for the night. As we dropped in elevation, an ominous north wind carrying the cold of the snowfields whistled through the pines, sending shivers through our bodies and triggering an urge to move within our horses.

Then the hum of four-wheelers added to the sound of swirling winds and grew stronger as we came off the plateau. Our horses searched for the source of the sound but couldn't place it. They became scared and

began to walk quickly, obviously agitated. The horses we turned loose to graze started to trot, ears pricked to the wind, heads high and looking for danger. Ben Thamer's riding horse, Ford, battled to join the loose horses, and Ben let go of Gill, his pack horse, to regain control. Ben dismounted to retrieve Gill, but on his approach Gill fled toward the loose horses. Ford followed Gill, which left Thamer horseless, running across the alpine meadow as the loose horses fled in full stampede. Jonny gave me his pack horse, Django, and took off on Cricket in pursuit of the stampeding horses. Tom and I quickly tied up the remaining horses just in time to see the stampede cross over the horizon with Jonny galloping in pursuit and Thamer jogging after them. After a quick discussion, Tom left to help Jonny and Thamer regain the horses. Our last words were that I would stay put with the remaining horses until further notice.

Forty-eight hours later, I hadn't heard from anyone.

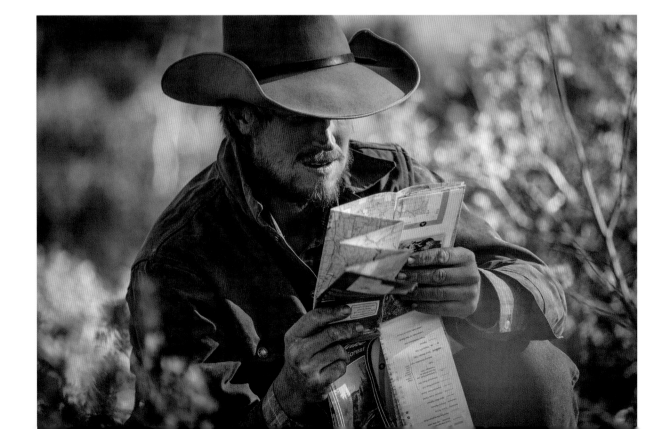

Losing the Horses: Round Two

by Thomas Glover

Riding my slowest but sturdiest mustang, Tuff, I loped across the large meadow in pursuit of the fleeing horses. Riding Cricket, Jonny had a head start in the chase and was already a half mile ahead of me. Thamer was on foot struggling to cover ground, and I quickly passed him. Catching up with the loose horses was top priority so I continued on, leaving him behind. I soon hit the four-wheel-drive road that we had been traveling on for two days, and I continued my pursuit, backtracking in the opposite direction. As the road went into the trees, I came upon Jonny on foot walking his limping horse. Cricket had thrown a shoe while running, stepped on a rock, and hurt his front foot. It wasn't a bad injury but enough to slow him to a walk. I reined up next to Jonny and we assessed the situation. This wasn't the first time our horses had run off, and we were pretty certain they would soon calm down and stop to eat at the nearest patch of green grass. As usual, we would find them and be back on our way.

We continued at a walk following hoofprints in the soft dirt road. It was apparent that the renegades had formed a line and were traveling at a good clip. At each bend in the road, we hoped to come upon them grazing quietly. At several high points we could see for miles, and each time we stopped to get a good look, we were let down by the fact that they were nowhere in sight. The sun was still high in the sky, though, and we had faith that they would be recovered by dinnertime. We hoped we didn't have to sleep on the cold ground without any of the gear that was packed away on the horses back with Masters.

A few hours into the pursuit, a winded Thamer caught up with us, having jogged most of the time. He had ditched his chaps and jacket on the side of the road to be picked up on the way back. We then reached an intersection in the road and split up to look for tracks in each direction. A group of four-wheelers approached us and the drivers claimed to have seen the runaways several miles down the road. They informed us that they were walking at a quick pace and didn't show any sign of slowing down. This was not quite the news we hoped for; on one hand it was good that they were not too far ahead of us but on the other hand it was unsettling that they were still cruising in the wrong direction. One of the men had an extra spot in his Razor off-road vehicle and offered to take one of us up the road to catch up with them. Jonny grabbed the extra halters and hopped in, and they zoomed off. Thamer and I remained with Tuff and Cricket and continued walking in that direction.

It was now clear that the horses were going back down the same path we had been traveling that morning. We were convinced we would soon meet up with Jonny and the runaways. We didn't stop to think that chasing the horses in an ATV would only urge them to flee farther.

As the sun lowered ominously in the sky, Thamer and I continued walking down the road with Tuff and Cricket. Luckily, the runaway horses had stayed on the road, making travel easier for us. We were now following ATV tire tracks as well as horse tracks. We then saw the ATV coming back in our direction, without Jonny. The man said that he needed to go back to meet his group and that he left Jonny on the road a

few miles ahead of us. He said that they had spotted the horses and that Jonny was sure to catch them. Filled with new hope, Thamer and I continued on. A couple hours later, we reached the spot where Jonny was dropped off and continued following the horse tracks and now Jonny's footprints. We were certain that we would find Jonny and the horses at any moment. The situation was becoming more urgent as the sun was nearing the horizon, signaling the end of the day. We were now determined more than ever to reach Jonny and the horses before dark.

We covered more ground, and as day turned into night, it became clear that we would have to travel into the night. At least we had a solid road to follow. At each turn and at each clearing we prayed that we would find Jonny and the remaining horses safe and sound. Adding to the urgency of the situation was the fact that we were getting closer to Interstate 70, which we had crossed the day before. We had seen two guys on ATVs right at dark who said they had not seen Jonny or the horses. This was not the news we were hoping to hear. We continued on nonetheless.

It was now midnight. Jonny and the horses were nowhere in sight. Exhausted from the all day and night pursuit and not having eaten since breakfast, we decided to make a fire and hope to get some rest so we could hit it hard in the morning. We tied Tuff and Cricket up and settled in for a cold night.

We were still at 9,000 or more feet in elevation and had no camping gear whatsoever. Needless to say, we got very little sleep. It was all we could do to keep the fire going and stay warm. At least we had a lighter to start a fire; we prayed Jonny was as fortunate.

With dawn bringing the light of a new day, we continued down the road. We soon reached the spot where we had all camped together two nights before. Still no horses or Jonny. We reached I-70 and saw where Jonny had camped alone the night before. There were some old cattle pens and a dilapidated shack right off the interstate. It appeared he was able to make a fire. That gave a little solace to our situation knowing he was able to keep warm. Another piece of good news was that the four-wheel-drive road crossed under I-70 and then continued along the busy interstate on the other side with a fence separating the two. A good-sized river also separated the fenced road and the interstate. It would almost be impossible for the horses to get on the highway.

Thamer and I followed horse tracks until they began to go in circles and appear to double back. Some tracks continued on down the road and others seemed to go the other way. We could also still see the tracks from a couple of days before when we initially traveled that way.

About midmorning, a sheriff in a Tahoe approached us. He had received a call that morning about loose horses along the highway and went to investigate. He said he came across Jonny with four of the loose horses a few miles ahead of us on the dirt road. Extremely excited about this news, we thanked the officer and continued in Jonny's direction. At last, we found Jonny, and it felt really good to be reunited.

That morning, Jonny had hitched a ride

from a trucker on I-70 and finally caught up to the loose horses. A cattle guard at the end of the road a few miles ahead created a dead end that stopped their escape. The only bad news was he only had four of the six horses that had run off. The other two, JR and Bam-Bam, appeared to have continued south down another hiking trail.

We led the horses back to the old cattle pen next to the interstate, secured them there, and began to formulate a game plan. We decided that Thamer would hitchhike to the town of Salinas and try to contact Masters, who was probably losing his mind worrying about us. Jonny and I would ride down the trail to locate the remaining two horses. At least now we had two saddle horses and could cover more ground.

Jonny and I followed tracks for several more miles on the trail before they ended. This meant that somewhere the two horses quit the trail and struck off in an unknown direction. We circled back and vigorously searched for tracks. As we began to lose hope, Cricket, the horse Jonny was riding, began to neigh excitedly. We then heard another horse calling. We followed the horse's voice and shortly found the remaining two renegades in a field full of daisies. Our search was over, and we had found all of the runaway horses unharmed though extremely fatigued. I took a look at my GPS and determined that we had traveled more than 40 miles during the entire pursuit, which took us exactly down the same path we had ridden the previous two days, undoing two days of forward progress.

When we got back to the pen next to I-70, we found Thamer waiting with our new cameraman, John. Luckily, John was driving to meet us to film the next leg of our trip. While Jonny and I went after JR and Bam-Bam, Thamer hitched a ride into Salinas. He was able to reach John by phone and met him in town. They then drove in John's truck back to the pens. More importantly, they brought delicious burgers and cold water. We hadn't had food or water for nearly 24 hours.

We now had the difficult task ahead of us to rendezvous with Masters and the other horses. Riding the 40 miles back to Masters was out of the question. The horses we had were extremely tired, as they had been traveling for 24 hours straight with no food or water. We were in no better shape. Fortunately, Jonny had the phone number of the sheriff we had met earlier in the day. We called him, and he said he would try to track down a horse trailer big enough to carry all eight horses. The sheriff came through and soon showed up with his buddy and a large horse trailer. The sheriff also had an aunt and uncle, Gary and Anne Olsen, who had a farm up the road where we could keep our horses and rest. They graciously took us in, let us shower, and fed us an excellent home-cooked meal. We now were able to contact Masters on his satellite phone to figure out what to do next.

The Olsens defined hospitality. Without question, they were the most wonderful and helpful people we met on the trip. The call they received and the story they heard that morning from their nephew had to be one of the craziest things they'd ever been a part of. The sheriff asked them to take in four complete strangers who needed help. They had no idea who we were or what we were up to. All they knew was that a group of dirty guys and eight horses were in a tough spot and needed a place for the night and some food in their bellies.

After we loaded our horses and gear in the truck, we drove to their house just north

of Manti, Utah. The Olsens have lived on the same property as turkey farmers for four generations. They had a two-acre pen with good grass where the horses could eat and relax. While Jonny and Thamer were unloading the horses, they invited me into their home to show me where we could shower. As I walked into the mudroom by the back door, they asked me to take my boots off before coming into the house. Although I did not want to walk through their house with the odor of my feet radiating off my socks, I obliged. That is when they realized how dirty and smelly we had become living on the trail. It didn't help that I had just walked 40 miles the day before. I quickly stunk up their house, and we all had to take showers and change clothes before we did anything else. Anne Olsen gave us fresh pajama bottoms and tee shirts to wear while she washed our nasty trail clothes. We then ate a delicious meal and went straight to bed. Words cannot describe how it felt to take a shower and sleep in a bed after all that time.

The next morning, Masters called us on the satellite phone. After much discussion and various plans, we decided to ride back up the mountain on a dirt road in cameraman John's truck. Since Masters had five horses with him, Thamer, Jonny, and I took our saddles and left the horses with the Olsens. We would ride back down with Masters and his horses to pick them up. So, back up the mountain we went, fresh and energized from the food and a full night's rest. It took a couple of hours via a remote dirt road in John's truck to finally get to Masters. The team was reunited at last and ready to move forward on the journey. Persistence, luck, and help from generous people got us through the toughest test we had faced.

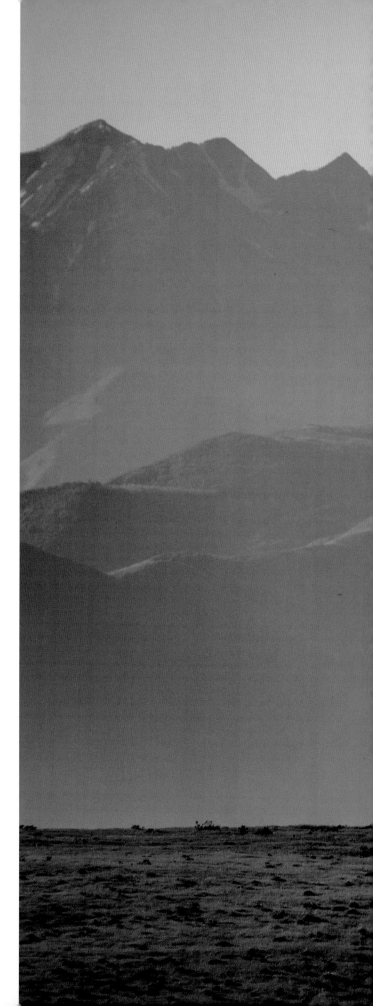

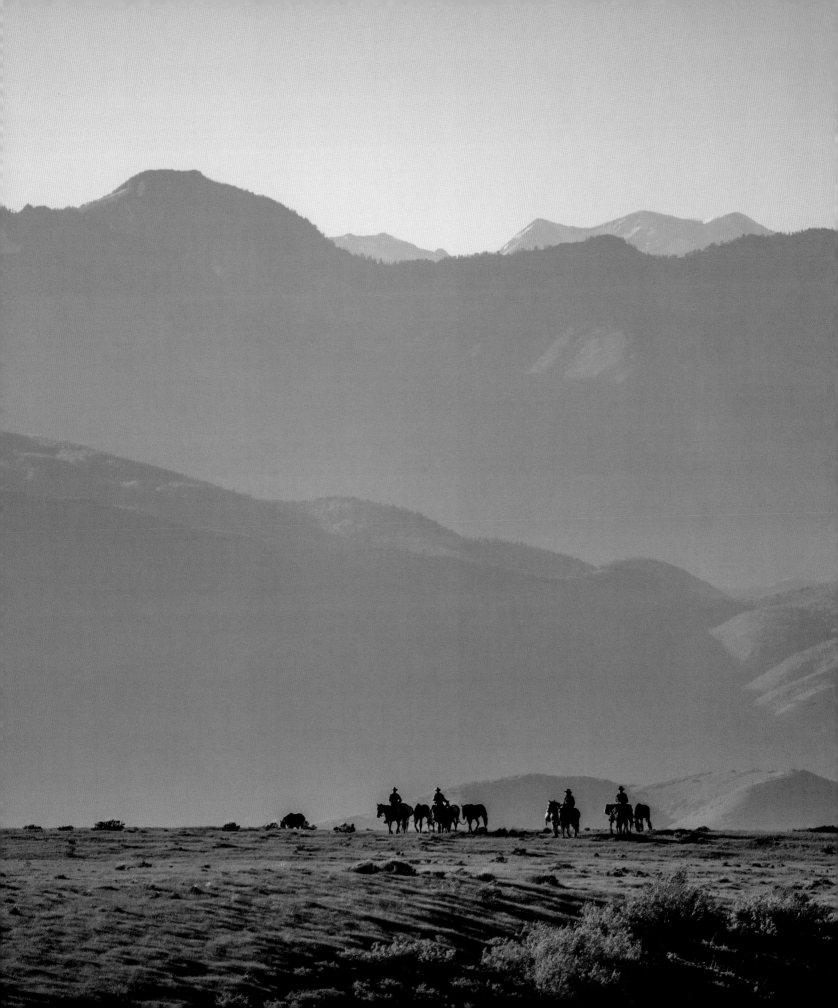

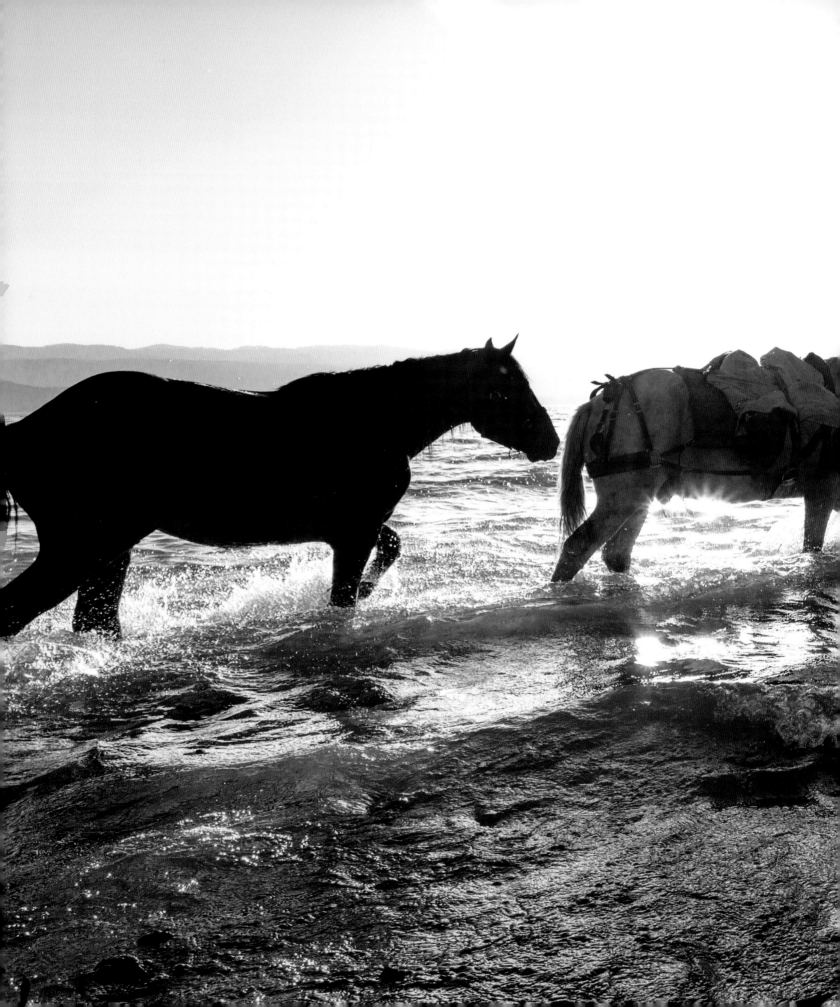

IDAHO AND WYOMING

June 27–July 26, 2013

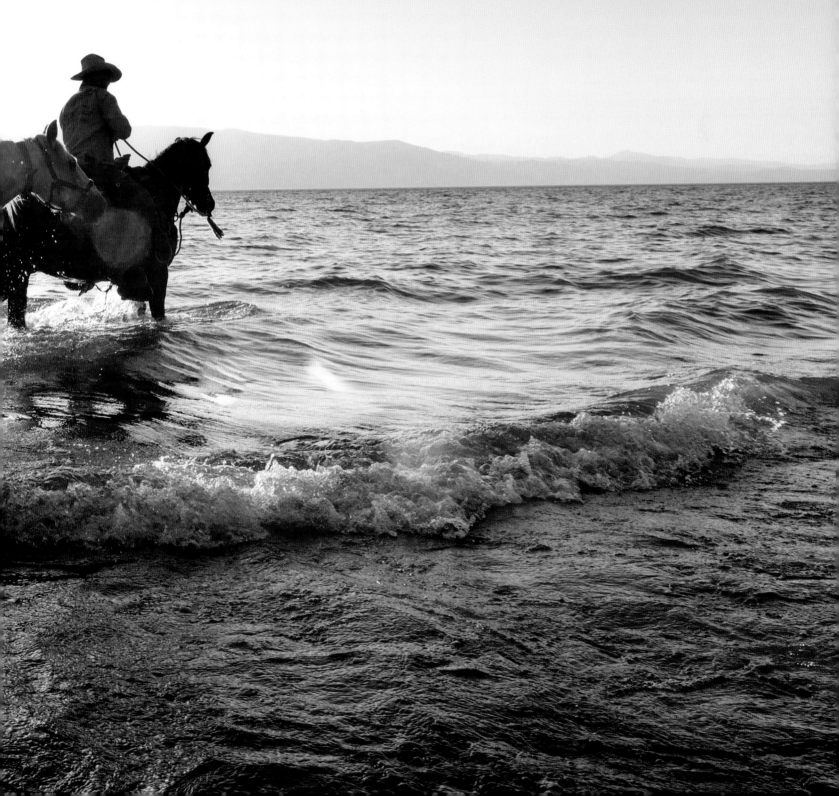

WYOMING

IDAHO

Lamar River

Yellowstone Lake

Hawks Rest
Yellowstone River

Buffalo River

Gros Ventre River

Gros Ventre Mountains

Hoback River

Wyoming Range

Greys River

Salt River Range

Gannet Hills

The Trail: 520 Miles

We entered Idaho June 27 at a gallop along the sandy beaches of Bear Lake. It was a beautiful day, and the horses were in phenomenal shape without the slightest injuries. Spirits were high as we had passed our halfway mark, well ahead of schedule, and with some of the best terrain waiting ahead of us.

We stopped to party at the beach, but our plans changed when our horses pulled down a couple hundred yards of buck rail fence. We spent the afternoon fixing the fence and catching horses, but we still got in a little swimming in Bear Lake before dark. We continued up the Bear River, cut through the Gannet Hills, and entered Wyoming on June 29, two days after we entered Idaho.

The Wyoming border was a huge landmark. For the next month we would be in the Greater Yellowstone Ecosystem, one of the largest, mostly intact ecosystems in the world. We would be in true backcountry, completely on our own with limited outside communication, few roads, and fewer people.

We traveled up the Salt River Range where we encountered little snowpack and phenomenal graze. Then we dropped into the Greys River drainage and kept our horses at the Box Y Lodge while we went to Jackson Hole for a Fourth of July rodeo. Jonny and Ben Thamer both lasted eight seconds on their bucking horses, whereas Tom's and my bull rides combined didn't last half that.

With rested horses, we left the Box Y Lodge and headed into the Wyoming Range, a beautiful mountain range often overlooked in favor of the more dramatic Tetons or Wind River Range. Jonny's horse, Cricket, passed away in the Wyoming Range. With heavy hearts we continued north, over the Hoback River and into the Gros Ventre Mountains. Rocky cathedrals and a massive landslide led us north to Red Rock Ranch on the Gros Ventre River, where we were generously given rest and graze for our horses.

We left the Red Rock Ranch and headed north into familiar territory. From this point on, we were on the same route that I took on my 2,000-mile trek in 2010. Trout rose to dry flies without hesitation as we moved up the meadow-filled Buffalo River to Two Ocean Pass on the Continental Divide. At Two Ocean Pass we looked at the Parting of the Waters, a hydrological phenomenon where Two Ocean Creek splits into Atlantic and Pacific Creeks, which flow to the oceans of their respective names. This is unique because it allows fish species to travel from

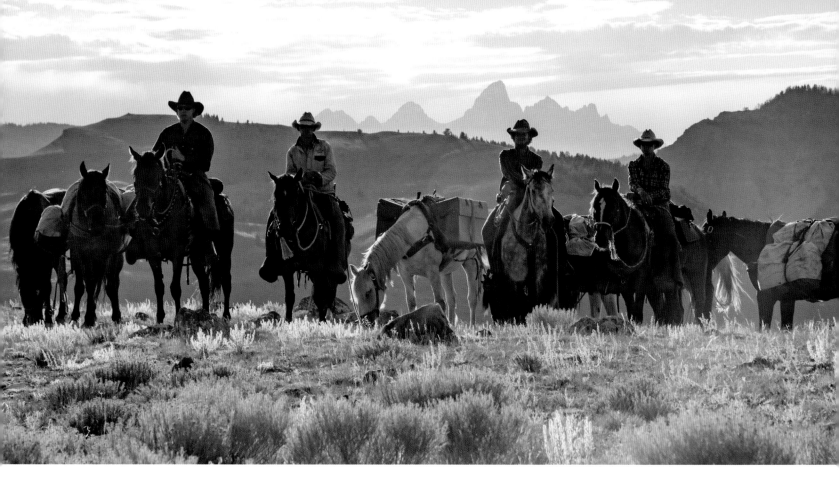

one side of the Continental Divide to the other. This is the waterway connecting the Atlantic to the Pacific that Lewis and Clark searched for but never found.

We traveled through head-high willows and hundreds of beaver ponds along Atlantic Creek to the Yellowstone River. The Yellowstone River originates in Wyoming and flows north, forms the 136-square-mile Yellowstone Lake, and eventually turns east in Montana where it joins with the Missouri River and later the Mississippi. It is the longest undammed river in the contiguous United States, and we would parallel its course through Yellowstone National Park and beyond.

We arrived on the Yellowstone River near Hawks Rest cabin in the Teton Wilderness. Val Geissler greeted us at Hawks Rest, and we rested for a day before heading into Yellowstone National Park.

Bald eagles, beavers, bison herds, wild rivers, steaming vents, and bubbling mud met us in Yellowstone. We rode along the east side of Yellowstone Lake and went up the expansive Pelican Valley before dropping over to the Lamar River. We took the Lamar north to Cache Creek, turned east, and crossed over a pass to the Soda Butte River. We took the Soda Butte to Pebble Creek, turned north, and rode to a pass that dropped us into Slough Creek and arguably the best cutthroat trout fishing in the world. Continuing north, our route took us out of Yellowstone National Park, out of Wyoming, and into Montana's Absaroka-Beartooth Wilderness. Rainstorms awaited our arrival.

Two-Second Rodeo Career

About halfway through Arizona we ran out of regular conversations. Shortly after, we ran out of regular thoughts. Our minds wandered to strange places, and we had some really brilliant ideas, but they were far outnumbered by dumb ones. Thomas Glover had a brilliant idea. We needed to ride bulls.

Cameramen and production people love high action, pain, stress, injury, and drama, so when Phill the film director heard word of a rodeo he began to scheme. We figured he would set us up with a tiny rodeo where we could ride our first bulls in semiprivate. Instead, he made plans for us to ride at the Jackson Hole, Wyoming, rodeo on Fourth of July weekend.

For the next 1,000 miles I tried to convince myself that I was too smart and too normal to ride a bull, a justification that didn't make much sense because I was riding mustangs from Mexico to Canada. But I'm uncoordinated, not very mean, and really don't see the point in riding a bull. However, I wasn't about to watch Tom erupt out of the chutes while I sat on the sidelines. In the end, Tom and I were going to get on bulls while Thamer and Jonny were going to try their luck on bucking horses.

We topped over the Salt River Range into the Greys River drainage south of Jackson Hole, where the folks at the Box Y Ranch gave us pasture for our horses. We got a ride into Jackson, met up with the camera people, and headed to the rodeo grounds. Brandon Wilson, the owner, met us and introduced us to our teacher, Levi, a 16-year-old bull rider. Levi taught us the suicide grip and how to stay balanced on a bull. He then set us up

on the bucking machine. We started slow, trying to get the right technique, and as we learned, Levi made the bucking machine go faster and turn abruptly. About the time we got the hang of it, Levi told us that being on a bull is completely different and we would forget everything we learned as soon as the chute opens.

After the practice session, Brandon walked us around the pens and showed us his bulls. He pointed to a small, brindle long-horned bull off by himself. Gravedigger was his name, and that's who I would ride. I expected to hear rock music and get scared when I looked into his eyes, but Gravedigger looked half asleep and quietly chewed his

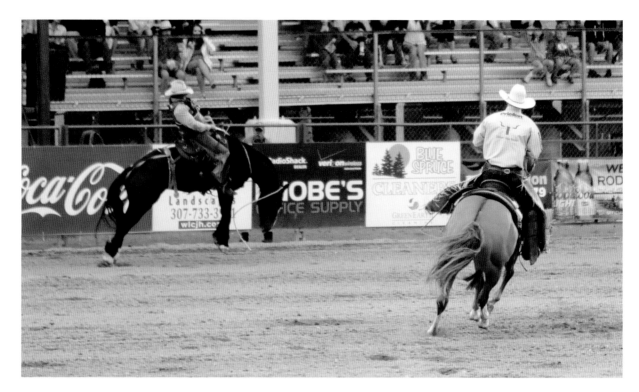

Jonny Fitzsimons

Ben Thamer

Ben Masters

cud when I approached. A mean name for a lazy bull. Jack explained to me that Gravedigger was a beginner's bull, who turned to the right every time. Very predictable, and I had no excuses. It was only eight seconds.

The next day we showed up hours early to prepare. We didn't have any gear, and we had to borrow ropes, spurs, jackets, helmets, and saddles. Tom took the biggest helmet, and I was going to use it after him. The folks at the Jackson Hole Rodeo really treated us great. The national anthem was sung, and the bucking horses came through the chutes.

Jonny was up first on a big dark bay mustang. He slipped into the chute, settled into the saddle, took a firm grip, and nodded his head. The horse exploded out of the chute and took off bucking toward the other end of the arena. Jonny stayed right in the middle and made short rakes with his spurs. The buzzer rang at eight seconds, and he made a perfect dismount, like he'd done it a hundred times.

Ben Thamer was up next. He crawled into the chute with a big bay paint that started jumping as soon as he sat down. Thamer looked half determined and half scared to death when he nodded his head. The big paint came bursting out and within two jumps had Ben out of position. He was way too far forward and his left leg got stuck behind his saddle. I thought he was done for, but he managed to ride all eight seconds clinging to the right side of that bucking paint horse with a blown stirrup and one leg behind the saddle. Ben walked back to the chutes, eyes wide with adrenaline.

The bulls were run into the chutes, and Tom's name was called out, the first bull rider of the night. He climbed on the bull, adjusted his hand into the suicide grip, tightened down, lowered his chin, and nodded his head. The bull lunged into a bucking frenzy;

Tom was thrown off balance and came flying off, almost landing on the bullfighter. He scrambled out of the arena, and I quickly went to get his helmet. I was almost up.

The helmet, the largest one, didn't fit. My head was too big, and I had way too much hair. I stuffed it as hard as I could, trying to get it on my head before asking one of the other bull riders to hit it on. Bad idea, because that hurt, and it was definitely not going on my head under any circumstances.

I told myself that I was going to ride that bull no matter what. Losing never even crossed my mind as I sat down on its back with full confidence that I could ride a beginner bull. I tightened the rope around my hand, placed my feet against his side, tucked my chin, and got ready to nod my head. The bull lay down. I wasn't expecting the bull to lie down in the chute with me on his back and didn't really know what to do. Someone yelled to nod my head so I did.

The chute swung open, and Gravedigger stood up with me already out of position. Gravedigger did a little spin, a little hop, I flew off, and my face connected right onto the tip of his horn. I ran out of the arena as fast as I could then turned around to see Gravedigger slowly walking out of the arena with a big smile on his face. The horn hit me in the jaw inches from my eyeball, close enough to end my rodeo career.

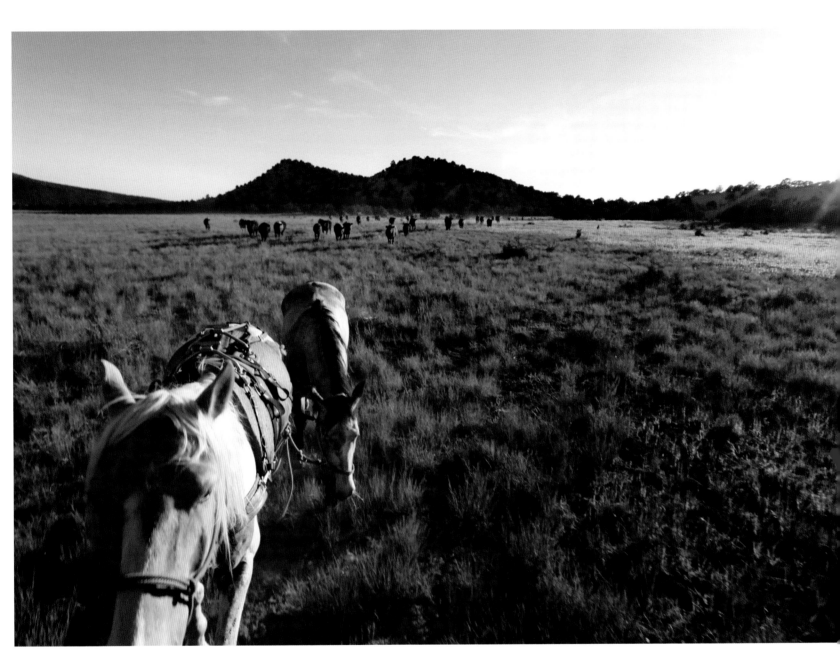

Western Hospitality

We met a cast of characters that even the most creative Hollywood mind couldn't conjure. Eccentric gold miners, homeless drifters, long-distance walkers covered in map tattoos, wealthy land barons, a dog named Sex, Spanish sheepherders, yuppie hikers, hardcore bikers, Big Foot believers, and a one-armed, mushroom-loving culinary artist who blew our taste buds. People from all walks of life helped us out, but ranchers saved us too many times to count. They knew the country and the wildlife, and it was easy to see the love and care they placed on the land that supported them.

In the desert country, their water traps, windmills, and stock tanks offered welcome relief for our horses as well as for the native animals. They gave us directions, transported our horses in times of need, and let us use their pens, pasture, and knowledge. I was impressed by the deep respect ranchers showed the land, even when leased from the government. A strong private-public land partnership remains crucial to conserving the biodiversity of the West while utilizing resources sustainably. We're fortunate in this country to have citizens, government officials, and ranchers who all care deeply about the future of our landscapes.

Horse Care

We learned a lot about horses living with them every day for more than five months. Before then, our knowledge of backcountry horsemanship mainly came from Val Geissler, our families, and working with outfitters, on ranches, and for dude ranch outfits. Other people have different methods, but this is what worked for us. We made a lot of mistakes and tried to learn from them.

When we adopted our horses from the BLM, they were thin and out of shape. We began pouring calories into them immediately. During the trip, we planned our days around maximizing time for the horses to eat. Their nutrition was more important than our own. In Arizona, with lack of graze and Val as our road crew, we fed our horses extensively on grass-alfalfa mix and grained them daily. After Arizona, good overnight grazing campsites were a necessity, and on rest days we supplied a mix of grass hay, alfalfa, and high fat grain. Depending on the graze and logistics, we carried some high fat grain and alfalfa pellets for our horses in the backcountry as well. Luring horses back into camp was much easier with a sack of feed than without. With the exception of one colic incident in Montana, we had no digestive difficulties and found that mustangs can eat just about anything and keep their weight.

Letting our horses eat at night was crucial to keeping weight on them for the long haul. We usually kept two horses picketed or tied up in order to have wrangle horses in the morning. Our picket stake was a 20-inch metal rod with a swiveling top that we hammered into the ground. We attached a 30-foot, three-quarter-inch cotton rope to the swivel and a neoprene hobble to the pastern (ankle) of the picket horse. The picket stake was placed in a meadow where the rope couldn't get tangled up in brush or logs. The best ground to picket a horse is firm dirt: not too muddy, sandy, or rocky.

We had multiple occasions where the picket came out of the ground and the picket horse ran off with a 20-inch metal rod and 30 feet of cotton rope trailing behind him. This can be dangerous for the people trying to catch the horse, the other horses, and especially the picket horse himself. We hobbled all of the other horses because if one horse wasn't hobbled, it would run in front of the pack and keep the rest of the horses moving faster than they would when all the horses were hobbled. We had the best luck putting neoprene hobbles on the cannon bones and using a chain to attach them. This method minimized friction burn on their legs.

The most important factor that kept the horses from running away at night was a good campsite. Horses are a prey animal and feel most comfortable in an open area where they can see all around them. Before the trip started, we used Google Earth to plan our route and identified camping grounds that were topographically flat, near water, and had a large opening or meadow. Rarely did our horses travel far from a good campsite.

Horses tend to run farther away from camp in the daytime than during the night.

A picket stake hammered into the ground, with Luke grazing nearby.

Gathering the horses at first light was crucial because they began to wander as soon as the sky lightened, which meant we had to walk farther to get them. We also put two to four bells on them at night.

Mike Dailey, an experienced Montana hunting guide and farrier, created the perfect horseshoes for our trip. He welded tungsten carbide onto the toe and heel portion of St. Croix Steel EZ shoes. The shoes were preformed for front and hind feet and could be fitted easily in the backcountry without the need of an anvil. The webbing was wide and offered extra protection from stone bruising. The welded tungsten carbide reinforcement was incredibly strong and had sharp points for extra traction in rocks. The shoes performed impressively; one of them lasted for 1,500 miles, from the Mexico border, through Arizona, and all the way to northern Utah. We had no stone bruises or hoof-related injuries, a testament to the durability of both the shoes and the mustangs' hooves.

Professional farriers reshod our horses every six weeks, and we were grateful for the skill and experience of farriers Carly Wells, James Wells, Val Geissler, Burke Smith, Mike Dailey, and Brandon Stubbs. When shoeing, we left lots of the hoof's frog and sole for padding. We tended to use smaller shoes or bend the heel of the shoe centrally so that it wouldn't stick out past the horse's hoof. This helped prevent ropes from getting caught in the horseshoe.

We carried very basic first aid for our horses, much of which we could use on ourselves as well. For wounds, we packed large gauze pads, maxi pads, sheet cotton, vet wrap, Elastikon, duct tape, poultice plasters, newspaper, and sutures. We used Corona cream, chlorhexidine ointment, and Vetericyn spray for healing ointments.

When a horse developed a sore, we tried to give him time off to heal. If the horse had to be saddled, we used Vetericyn spray or chlorhexidine ointment on sores contacting the saddle pad because they didn't create residue buildup in the pad like Corona cream did. The Corona cream kept sores moist and lubricated, though, and worked really well on hobble-related pastern burns. When our horses ran away from us early in the trip, the hobbles rubbed sores on some of their pasterns. Val put bacon grease on the wounds; we looked at him funny, but they healed more quickly than those with conventional ointments.

We carried bute paste, a pain-relieving anti-inflammatory, for lameness or injury to keep the horse as comfortable as possible until we could reach safety. We had injectable Banamine and syringes for colic cases and had to use it on Simmie in Montana when he was showing symptoms of colic. Simmie had a bowel movement and was fine after a few hours. We also carried dexamethasone to combat inflammation, but we never used it.

Keeping weight on our horses and preventing them from getting hurt was a full time job. We were constantly cleaning our 5 Star saddle pads, treating the tiniest of abrasions, and inspecting their bodies for the slightest lameness. I was really proud to cross the Canadian line with horses that were in phenomenal shape, with minimal sores. Many times during the ride, I was thankful for the durability of the mustangs; they are true survivors.

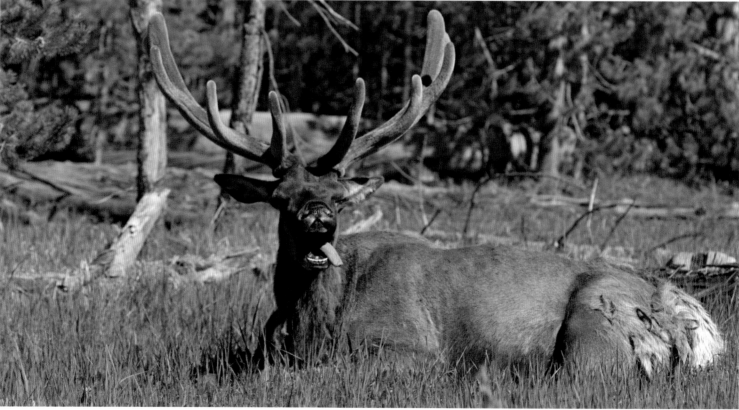

Managing habitat wisely is a responsibility that my generation has inherited from a long list of conservationists who devoted their lives to promoting and maintaining biodiversity through informed land management. Honoring this legacy often requires large sacrifices and unpopular decisions, but no responsibility is more important.

Trout Fishing into a Thunderstorm

Fly-fishing has gotten me into a lot of trouble in my life. Teachers, parents, and girlfriends just don't understand that insect hatches take priority over schoolwork, chores, and anniversaries. Fly-fishing was one of the main reasons I rode a horse from Mexico to Canada, and the river where we camped was one of the best I've ever fished. I'm not going to tell you the name of the river because I don't want you to go there. Nobody was there when we fished it, and I want it to stay that way.

It was a classic trout river. Melted snow from the surrounding white-capped mountains slowly made its way into small streams. The small streams ran into bigger ones, bringing the cold water into a huge meadow half a mile wide, where the streams entered into a lazy river meandering through the wide valley. Beaver ponds were scattered in the meadow, moose made their way through the willows, and cutthroat trout fed on millions of insects skimming the surface of the water. There wasn't a person, campfire, fence, electric line, cabin, or any sign of human life for as far as we could see.

Clouds were building as we quickly stripped the tack off our horses, grabbed our fly rods, and ran to the river. It was about ten yards wide with shallow riffles that took the cold water into deeper pools. Willows protected deep undercuts at the river's bends. That's where the big trout normally

live, deep in the slow pools. But not that day. They were instead in a mad feeding frenzy, bursting through the surface of the water to gorge on the all-you-can-eat buffet of gourmet caddisflies and mayflies.

Fish rose all around me as I stood on the bank looking at my tackle box trying to decide which fly to use, not that it would matter. Keeping it classic, I tied on a size 18 Parachute Adams. I made my way downstream where a small pool fed by an eddy was covered in insects. Trout were splashing at the surface as I got into position. My first cast was sloppy, and I landed my bright orange line right in the middle of the pool. The fly was dangling on a limb sticking out from the bank. I didn't want to recast for fear of getting tangled, and in my moment of indecision the loose line created the tension to slowly pull the fly over the limb. It gracefully landed at the mouth of the pool and was immediately inhaled. I jerked my rod back, but my sloppy cast and loose line didn't set the hook. That fish got away, but the next one didn't.

I couldn't keep my fly in the water without getting bit. It was ridiculous; I caught a fish on my backcast by accident! After releasing a few 12- to 14-inch, vividly colored cutthroats, I relaxed, soaked in the scenery, and studied the water. The building storm clouds had smothered out the sun, lightning crashed to the west, and an occasional raindrop would hit the surface when the breeze picked up. The storm was imminent, and the trout knew it. The fish went into an unprecedented maniacal fervor of gluttony, feasting on the bounty before the storm hit.

A little farther downstream, shallow rapids dumped into a bend of the river containing a ten-foot-deep pool that extended for 30 yards. Trout were bursting through the surface, but I didn't cast. The top of the storm was blue-gray, but would ignite in a flash of colors caused by the lightning. The bottom of the storm was a deep blood red as the evening sunlight tried to penetrate the wall of rain headed my direction. The surface of the water looked like it was on fire. Reflected lightning danced in the rapids and seemed to energize the river.

A gigantic trout swirled at the end of the pool. Its dorsal fin sliced through the smooth surface as the monster from the deep came to feed on the feast above. He was huge; his white mouth gulped one fly after the next as he meandered through his pool, his kingdom. He disappeared for a moment, and then he rolled out of the water showing me his entire body. The bloodred cutthroat shone in the fiery light as I stripped line out of my reel and landed the fly in the direction he was heading. It was a good cast with a gentle landing. The fly floated for a lazy moment. The mighty dorsal fin appeared, disappeared, and I was about to recast when the behemoth slowly came to the surface and gently closed his huge white mouth around my fly.

I set the hook. It felt like a log. Then it started to move; the trout realized he was hooked and with a mighty surge took off downriver. Line spun off my reel as I fought to regain control. My drag wasn't set for a fish this big, and I couldn't keep tension on the line. Reeling frantically, I ran after the monster fish, trying to catch him before he became snagged in a tree or rapids. The sprinkle turned to rain, and lightning bolts lit up the sky. He turned upstream, and I knew I had him. Slowly, the monster trout began to tire as I fought him, using the upriver current. His runs became shorter as I walked into the river to land the beast. As I lifted the rod high, the monstrous fish

came to the surface and slowly floated my way.

I held the line with my left hand as I slipped my right hand under his tremendous body. The slightest touch of my fingers on his belly gave the trout a new life, and he sprung out of my grip too fast to let the line loose. SNAP! He was gone, the biggest cutthroat I'd ever seen.

The sprinkle that had turned to rain was now a downpour. But I couldn't stop. Insects were no longer flying, but they still floated lazily on the raindrop-dappled surface of the water. I caught a few small fish, and the sky turned green. Hail began to fall, jarring me to my senses. I was in the middle of a meadow holding a lightning rod during an electrical storm getting pounded by hailstones that kept getting bigger.

I ran back to camp to find everything soaked, horses gone, gear in disarray, and our tent straddling a small stream. It was too much to handle, so I sat under a big pine, drank whiskey, ate Copenhagen for dinner, and watched the thunderstorm roll by. I was glad that trout got away.

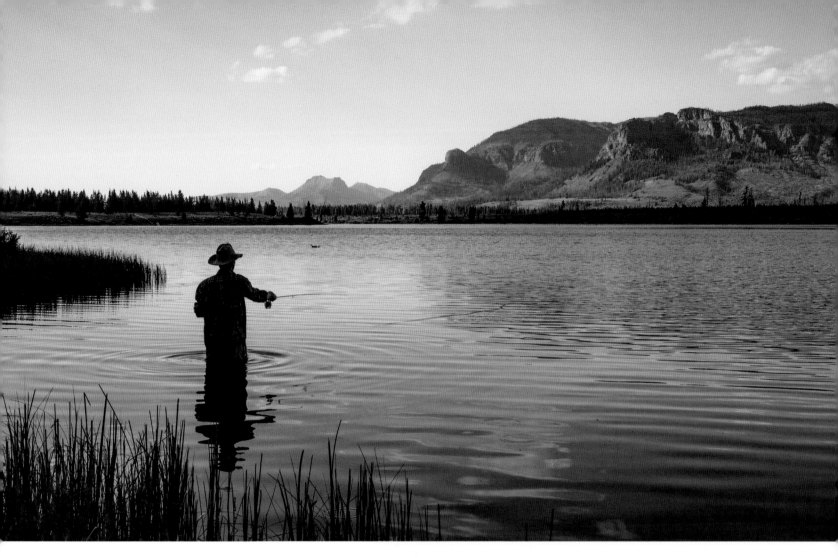

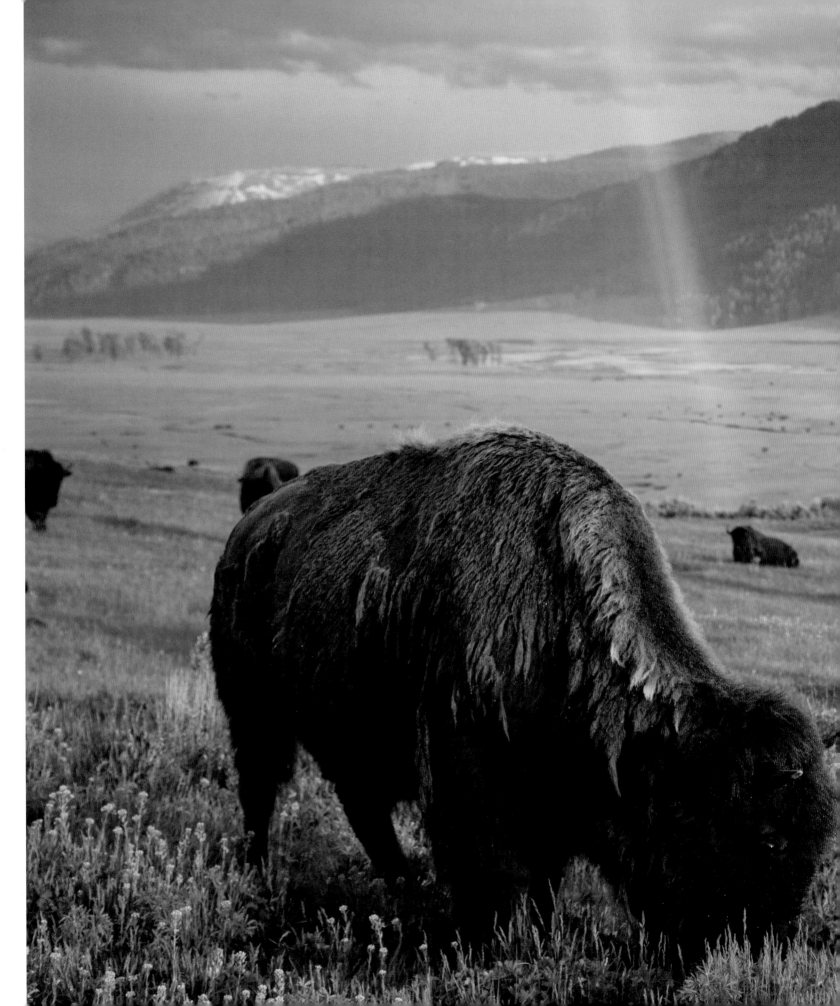

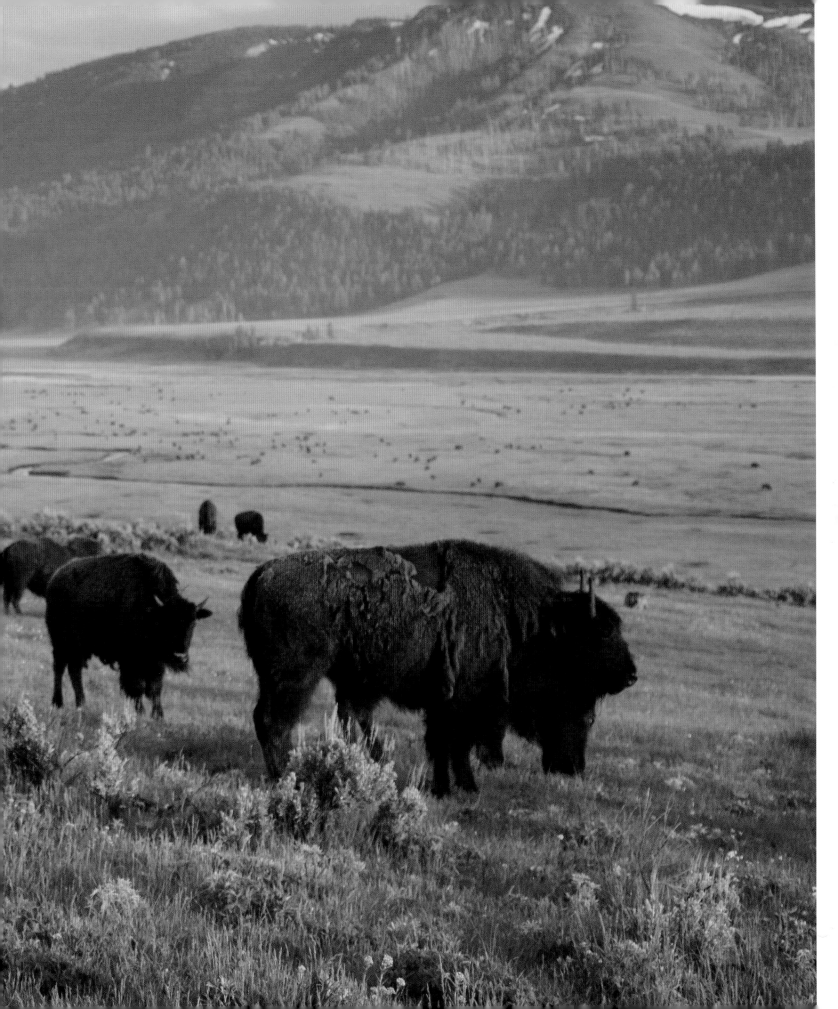

MONTANA

July 26–September 6, 2013

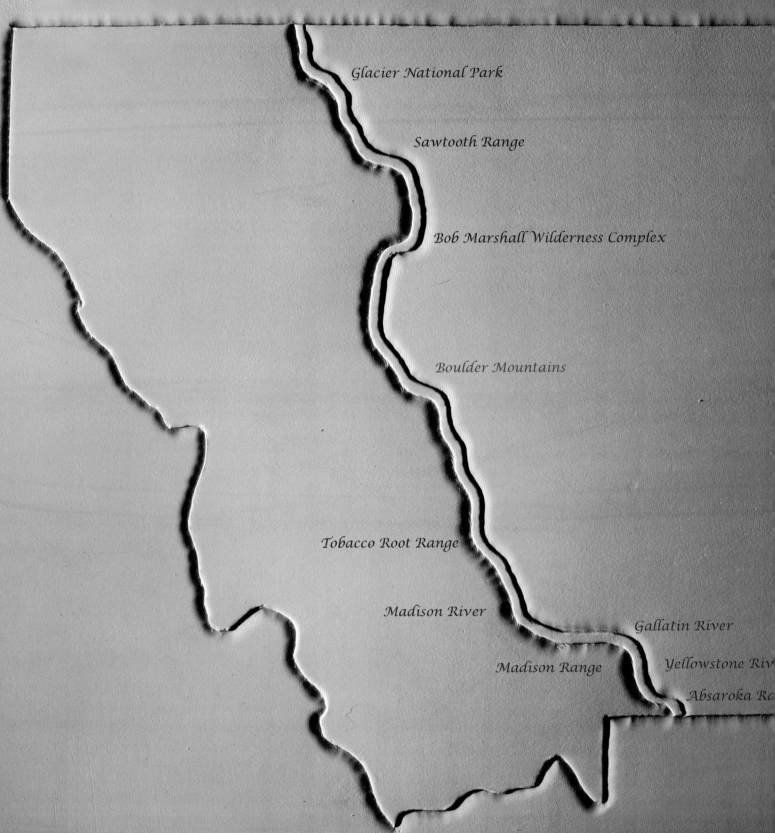

MONTANA

Glacier National Park

Sawtooth Range

Bob Marshall Wilderness Complex

Boulder Mountains

Tobacco Root Range

Madison River

Gallatin River

Madison Range

Yellowstone Riv

Absaroka Ra

The Trail: 800 Miles

Montana, our last state. Eight hundred miles of towering pines, sheer cliffs, raging rivers, wide valleys, rolling hills, and a big sky. Montana greeted us with a three-day rainstorm as we traveled through the Slough Creek, Buffalo, and Hellroaring drainages of the Absaroka-Beartooth Wilderness. The rain turned to hail and sleet as we gained in elevation and rode the crest of the Absarokas north before dropping off to the west toward the Yellowstone River in the appropriately named Paradise Valley. Mountain Sky Guest Ranch, where I worked for two summers during college, provided pasture for our horses, and we took some footage with a remote control helicopter on their stunning property.

We rested the horses for five days at Mountain Sky. During that time, I went to Bozeman to see all of the film footage of the trip thus far. I had a very odd feeling watching behind the scenes the life I was currently living. I couldn't believe how dirty I was. We headed west from Mountain Sky and crossed over the Gallatin Range to the Gallatin River. The Gallatin is a boulder-strewn river at the bottom of a steep canyon that runs next to one of Montana's most dangerous curving two-lane highways. After some close calls with vehicles along the highway, we were forced into the river with its many rapids, large boulders, deep pools, and log jams. It took us hours to travel the mile and a half to where we were able to get out of the Gallatin. We headed west into the Madison Range and the Lee Metcalf Wilderness.

Soaring peaks, shale passes, and alpine lakes welcomed us as we went west through the Madison Range's Spanish Peak area then dropped in elevation into the Ennis Valley. We crossed the Madison River at Ennis Dam and went west into the Tobacco Root Range. The infamous Pony Bar in Pony, Montana, beckoned to us, which created a small diversion and a rather late morning start the next day. From Pony we stuck to the valley bottoms, farm roads, and small highways as we made our way north through the Whitetail Valley into the Boulder Mountains.

We headed north on logging roads through the beautiful rolling Boulder Mountains until we met back up with the Continental Divide Trail. We took the CDT north to the town of Lincoln and stayed at the Lumberjack Inn for three days to rest our horses. We then headed northwest out of Lincoln to the Bob Marshall Wilderness Complex, a roadless two and a half million acres famous for its abundant grizzly bears. Smoke from forest fires, which got worse with each passing day, turned the sun into a pale orange ball.

We entered "the Bob" at Arrastra Creek and crossed over a pass into the East Fork of the North Fork of the Blackfoot River. We traveled through the Danaher drainage and followed the creek before turning east toward Benchmark trailhead. From Benchmark, we rode north along the South Fork of the Sun River to Gibson Reservoir. Forest fires and a lame horse forced us to reconsider our route, and we turned east toward the Sawtooths, a much rockier, steeper, and less flammable mountain range. The travel was slower through the Sawtooths, but the rugged scenery was captivating and devoid of humans.

The North Fork of the Teton River took us north, over a few passes, and into the Two

Medicine River drainage. There we turned northwest and followed the Two Medicine to Glacier National Park. The town of East Glacier offered a much needed rest after the ordeal of the Bob as we prepared for the last leg of our journey, Glacier National Park.

From the town of East Glacier we went northwest into the mountains to the aptly named Scenic Point. Mountain ranges shown for hundreds of miles in the distance as we dropped in elevation, past Two Medicine Lake, and up the Dry Fork. Glacial lakes, too blue to describe, lay thousands of feet below us as we crossed over Pitamakan and Triple Divide Passes into Red Eagle Creek. Bugling bull elk and charging bull moose were our companions to Saint Mary Lake.

We traveled north from Saint Mary Lake, over Piegan Pass, and into the bighorn sheep and mountain goat cliffs along Cataract Creek. Lake Josephine and Swiftcurrent Lake made for a postcard quality landscape as we stayed north up Wilbur Creek to the Ptarmigan Tunnel. After 2,990 miles of travel we had no problem getting our horses through Ptarmigan Tunnel, and the view from the north side was of Canada. Seeing the finish line gave us a beautiful feeling, and a sense of accomplishment swept through the team.

We spent our last night at Elizabeth Lake, took our time on the final morning, and savored the last of our mud coffee. The horses felt the excitement of the last day and stepped with a new energy toward Canada. The lovely rolling hills along the Belly River delivered quick travel to the turnoff trail to the Canadian border at Chief Mountain Trailhead. The turnoff trail was a brisk two-mile uphill climb to our long-awaited goal. One mile from the border, Jonny stopped and told us he didn't want to finish with the team; he wanted to leave a mile for luck.

Stunned, and with sad hearts, we left our compadre of more than five months and 2,999 miles. Ben Thamer, Thomas Glover, and I completed the ride to the Canadian line. We had shared joys, pains, triumphs, failures, blood, sweat, tears, spoons, tents, horses, laughs, and love with Jonny. We crossed the finish line, but not as a team.

Seeing the Production

Cameramen Phill Baribeau and Korey Kaczmarek had no horse experience before the trip. This turned out to be for the best because if they had known what they were getting into, they probably wouldn't have signed up. Not only did they learn to ride for 20 miles a day, they also ran ahead on foot to get shots, stayed behind to get shots, and always had cameras ready to roll when disasters occurred. They managed the audio, conducted interviews, and dealt with the unending problems of having way too much technology way too far from a power source.

A wallet-size transmitter with a wire antenna lived in my pocket. The cord was taped under my shirt, with the microphone located under my chin. It was a pain to take on and off, so I just wore it everywhere. I even slept mic'd up.

Every day started with new batteries and an audio test. "Good morning, Ben. Put this battery into your transmitter. Talk to me. Say it again. Sing. Okay, keep talking while I adjust the levels. All right fine, you can finish brushing your teeth." At least the batteries lasted all day.

We kept the sound receivers on Luke, whose saddlebag was specially designed for audio gear. The cameraman had only to flip

the switch to receive audio from all four of us. It worked well, except for sound designer Will Springstead who had to listen to the hundreds of hours of audio that had no corresponding footage after the trip.

Princess was the main camera, the Canon C500, which stayed in a case on top of one of Luke's hard panniers. The tripod and slider went on the other side to balance the load. When a cameraman wanted a shot we would stop, and he would take out Princess and the tripod, run ahead on foot, get the shot of us coming to them, get a shot of us riding by, get a shot of a flower, get a shot of us in the distance, crossing a ridge, going over a bridge, through a stream—sometimes it all became really annoying, and we would have to decline the cameraman's request in order to make the day's distance.

When the cameramen weren't around, we had an easy-to-use Panasonic HPX250 camera that we kept on automatic. When things went bad fast, we would just grab it and start shooting. The only time we ever used it was during disasters, so we dubbed it the Panic. Some of the best footage was captured with the Panic.

For three months, the four of us had been mic'd up, living with cameramen and hearing rumors from the production team of how good the footage was. Every ten days or so, the cameramen had been rotating out, taking back batteries and film cards to the studio in Bozeman and returning with fresh ones. We, of course, were living in the woods and couldn't watch any of it. Having someone document your daily life but having no idea what all they were getting was really strange. Much of the time, we didn't know when they were shooting, and there was no way to tell when they were recording audio since they had control of the switch. Real-

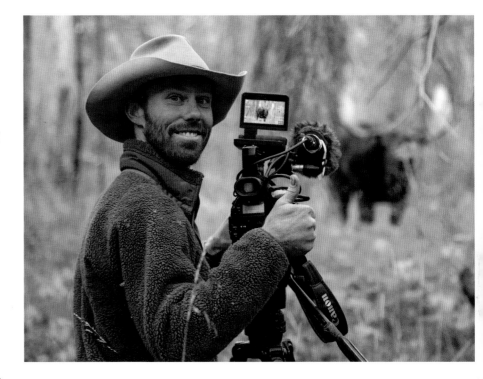

izing that hundreds of hours of my speech could be reconfigured in an editing room to sound like I had just about said anything was a little unnerving.

At the beginning of the trip, Phill kept telling us to let our guards down and act natural. A month later, when we got used to the camera and turned off all self-censors, Phill asked us to start watching what we said. Mountain talk by 24-year-olds sometimes wasn't suited for a PG audience.

The great mystery of what they had been shooting was solved when we got to Montana. Our horses needed a break after traveling through the Teton Wilderness, Yellowstone, and the Absaroka-Beartooths, so we left them at Mountain Sky Guest Ranch near Emigrant, Montana, and I went to Bozeman to see the film production.

The Fin & Fur Films, LLC office was located on Main Street in downtown Bozeman. I was looking at the sign when a man

I'd never seen before walked up to me and started a conversation like we were old friends. He obviously knew me well, but as my blank stare continued, he finally introduced himself as Scott Chestnut, the main editor for the film. He apologized; we had never met in person but he had been watching footage of me for weeks.

After being on the trail, walking into the office was surreal. Pictures of me hung from the walls, and a big whiteboard was covered with intricate lists of all the storylines and objectives for upcoming shoots. Assistant editors Paul Quigley, Katie Roberts, and Vanessa Naive had a lot of fun showing me footage of myself picking my nose and falling off my horse. I looked like the goofy character Ben Masters who falls down all the time, just like in real life.

I knew the production team was good at what they do, but I didn't fully appreciate how talented they were until I sat down and began watching the footage. I realized then how fortunate I was to have found Phill Baribeau in the early stages of *Unbranded*. Phill brought aboard veteran filmmaker and producer Dennis Aig, director of the film and photography school at Montana State University, and all their work, planning, and determination were paying off. I left the office with fresh inspiration and renewed confidence that we were making an awesome movie.

Fly-Fishing Horseback

It was my birthday, August 8, and we rode through some spectacular mountain passes in the shadows of soaring peaks before breaking camp near a glassy high-country lake in southern Montana. Ripples from rising trout scattered across the lake and fish

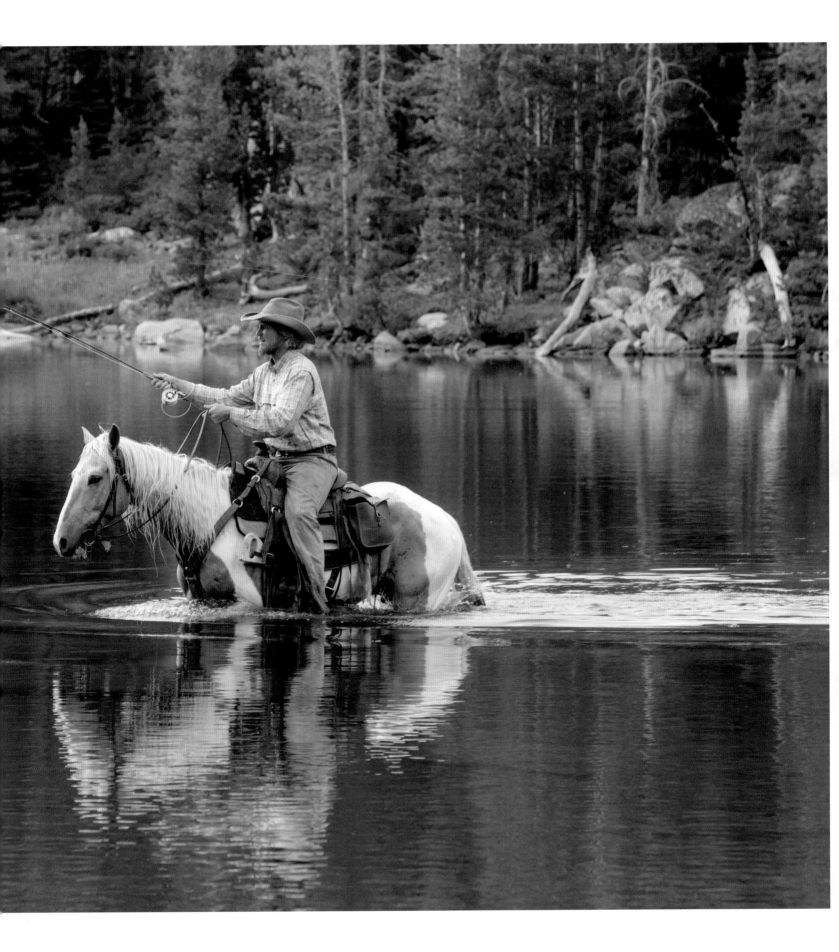

literally jumped out of the water to feast on the all-trout-can-eat buffet of various small insects skimming the surface. We grabbed our fly rods after breaking camp and raced to the lake's edge to take advantage of the feeding frenzy.

Trout tend to rise five feet farther than one can cast. This phenomenon occurs whether you cast 30 feet or 100 feet. The fishing is always better just beyond your reach, which can become very frustrating. Frustration is the fly fisher's enemy. Frustration leads to casting harder, which leads to sloppy rhythm, which eventually culminates in a messy knot usually involving a tree, rock, or bystander. Naturally, the fish were just out of my casting range, I was getting frustrated, and I got tied up in a tree.

As I finished retying my knot, I noticed Luke, the cameraman horse, watching my antics as trout were rising all over the lake. I can't prove this, but I swear that horse was getting amused watching my blunders. Five minutes later, I had Luke saddled up and was pointing him into the lake, fly rod between my teeth.

After a minute of coaxing, Luke cautiously stepped into the lake toward the rising trout. Ten feet from shore he whinnied to the herd, got a reply, and tried to head back

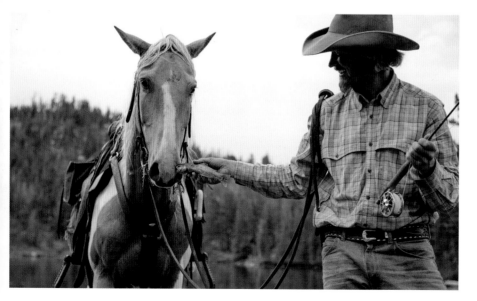

to join his buddies. I talked to him calmly, but he didn't care, he wanted to be with his friends. Fly-fishing off a horse probably wasn't a good idea anyway, so I turned Luke back to shore. He wanted to be back on dry land pretty bad, and as he lunged forward toward the herd, he lost his footing and fell face first into the lake. His entire head was completely submerged, and we went deep enough to get the top of my saddle horn wet.

Luke must have seen a trout when he was underwater because when he surfaced he was a fishing machine. No longer did he care about joining his friends; he had his full attention on me as I redirected him out to where the trout were still biting on the surface. Once Luke was belly deep into the lake, about 30 feet from shore, I stopped him and began stripping line off my reel to make the cast. A trout rose to the surface within casting distance, and I landed a Parachute Adams fly right in the center ripple the trout had made just seconds before.

I watched the trout come to the top, look intently at the fly, and with a quick flash dart to the surface inhaling my fly. I lifted the rod, set the hook, and began bringing the fish in. Luke watched curiously as the fish came closer. His ears zeroed in on the fish making z's in front of his face, and I'm sure his eyes crossed as I lifted the fish out of the water, over his head, and into my hands.

I tried to unhook the trout and slip it into my saddlebag so I could cook it for dinner, but I was laughing so hard the fish slipped through my fingers and back into the lake. The whole time Luke didn't move an inch.

We cruised the shoreline, belly deep and 30 feet from land, for the next half hour. Luke and I didn't catch another fish, but that didn't matter. We had achieved a long-time goal of mine, pairing two of my biggest loves in life. Fly-fishing off a horse. What a birthday!

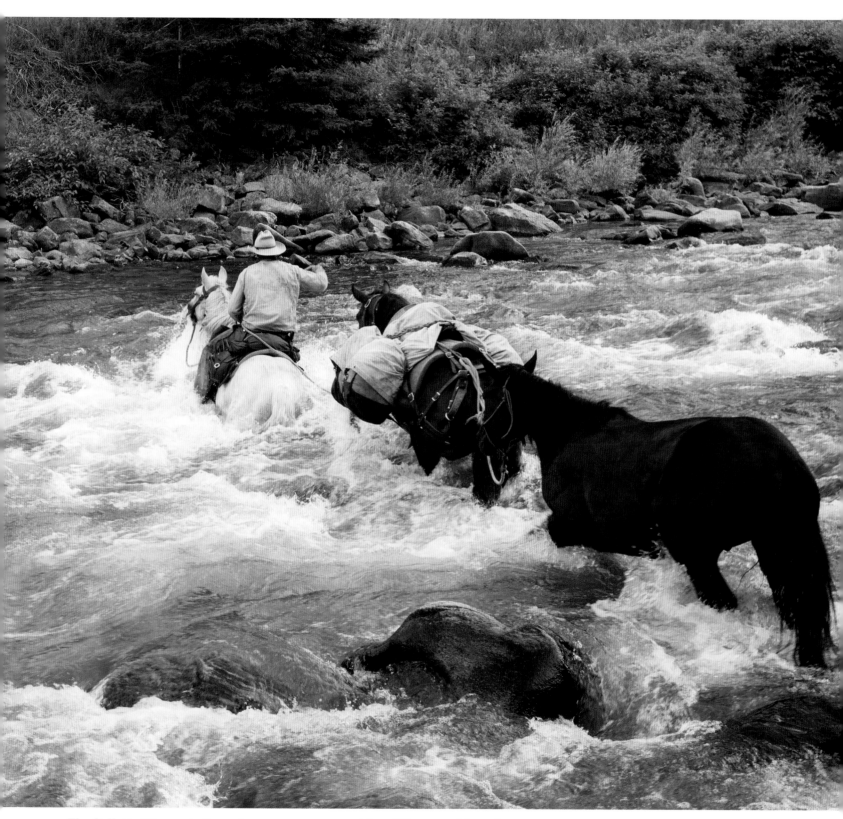

The Gallatin River cuts through a narrow canyon with a cliff on one side and a dangerous highway on the other. We had no choice but to ride upriver.

Switchbacks

Burned Out of the Bob

The sun was a little orange circle barely visible through all the smoke. The grass that was green a month ago was now brown and brittle from the hot summer. Streams were low, and the forecast called for high winds, lightning, and little chance of rain. Fire season was upon us, and we were getting ready to go through the Bob Marshall Wilderness Complex, a two-and-a-half-million-acre roadless area straddling the Continental Divide. The Bob was our last major expanse of wilderness, and once we were through it, only a hundred miles lay between us and Canada.

We rested our horses for three days at the south side of the Bob in Lincoln, Montana, to look at maps, talk to rangers, and create a safe route with exit strategies in case fires began to grow. Four fires were burning in the Bob, the biggest was 15,000 acres, but they could all spread under the right conditions, and they could spread fast. The Bob's mountain ranges run north to south, and massive cliffs, such as the Chinese Wall, create natural firebreaks that a fire is unlikely to jump. With the help of rangers and current fire reports, I mapped what I thought was the safest possible route through the Bob. I took into account where the natural firebreaks existed, whether a fire would have to travel downhill to reach us, the prevailing wind direction, distances to trailheads, exit routes, and our horses' condition.

One part of our route worried me, Switchback Pass. Switchback Pass was only one mile to the east of where the Red Shale fire was burning with no natural firebreak in between. The forecast called for west winds, but if for some freak reason the fire did move east, we would be blocked from going over the pass and forced to backtrack and reroute to the east, through the notoriously rocky Sawtooth Range. With the route decided and a satellite phone to keep us updated, we headed north into the Bob.

The first half of the Bob was beautiful in a smoky, ominous way. We saw almost no wildlife except one lone gray wolf running along North Fork of the Blackfoot River. He ran away as soon as he saw us, but it was odd to see a single wolf traveling in the heat of a hot, windy afternoon. We caught trout from low streams and checked the fire report regularly with the satellite phone. The fires were growing, but not quickly.

Halfway through the Bob, we met up with Joseph Fitzsimons, Jonny's father, and his friend, Jamie, at the Benchmark Trailhead. They brought Jonny's horse, Tamale, who went lame in Arizona, so that Jonny could finish the trip with his original horses. Since Tamale's injury was almost three months old and he had gone through rehabilitative exercises, we hoped he would do well. However, having a horse that was recovering from an injury while in a huge expanse of wilderness that was prime to ignite didn't comfort me. We would need to be extra diligent and take into account yet another factor.

After checking fire conditions, we headed north from the Benchmark Trailhead back into the Bob. Less than an hour later, we ran into a pack string of tired horses and tired men. They had been over Switchback Pass and said the fires were closing in and the smoke was unbearable. The US Forest Service was considering closing the trail, and they strongly advised not to attempt it.

So we rerouted to the east, through the rocky Sawtooth Range where graze was limited. This increased our distance by 30 extremely rocky miles with limited graze, but I prefer rocks to flames.

We headed toward the Sawtooths via the Sun River, and the wind whipped into a rage. We passed through a massive forest that had burned a few years previously, and the standing skeletons of the dead pines came crashing down against the torrential winds. Smoke smothered the sunlight and cast the landscape into an unearthly orange glow.

We broke camp near Gibson Reservoir, where the South Fork and the North Fork of the Sun River converge. The next morning, Tamale's leg was slightly inflamed, and I thanked God that we ran into those packers who gave us a firsthand fire report. Attempting that pass would have put us in the center of the Bob, 30 tough miles from a trailhead, surrounded by fires, with a potentially lame horse. Strong west winds pushed us east along the Sun River before we turned north into the rocky Sawtooths. Tamale's leg loosened up with movement, and he kept up without a problem.

Our route through the Sawtooths was easier than expected. The forest service has done a tremendous job creating safe horse trails through the boulder-filled cliffs. We were able to meet up with my little brother and give him Tamale before he became seriously lame. Looking back, the smart thing to do would have been to wait out the fires or bypass the Bob to the east altogether, along the highway. There is no escaping a raging forest fire when conditions flare. We had flirted with disaster but came out relatively unscathed. The last 50 miles of trail through the Bob met us with much-needed rain showers and cooler weather. We exited the Bob and entered Glacier National Park with smoke-free skies, a dusting of snow on the peaks, and only a week's ride to the Canadian border.

Glacier

Glacier National Park, the crown of the continent, one million acres of sheer cliffs, unworldly lakes, abundant wildlife, and unimaginable views that genuinely seem as if they don't belong on this planet. Glacier, a word we had reverently spoken for five months, the last obstacle, a landscape more extreme than any other we'd traveled through. We were finally there. One week to go. One hundred miles to the Canadian border. I could feel it on a north breeze.

We entered Glacier on the Continental Divide Trail and took it into the town of East Glacier, where we met some Texan wooden spoon makers, Charley, Amber, and Jo. Our appetite was ravenous after a rough trip through the Bob, and they smoked briskets and ribs and threw us a party we didn't deserve but weren't about to decline! Texas barbecue made us homesick, but when we left the next morning, we were only five days from the finish line.

The Continental Divide Trail leaving East Glacier goes up to the well-named Scenic Point and the most remarkable and vivid view that I saw in Montana. To the south, we could see the serrated Sawtooth Range stretching into the distance. To the west were massive stone cliffs with scraggly pines interspersed on the walls and rivulets of water shimmering on the rock faces. To the east, beyond the forests of yellow-tinged quaking aspens, lay an uninterrupted expanse of grass as far as the eye could see. Ahead of us, to the north, jagged mountains with glaciers carved into the rock rose above a pine-clad valley containing two massive crystal-clear lakes reflecting the peaks above.

For the next couple of days, we crested one glacier-studded pass after the next. The

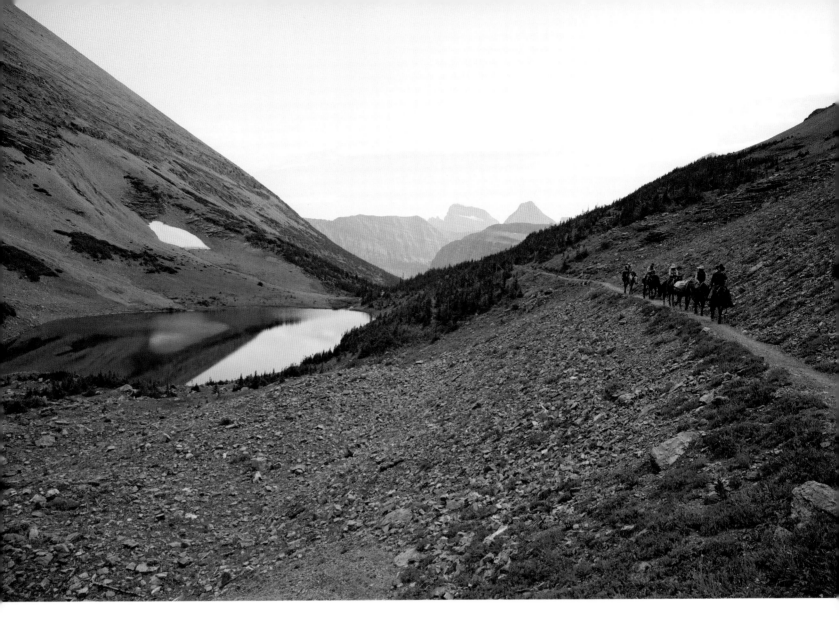

views became grander as we made our way deep into Glacier's remote mountains. Mountain goats clung to the vertical cliffs above us, elk bugled in the pines, grizzlies watched us from a safe distance, and bald eagles soared the heights above us. This magical place couldn't get any better until it did.

Red Eagle Lake is a typical Glacier lake, except the drainage around it had burned six years before. The skeletons of massive scorched firs, pines, and spruce stood sentinel above tangled fallen trees. Young aspens rose above the plethora of flowers and brush the open canopy nurtured. Stands of green timber still stood where the fire missed a spot. It was the perfect habitat that nature intended, and animals were everywhere. By the time we unloaded our horses, a young bull moose had made his way into Red Eagle Lake where he grazed underwater plants above a bright red surface reflecting the sunset above. The tranquil sight drew me closer; the moose didn't mind. He lazily grazed as I approached the shore of the lake, 50 yards from where he fed. I snapped a few pictures but put the camera down when I looked at the results. Some things are better in the moment than a lifetime of staring at a picture would be.

I swirled when a branch snapped behind me to find a cow and a calf moose 20 yards from where I sat. They saw me but continued to feed in the lake. They dunked their entire heads into the water; they looked comical feeding on vegetation three feet long that they slurped up like pasta. They fed with their mouths moving in a side-to-side manner, not up and down, and I got really tickled watching them watching me while their mouths made a ridiculous motion as they munched on the underwater moose version of spaghetti. Stars were easily visible before

I left the lake and went back to camp for the night.

I woke up to elk bugles. My favorite sound coming from my favorite animal. They were bugling to daybreak, and they were close. I threw my clothes on as fast as I could, grabbed a camera, and went after them. The grass and vegetation were heavy with dew, and I was soaked by the time I made it out of the creek bottom and onto a burned hillside. Two bulls were bugling back and forth to each other, with the chirps and mews of dozens of cows in the background.

It was a big herd, and by the sound of it, the bulls were bugling to attract the attention of the ladies. As I slipped closer and closer, I stumbled onto a young satellite bull on the fringes of the elk herd. He looked at me like a curious dog for a few minutes before slipping back into the trees.

The elk were still bugling back and forth, a couple hundred yards apart, and I crept through the forest after them. All of a sudden, I was right in between them but couldn't see either because of the thick undergrowth. Standing on a log, I saw the tips of a massive rack moving through the jack pines. He bugled, and the other bull

bugled behind me. He bugled back then started destroying the nearest small pine with his massive headgear. I had walked into a territorial display of two old bulls trying to resolve the matter with words, but both elk knew it would come to blows.

The intensity of the bugles grew. No longer were they long high notes; they were low, raspy, guttural sounds with hate in them. I still hadn't seen the bull elk behind me, but I knew he was close. A moment of silence, then the forest shook with a challenging roar; the other bull responded and started coming in. He came into view a hundred yards away, moving at a trot. He held his

head high and swiveled it back and forth to fit his massive six-point rack through the dense pines. He was coming right toward me. I hid in the bushes and got my camera ready.

The huge elk roared and bugled as he came in, and I heard the bull behind me take off running. He ran down a game path into a ravine 20 yards below me and was out of sight. I held my breath, not knowing where he was or what to do. With a crashing of branches the massive bull burst into a clearing ten yards from me with bristled fur and bloodshot eyes then let out a bugle that reverberated through my body. The wind changed, he caught a whiff of me (poor guy), and whirled back into the forest. The woods were silent as if nothing had ever taken place. I sat on a log for a long moment before walking to camp.

Back at camp, Tom said Phill was off chasing a moose, and I grabbed my camera to go find him. After a half-mile walk, I found two young bull moose grazing lazily on waist-high vegetation in the burned area. No

Phill, so after taking a few pictures I headed back. On the way, I heard a low grumble in the trees to my left. I hopped on a log to get a better view and saw a massive bull moose 70 yards away comically ambling side to side toward Phill, who naturally was lost in his camera. I walked towards Phill as the big bull moose slowly got closer and closer. He was puffing up his chest and making a low grumbling sound in a testosterone-filled display similar to the elks' an hour before. Phill and I looked at each other, both thinking to ourselves that we should get the hell out of there. Then we looked at the camera monitor. We were getting really good footage. We looked back at each other at the same time the moose charged.

Phill split left and I ran right, leaving Princess the camera in the path of the moose. Luckily, the mighty moose veered from the path before destroying our $30,000 camera and grunted in disappointment. We climbed a ridge to get a better view, out of the moose's way, and watched him join his friend, yet another moose! The new moose was a huge old bull with bloody fresh velvet dangling from his antlers. We watched them feed on the abundant fresh growth of the recently burned area for an hour before heading back to camp.

By the time we finished packing our horses, the moose had made their way out of the forest and into the lake, feeding on underwater vegetation while we watched from shore. After an hour they moseyed their way out of the water where, once again, Phill was in the way of the moose and almost got Princess killed.

Two days later we passed through Ptarmigan Tunnel, hewn through a rock face. On the other side lay our first view of Canada. Below us, the Belly River drainage made its

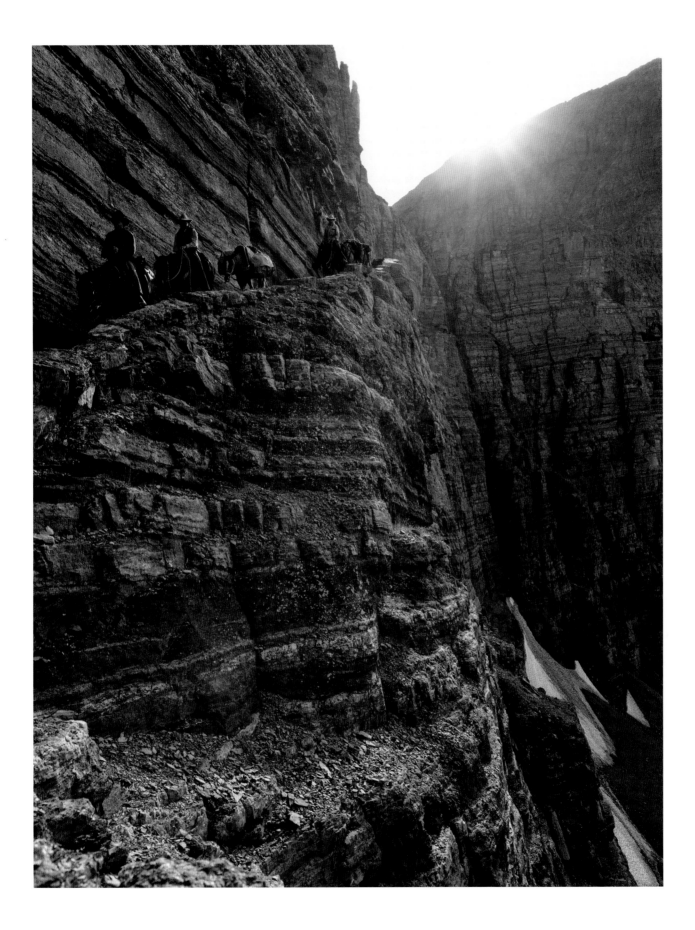

way north out of the United States. Although we knew the border was there, the landscape didn't. Nature doesn't abide by political boundaries.

That night we slept in our filthy sleeping bags for the last time before waking up to our last cup of mud coffee. Only ten miles lay between the border and us, but I wasn't in a hurry to leave the life of a drifting packer behind. I cherished that last morning, but when we did pack up to go, the horses sensed the building energy and set off at a strong pace. Ten miles blurred by as I thought about our lifestyle that was about to change forever. In a way it was time. Our horses needed rest, we needed rest, winter was coming, and we had responsibilities. Still, I was sad to leave a world of camaraderie and closeness to nature that few others could appreciate.

It was a perfect early autumn day, with the sun shining through mixed clouds. As we got closer to the border, the feeling of elation grew. Two miles out I couldn't keep a stupid grin off my face. One mile out I had butterflies in my stomach and a natural adrenaline high. The horses felt the excitement and stepped with a renewed vigor, the same liveliness as when we left the Arizona border, over five months ago.

Less than a mile from the border, Jonny asked us all to stop. He had something to say.

The Last Mile

by Jonny Fitzsimons

"Fellas, this is where I stop. I am going to leave the last mile undone." Tom, Masters, and Thamer stared at me with blank looks of disbelief. "I don't expect y'all to understand right now, but this is what I need to do."

During the month of August, we had traveled across the state of Montana. The end was drawing near, and we could taste the finish line. As the days passed, and we got closer to Canada, my mind grew uneasy. *Why?* When we left the Mexican border, I had been bursting with excitement. Now after 3,000 miles and five months, I felt nothing.

With every mile, I tried to diagnose my uneasiness. Conversation had ceased a thousand miles behind us, and we were left with our thoughts. I reflected on our group and personal goals. Crew safety had been our number one priority, and it had been achieved. Make it to Canada; that was now within our grasp.

Then there were the horses. Through months of training and travel, I had developed a strong bond with my string of mustangs. As much as I wanted to get to Canada, I wanted them to get there as well. In Arizona, Tamale strained a suspensory ligament and had to be sent back with Val. Had I pushed him too hard? Had I neglected some rudimentary tenet of horse care? In Wyoming, Cricket had inexplicably fallen over dead. What had I missed?

But horses get hurt and they die. I knew what to expect when I signed on for this trip. There must be something else, something else that was causing this nagging feeling. Had it been too easy? Although this seemed a ridiculous thought for someone to be having at the conclusion of a 3,000-mile journey, I pondered it. We had been faced with plenty of hard-ships along the way, but had it been enough?

As we traveled through Montana, we had never been more than a couple of hours drive from our film crew's headquarters in Bozeman. Had this been too much of a safety net? Approaching the end, had we not allowed ourselves enough room for failure?

Or was I just not ready for the trip to end?

As the finish line loomed, I thought about all the people who would undoubtedly approach us and say, "Wow, Mexico to Canada, what an adventure." But that had never been my motivation for making the trip, being able to say I rode across the country. Obviously, I had done it for the experience, but more importantly I did it for the lessons learned from the experience.

I thought about my past adventures, working in Argentina and chasing poachers in Tanzania. Those had been learning experiences as well, but somehow through the years, the telling and retelling of those experiences had glossed over whatever lessons I had learned from them. I had returned to my normal life seeming to have learned nothing, still to repeat the same mistakes.

What does it take to truly learn from one's experiences—a daily reminder?

When I turned my horse around and left my buddies one mile from the border, I felt more alive than ever. Anyone could ride the last mile of a 3,000-mile trip; for me, resisting that temptation was the final challenge. After all we had been through, it was this personal, mental challenge that truly defined my journey. Since the end of the trip, there is not a day I do not think about that last mile. I still do not fully understand why I stopped. But I will always have that last mile to remind me of the lessons I learned, a daily challenge not to repeat my mistakes because the adventure lives on.

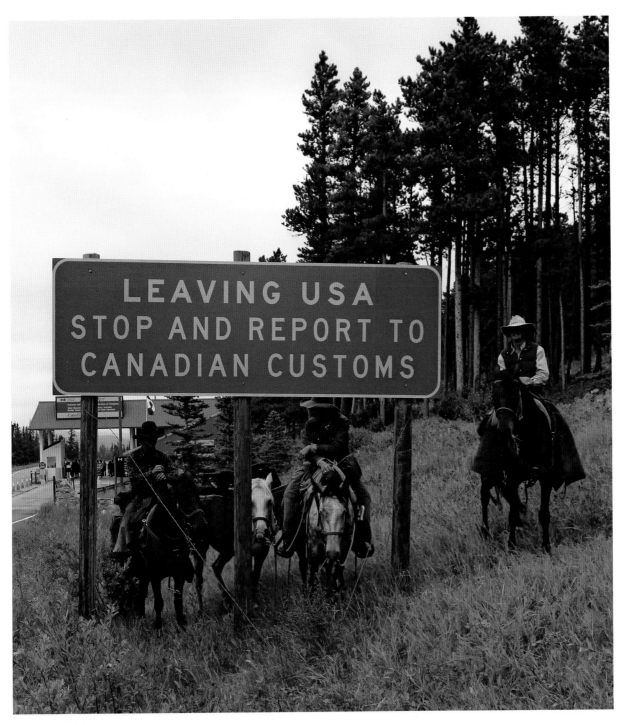

Finish Line

After 2,999 miles of joys, pains, and companionship, Jonny left us one mile from the finish line. The long-anticipated celebration at the Canadian border was transformed into a blur of confusion and sadness. Although his reasons weren't malicious, he gave no explanation at the time, which left us stunned and hurt at the end.

REFLECTIONS

Auctioning Luke

Luke was my go-to cameraman horse. He is a gorgeous palomino paint that Val Geissler rescued and brought to Texas when he heard I needed a dependable horse to carry both the cameraman and the gear. He has a brisk walk, sure feet, and is totally harmless. You can pull on his tail, ride him bareback, and even fly-fish off him. His one vice is that he's hard to catch when he's excited, but a little snack of feed cures that. You can't help but love Luke, and I certainly fell for him. He is just a really good horse with a big personality.

During the ride, I tried to think of ways to help out the nation's wild mustangs. Yes, adoption is good, raising awareness is great, but I didn't have any money and money is what adoption organizations really need. I decided to auction Luke off to raise money for mustang adoptions. It was what I could do, even though I knew it would be painful to see him go.

The Mustang Heritage Foundation (MHF) had been a tremendous supporter of *Unbranded* since day one. Their Trainer Incentive Program gave us professional trainers to work with and made it easy to find the right horses, and they gave us invaluable support during our Kickstarter campaign. It is an important organization whose sole focus is getting more mustangs adopted. I proposed my idea to Patti Colbert, the president of MHF at the time, and she was shocked that I would just give Luke to them. I explained that the foundation helped me tremendously and donating a horse for auction was the only way I could think of to give back. We decided to auction Luke off at the Extreme Mustang Makeover competition in Fort Worth on September 22, 2013, a few weeks after our trip ended.

After we made it to the Canadian border, Phill made a two-minute video to promote Luke and publicize the auction. The video immediately spread over the Internet. People from everywhere wanted a piece of Luke, and folks who normally wouldn't show up at a mustang event took interest. I bet Phill he would go for $10,000.

When I went to Texas to attend Luke's auction, I thought giving the horse and supplying a video would be enough, but I was wrong. They wanted me to make a speech in front of 7,000 people. I'd been living in the woods for five months, I'd never spoken to a crowd before, and I was scared to death.

The day of the auction I rehearsed my speech to a wall corner at least a thousand times. Luke got fancied up, shampooed, and his mane straightened. Luke and I walked outside for a couple hours; he had no idea what was going on, but like always, he loyally followed my direction. As the Extreme Mustang Makeover competition wore on, I began to get really nervous and I think it rubbed off on Luke, or maybe vice versa.

Eventually the event manager told me that I was almost up and needed to get ready. That's when I got really nervous, Luke too. He started pawing the ground, which wasn't comforting, but I didn't have time to think about it. My name was called, and, riding Luke, I was ushered into an arena filled with 7,000 screaming people. They had just seen Phill's video on the JumboTron, and every person in that stadium wanted my horse. Patti shoved a microphone in my hand and told me to start talking. That's when Luke starting pawing, and it dawned on me that he'd likely never even been in a building before, much less alone in a crowded stadium with thousands of very loud people.

I began to panic and started my speech, thankful that I'd practiced enunciating every single vowel thousands of times that day. I got through the speech but I'll be honest, I don't remember any of it. I handed Patti the microphone and got off my pawing horse to rub his neck and let him know he was all right. Kind of funny, Luke will walk up to a grizzly bear, but don't get him near a crowd of humans!

The auctioneer fired up. One thousand. Two thousand. Five thousand. Seven thousand. Ten thousand dollars! I walked Luke around with a big stupid grin that I couldn't get off my face. That's right Phill, Luke'll bring ten grand. Twelve thousand. Fifteen thousand. Damn, 20 people were still bidding and the auctioneer didn't have time to catch his breath. Eighteen thousand. Twenty thousand dollars! I couldn't believe it, 20 grand??? For a $125 mustang?!

The price hung at $20,000, the bidding was down to a few people, and Patti was whispering into someone's ear. Twenty-five thousand dollars. SOLD!!! I was floored, literally; I fell to the ground in disbelief. The number really didn't register in my head at the time, the excitement of the auction and the cheering of the crowd consumed the moment. Luke soaked it in, flashing his flowing mane to the crowd.

Tears of joy rolled down my face as I shook hands with the people who bought Luke. Tom O'Brien and his daughter, McKenzie, were all smiles, and when I offered, McKenzie hopped on Luke to ride him out of the arena.

Out of the spotlight, Luke was the same as always. Those tears of joy in the arena turned bittersweet when I handed the reins over to the O'Briens. Luke didn't know what was going on. He tried to follow me when I walked away, but the reins were in another's hands.

A few weeks later I talked to the O'Briens. They were letting Luke rest after his journey so he could regain some weight. They told me he has a big grassy pasture with other horses to play with, he gets grained daily, and he has his choice of grass or alfalfa. Luke found his home. Most mustangs don't.

Mustang Dilemma

I learned a lot about the complex and sad situation of mustangs over the course of *Unbranded*. Wild horse management is a misunderstood, controversial, and emotional subject with tremendous financial and ecological consequences. At the source of the controversy lie the mustangs themselves. What exactly are they? Are they icons of American history that should be allowed to roam freely in the West without interference or management, or should mustangs be treated like feral hogs and other invasive species that disrupt the natural ecosystem?

I wanted to know more about our mustangs, and one way to find out was through genetic testing. I plucked hair from *Unbranded* horses and brought it to the Texas A&M University lab of Gus Cothran, who has tested more than 70,000 horses and knows what they are, at the biological level, better than anyone. According to Cothran, a mustang is a horse that was born in the wild whose ancestors, at some point in time, became feral either by being released or escaping from their owners. Some mustangs have wild ancestors that go back hundreds of years; others have ancestors that go back

only one generation. Because all horses are the species *Equus caballus*, the genetic differences aren't huge, but some genetic markers differentiate between breeds. Comparing the markers can give insight into the history of each of our horses.

The results of our mustangs' genetic testing told the history of the West. They carried traces of draft horses brought west by farmers, the thoroughbred markers of the cavalry remounts, and cow horse blood from the era of cattle drives. One of our horses, Tuff, showed strong Spanish ancestry from the days of the conquistadors. Simi-

lar to American people, our mustangs had ancestry from all over the world—Arabian, South American criollo, and even Russian yakut. They were a melting pot of bloodlines representing the various cultures that have interacted with the Americas in the past 500 years.

Whatever the genetic make up of a mustang or wild horse, one thing is certain: the Wild Horses and Burros Act transformed unclaimed horses into a mystical animal that captured the hearts of Americans. When the act was passed in 1971, the country's wild horses and burros became protected as "living symbols of the historic and pioneer spirit of the West." Under protection, their populations boomed, and amendments to the act were added in an attempt to manage the mustangs as "an integral part of the natural system of the public lands" while gathering excess horses "to preserve and maintain a thriving natural ecological balance." The BLM assessed the rangelands and set an Appropriate Management Level that in 2014 was 26,700 animals, a population they believed allowed for healthy wildlife, cattle, and range conditions under the bureau's multiple-use policy.

At the time of our *Unbranded* ride, the population of wild horses and burros was almost double the Appropriate Management Level. The BLM can't round up enough excess horses because they don't have any place to put them. There are already 50,000 wild horses and burros living in captivity. Fifteen thousand live in feedlot-style holding pens waiting for an adopter who rarely appears. Thirty-five thousand live in long-term leased pastures where they will live out their lives with almost no chance of ever finding a home. A horse can live to be 25 years or older, and its lifelong feed bill may

cost more than what I paid to attend Texas A&M University.

In 2014, the US government spent about $46 million on board, feed, and personnel to hold almost 50,000 formerly wild horses in short-term pens and long-term pastures. An additional $4.8 million was spent on roundups and another $7.5 million on adoption events where just over 2,500 animals found homes (half the number that had found homes ten years before). For our horses, we paid an adoption fee of $125 each.

Roundups, stockpiling horses in pens, and paying for expensive pasture leases is not a sustainable management policy. Until a solution is found, horses will continue to be crowded into holding pens, costs will climb, and the risk of rangeland degradation will rise. Adoption can be part of the solution but cannot fix the entire problem. Fertility control might be a viable option to maintain wild horse populations, but current contraception methods are too expensive, unrealistic, and inhumane. For example, PZP-22, an immunocontraceptive effective for about one year, subjects a mare to continuous estrus cycling and harassment by stallions. But because the drug's cycle doesn't necessarily follow nature's cycle, when the drug wears off, the mare can become impregnated and her foal might be born during the harshest time of the year, such as the onset of a Western winter. Maybe a portion of the $46 million spent annually to feed unwanted horses would be put to better use on research for a birth control strategy that is cost-effective and works as naturally as possible.

The future for mustangs isn't bright, and if actions aren't taken to lower population sizes, my fear is that our prized horse herds will be managed like they are in Australia,

where excess feral horses are gunned down by helicopters. Even scarier, but more subtle, is the possibility that overpopulated herds will destroy vulnerable ecosystems that native plants and animals have relied on for thousands of years.

The Bureau of Land Management is a multi-use agency facing many economic and political pressures. Recreation, wildlife, timber, mineral resources, ranching, native plants, endangered species, and wild horses all depend on the management decisions of the BLM. Proper planning and an adequate budget might provide for all of these, but budget cuts, emotions, misinformed media attention, and politics have too often influenced management decisions away from what science says is needed for a healthy rangeland to what is popular with a public largely uneducated about the biodiversity of our country's remaining wild landscapes.

I've adopted four mustangs, and I love every one of them. But I realize that adoption efforts won't fix the mustang dilemma. Their numbers must be reduced in an alternative manner, and it will require hard decisions met by stiff opposition. The future of the mustangs, wildlife, and western communities depends on a healthy rangeland. As conservationists, we must use our resources wisely and recognize that the current wild horse and burro management policy is not sustainable or beneficial for the future of the western landscapes.

Chief, rolling in the dirt

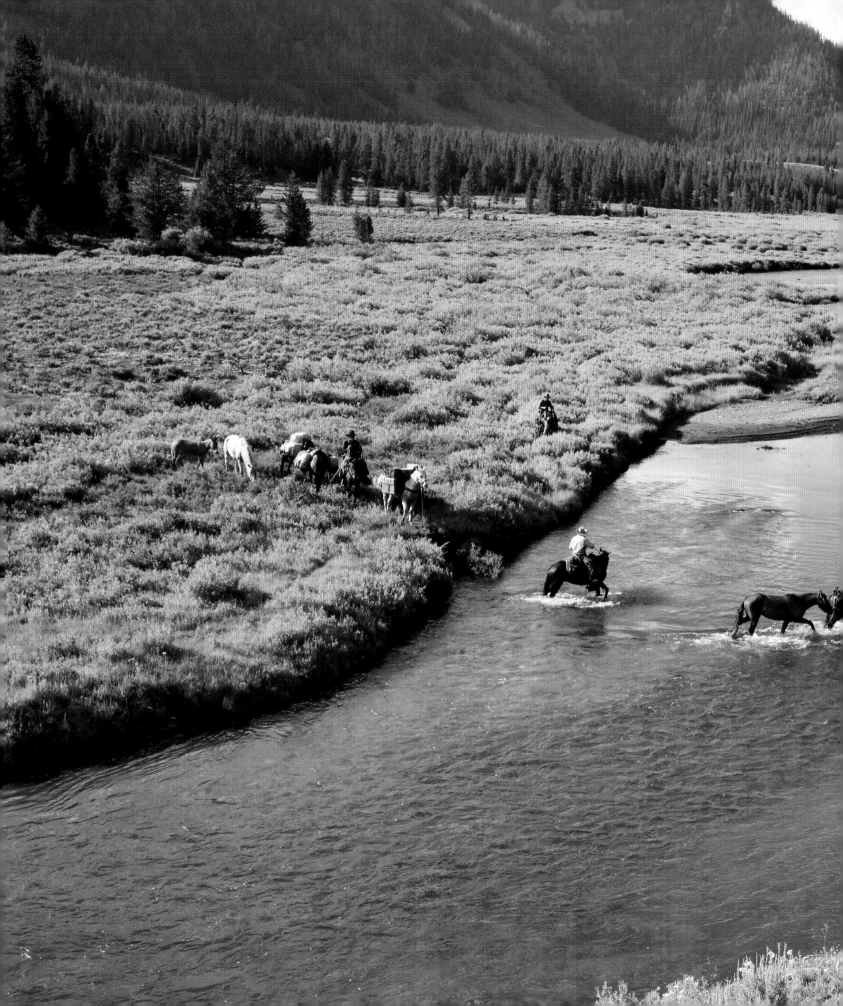

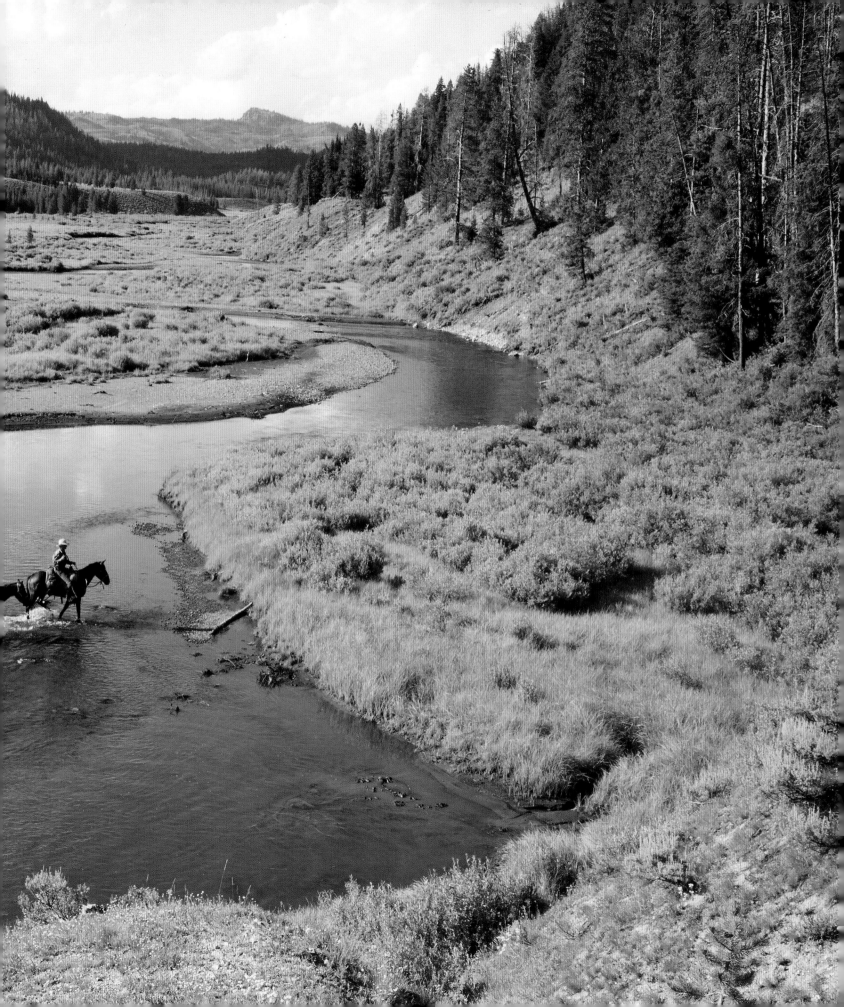

Looking Back

The question everyone asks is why did I do it? That's a difficult question to answer. There were obvious reasons—to promote mustang adoptions and conservation awareness, to advance my career, and to realize my dreams. But really, why was I doing it? I may not have fully known then, but with time it became clearer. I was searching for purpose—to find direction for the rest of my life and to find my place on a changing planet.

In the five months and six days of the *Unbranded* ride, through constantly changing landscapes, I gained an appreciation for nature that other backcountry horsemen understand. Driving down the highway, you keep your eyes between the lines. Backpackers stare at their feet, and bikers look at the trail, but horses allow you to see the country unfold. Horses travel at 2.5 miles per hour, a pace that allows you to see the small things that too often go unnoticed—the intricacies of stream rivulets combining to create a river, the overwhelming smell of sage after a rainstorm, or the innocent eye of a fawn hiding in tall grass. I don't know if God put horses on this earth as the perfect traveling companions, but if so, he did a fine job.

As we crested mountain ranges, crossed highways, swam rivers, and navigated suburbs, my thoughts often revolved around the interaction between humans and nature. I noticed a conundrum. People love the idea of nature, wildlife, and open spaces. But people also love to live on fenced, five-acre ranchettes, to drive SUVs 200 miles a day through Yellowstone, and to eat sushi imported from the other side of the world. People love nature, but not at the expense of luxury. A dichotomy exists between land that is conquered and land that is preserved. People's land vs. nature's land. We want to preserve nature's land and venture into it from people's land, or maybe just observe it through a windshield.

We can't preserve everything. I eat food, drive, wear clothes—we all use natural resources. There is room in the West for both nature and society, but there may not be enough room for both without personal sacrifice and a willingness to acknowledge that everything we do and everything we buy has an impact on the world around us.

Riding high above the Wasatch Range in Utah, watching lines of cars below me leave oversized homes to make a 50-mile commute, I reminisced about the first class I took after transferring into the wildlife department from the Mays Business School at Texas A&M. My professor, Douglas Slack, began that class with the definition of conservation: the wise use of natural resources. It was a broad definition, possibly vague and politically correct, but it struck me as profound.

With my mind lost to the rhythm of hoof beats, I thought about how I could use my own resources—time, energy, and money—for the wise use of our natural resources. I began to question the societal pressure that had always directed my life: go to college, get a degree, work hard, build wealth, accumulate stuff, accumulate more stuff

After immersing myself in the outdoors for all those months, I gained a huge amount of respect for land stewardship, both private and public. What surprised me on the journey, and still does, is how well thought out our public lands are. That statement might be criticized, but it's true. Wilderness and other protected areas satisfy the longing in our souls for untouched wild places. They can also serve as a kind of scientific control

to the management practices in unprotected areas. Logging, grazing, oil extraction, and mining occur on some public lands but under close scrutiny by conservation interests, and rightly so. Critical natural habitat is often secured on public lands while recreational opportunities for people remain endless.

I often wished I lived in the year 1500, when nature dominated the continent. But I don't, and I now feel an obligation to take care of the land that has taken such good care of me—to conserve nature in a manner that accepts the human need for nature's resources. I love the wild places we traveled through—a genuine love that came from being in those places. It's difficult to love wild places if you don't experience them, and you can't experience them if they don't exist. Using our resources wisely, conserving the integrity of landscapes, and getting outside—away from the lights and bustle of cities—are necessary for the future of wild places. If we lose them, we won't get them back.

The *Unbranded* ride gave me purpose: to become a conservationist. To devote my time, money, and passion to the wise use of our natural resources. I'm far from perfect, but I try to incorporate the cost to nature in the decisions that I make. A hundred years from now, I hope that there is still a rugged route across our great nation and that my great-grandkids can tame a string of wild horses and ride it.

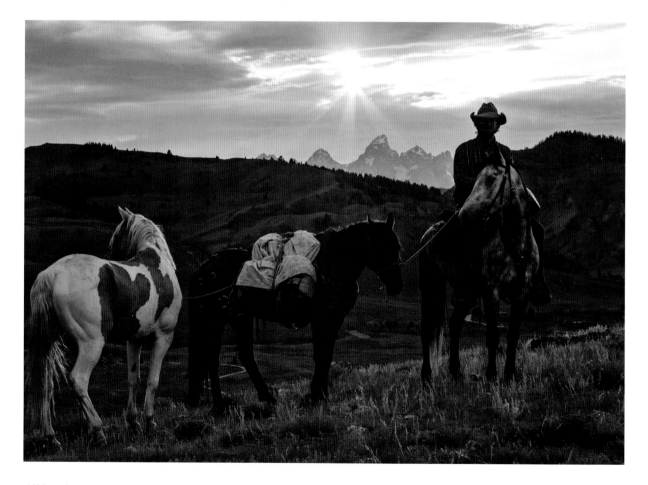

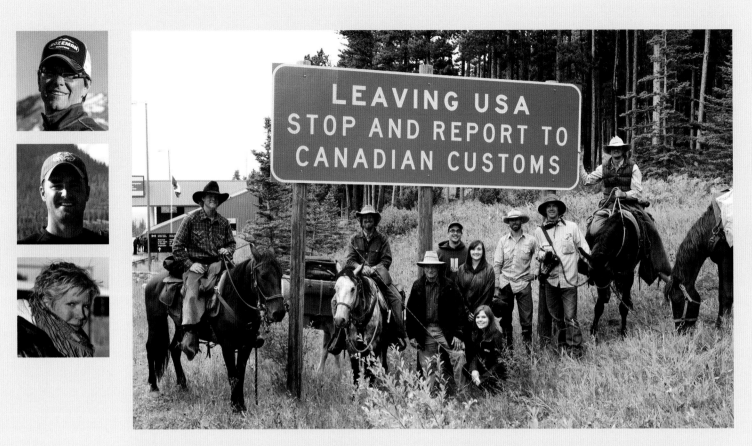

Like many Western films, the making of *Unbranded* was really about a family. The riders—Ben Masters, Ben Thamer, Thomas Glover, and Jonny Fitzsimons—all in their mid-twenties, were the prodigies, brilliant and challenging, often at the same time. Phill Baribeau was the older brother who could quietly mediate argumentative situations and keep everyone on track even while filming in some of the most difficult physical environments possible.

Because of our ages and experience, Cindy Meehl and I became the "parental unit," guiding our younger colleagues both on camera and off. Editor Scott Chestnut, with his extensive background in Hollywood, was charged with the task of transforming more than 400 hours of footage into a coherent film and became the obsessed uncle who couldn't rest until his masterpiece was

finished. Korey Kaczmarek, who did much of the second camera shooting, was the New Age cousin who added philosophy to his expert camerawork. Third cameraman Dan Thorstad was the cool step-uncle who excelled at everything without breaking a sweat and had better stories than everyone else but rarely told them.

The office staff, assistant editor Paul Quigley and production coordinator Vanessa Naive, were the stay-at-home kids who did not get to go to the big show on the trail but kept the logistical machinery operating. Val Geissler emerged as a star of the film in his own right as well as the steady but fun-loving grandfather figure.

The "real" parents and siblings, of course, were working in the background throughout, providing encouragement and support.
—*Dennis Aig*

Thanks & Acknowledgments

Unbranded is the culmination of good will from thousands of people.

Thank you to Wes and Karla Masters, Rick and Janie Thamer, David and Anne Glover, and Joseph and Blair Fitzsimons for your unending support and for teaching us our love for the outdoors. To Katie Solcher: you're the only girl I know who would put up with me going on a five-month pack trip, twice. Uncle Val Geissler, you called us son and you meant it; we'll never forget your fatherly care and priceless horsemanship.

Phill Baribeau, you've been the cornerstone of the *Unbranded* production since day one; you deserve an entire book of acknowledgments. Thank you, Cindy Meehl. You saw *Unbranded*'s potential and made us reach for it. Dennis Aig, I still can't believe you wanted to be the producer of *Unbranded*, but I'm so glad you did. Korey Kaczmarek, John Reed, and Dan Thorstad, thanks for being as good of traveling companions as you are cameramen. And to the film editor who knows me better than myself: thank you Scott Chestnut for not making us look like raving lunatics who spent way too much time in the woods. To Paul Quigley, Vanessa Naive, William Lake Springstead, Katie Roberts, Preston Reeves, Julie Goldman, John Bissell, Sam Hedlund, Kathy Kasic, Logan Triplett, Eli Weiner, Denver Miller, Jason Manzano, Tim Dallesandro, Mathew Wheat, Luke Masters, and Guy Mossman: thank you for your dedicated work.

To the 1,062 Kickstarter donors: *Unbranded* wouldn't exist without you. Thank you isn't strong enough.

To Cindy Meehl, Jerry and Margaret Hodge, John and Cami Goff, Doug and Anne Marie Bratton, Jeff Steen, Brenda and Dan Hughes Sr., Peggy and Dan Allen Hughes Jr., John Saunders, Robbie and Dudley Hughes, Preston Reeves Sr., Mary Beth Reeves, John Reimers, Wallace Allred, Max Werner, Tol Ware, Josh Holmes, and Sam Teer: thank you for believing in a film company run by a 24-year-old, prone to spending months in the woods, who took a leap of faith into a difficult business. Your support means the world to me.

And an enormous thanks to Steve Solcher, Hugh A. Fitzsimons Jr., David Mark Fenn, Mark Wyatt, Ron Broadway, Scott and Jennifer Valby, Jonathan Calvert, Al Allred, and David and Libby Hunt.

Thanks to TIP trainers Lanny Leach and Jerry Jones for risking your necks. The *Western Horsemen* team and Mustang Heritage Foundation were crucial to our success in too many ways to count. To 5 Star Equine Products: thank you from the backs of our horses. Garmin, your 24K software and GPS units are awesome.

Thanks to all the public land employees, ranchers, outfitters, and locals who helped with logistics. The Arizona Trail Association and Continental Divide Trail Coalition have done an incredible job of ensuring a wild passageway through incredible landscapes—keep up the great work. Sue Robinson, Rachel Cudmore, Debbie Bird, Elizabeth Donehoo, Sarah Grieb, Mark Norby, and Lisa Reid, few people appreciate the difficulties of acquiring filming permits; y'all are the best.

A massive hug to all the people who helped us along the way, especially to those at the Jacalon Ranch, San Pedro Ranch, Marvel 4D Ranch, Laforborn Ranch, Red Rock Ranch, Box Y Lodge, Mountain Sky Guest Ranch, Bandit Outfitters, Browning Firearms, Moon Ranch, Mad Wolf Bison Ranch and to Bobby and Dotty Hill, Jay Groppe, Robin Suggs, Siegfried, Korgal and Dave, Ronnie and Barb, the Olsen family, the O'Donnels, Garl Germann, Eduardo Garcia, and Scott Grange.

For your time, knowledge, and willingness to help our production, thank you Katie Bischoff, Burkley Wombwell, Patti Colbert, Eric Reid, Gus Warr, Ellie Price, Kelly Jay, Robert Garrott, Neda Demayo, J.J. Goicoechea, Boyd Spratling, Jim Stephenson, Joan Gillfoil, Dean Bolstad, John Fallon, Julie Gleason, Lynn Huntsinger, Rick Danvir, Roxie June, Timothy Harvey, Dee Kline, Chad Bigler, Kevin Ballard, Heath Weber, Jeff Jones, R.C. Lopez, Jackson Hole Rodeo, Tim Rutar, Carly Wells, James Wells, Brandon and Levi Wilson, Darrell Dodds, Ross Hecox, Ryan Bell, Kate Bradley, Kathy Leach, Kali Sublett, Jim Hicks, Mark Wintch, Ryan Rickert, Lauren Betancur, Fay Fitzsimons, Wyman Meinzer, Steve Schechter, J. Edward de Steiguer, and Reid Morth.

To all the family, friends, strangers, and acquaintances who are too numerous to list: Thank you. Your generosity will be passed on.

Texas A&M University Press: making this book has been a blast. Shannon and Katie, thanks for helping me make the text sound intelligent. Mary Ann and Kevin, you've done a beautiful job. Charles, I'll beat you at pool one day, as improbable as that may seem.

And to all the conservationists who've shed blood, sweat, tears, and money securing wild places across the West . . . thank you. I'll follow in your footsteps.

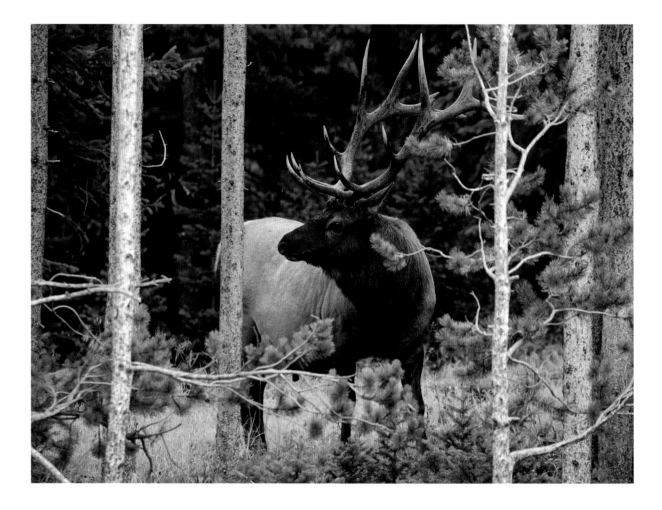